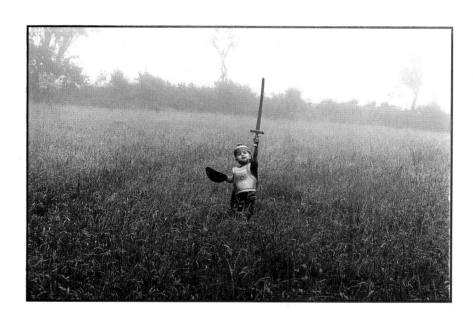

IF WE SHADOWS

DAVID BAILEY
IF WE SHADOWS

Preface by George Melly

With 200 duotone plates

Thames and Hudson

To Catherine, Paloma and Fenton

First published in the United States in 1992 by
Thames and Hudson Inc., 500 Fifth Avenue,
New York, New York 10110

Library of Congress Catalog Card Number 92-80336

Printed and bound in Singapore

CONTENTS

PREFACE BY GEORGE MELLY

The title, from the dying fall at the end of *A Midsummer Night's Dream*, hints at an envoi. Is this Bailey's swansong? On the other hand, it could be no more than a sign-off from the eighties, from which all the photographs are drawn, in the same way that his *Goodbye Baby and Amen* dispatched the sixties. Who can say, for Bailey has always been a tease, but certain themes running through the book do suggest another Shakespearian metaphor: that he has decided to break his wand, or at any rate hang up his camera.

As you will have realized already – for surely no one reads the introduction to an album of photographs first, if indeed at all – his scheme here is to print two images side by side and, with very few exceptions, these appear to relate to each other in some way. This is not a new idea; older readers may recall that *Lilliput*, an admirable and long-defunct magazine, used it for many years to humorous or satirical ends; but Bailey has taken this simple if effective formula and elaborated it to encompass a wider response. There is humour certainly – John Lydon in juxtaposition to the interior of a dissected pig's head, for instance – but it is black humour, and connects with a high proportion of twinned contrasts much concerned with death, the photographic equivalent of an Old Master's *memento mori*. Indeed, on the opening page is a picture of an Australian tombstone. 'In loving memory of DAVID BAILEY,' it reads, 'Died February 10th, 1926, aged thirty-nine.' No doubt happening upon it made him laugh, but surely not without a slight shiver.

In the past Bailey has largely celebrated the transitory. Here too there are plenty of golden lads and girls, but he, if not they, seems to have become aware of the chimney-sweepers. The most extreme example shows Anita Pallenburg, the Rolling Stones' *femme fatale* of the sixties, screaming with hysterical laughter. Next to her is a mummified Peruvian corpse in an identically frantic pose. In that the icon and the cadaver were clearly photographed at different times, and presumably a conscious comparison did not occur to Bailey until he was selecting the photographs for this book, he has put together not just examples of his work during the eighties, but an extended collage.

His sources are various: those hard-edged photographs of the famous and beautiful (the kind of people the bouncers at Studio 54 would happily allow in); jokes, like his wife made-up to look like a Picasso; images of Rome, Peru, the West Country and South Wales. There are also parts of dead animals, especially the heads of beady-eyed chickens. Of course not all the pairings are as pointed as the modern version of Death and the Maiden mentioned above. There are clusters of images on the same theme: a very erotic lesbian sequence, for example, and two old photographers, Bill Brandt and Brassaï, placed side by side, as a kind of ancestral homage. Sometimes too there are puzzles and obscurities. Why the rather leathery Mick Jagger and a stained and discoloured mattress? Why Schnabel, the painter, next to a coffee cup covered by a hand (Schnabel's hand?) with one beringed finger poked into the liquid? I don't think these conundrums work against the book, however. On the contrary, they reinforce the atmosphere of dreamlike mystery.

The photographs of Rome, predominantly broken statuary, are used quite methodically in contrast to our impermanence. On the other hand, Peru equals poverty; Australia, rather originally, the detritus of Empire; the British countryside a certain lyricism. Just occasionally there is something a little too obvious: a shot of the all-girl group Bananarama, jumping around for a publicity still, in contrast to a sedate crocodile of nuns; but for the most part this is a thoughtful and disturbing book, equal in impact (while the antithesis in its effect) to his very first collection, that 1964 celebration of hedonism, glamour and danger, *David Bailey's Box of Pinups*.

* * *

Bailey has always struck me as more complicated and endearing than his self-promoted public image. He emerged originally as the personification of the 'classless' sixties, with impeccable East End credentials (which he tended to play up) and with the chutzpah and talent to impose himself on the world of fashion.

His method, as I have observed it on several occasions, is to buzz insect-like around his subject, using up roll after roll of film while keeping up a monologue of seductive

encouragement. Some might think that anybody could take a good photograph in this way, but the point is that the end result could be by no one but Bailey. Whether the explanation lies in his ability to recognize the right image on the contact sheets, or his skill in cropping it or printing it, the final photograph is always remarkable. In my view, only a handful of photographers, Man Ray for instance, had this ability to impose an individual vision on a mechanical process again and again.

A more sensitive area is his eroticism. Not content to marry or live with some of the most beautiful women of our time, he chose to photograph them as sex objects, often in sado-masochistic situations, and to let us in on it. During the sixties such imagery was considered 'liberating', but with the emergence of feminism it has become taboo and has put most nude photographers on the defensive. Not so Bailey. Personally I find his imagery very exciting (I share his taste for very long legs and a certain androgynous quality), but I remain nervously in the closet, and furthermore understand and sympathize with those who find these photographs unacceptable. Bailey seems completely indifferent to any such pressures and, to compound the offence, several of his ex-wives and mistresses (I cannot speak for all) retain great affection for him. It is also certain, not that it will in any way placate the sisters, that his erotic photographs emanate a disturbing poetry. Art, after all, is not necessarily 'correct' and Bailey is undoubtedly an artist.

Bailey's wife, Catherine, is often photographed with their children, and these little creatures, Fenton and Paloma, are of enormous importance to this book. Entirely without cuteness or sentimentality, their images offer a challenge to the rattling of bones. Not shadows but substance.

If we shadows have offended,

Think but this – and all is mended –

That you have but slumber'd here

While these visions did appear.

And this weak and idle theme,

No more yielding but a dream . . .

William Shakespeare *A Midsummer Night's Dream* Act V, Scene II

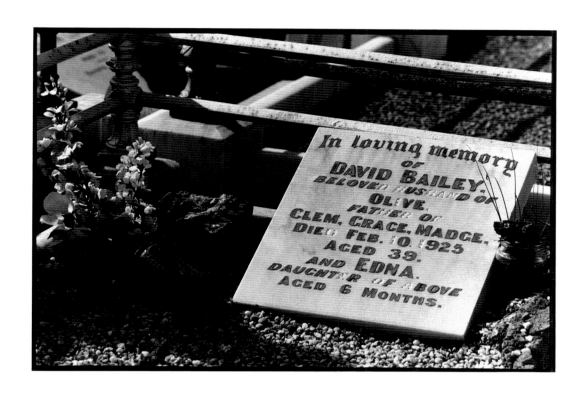

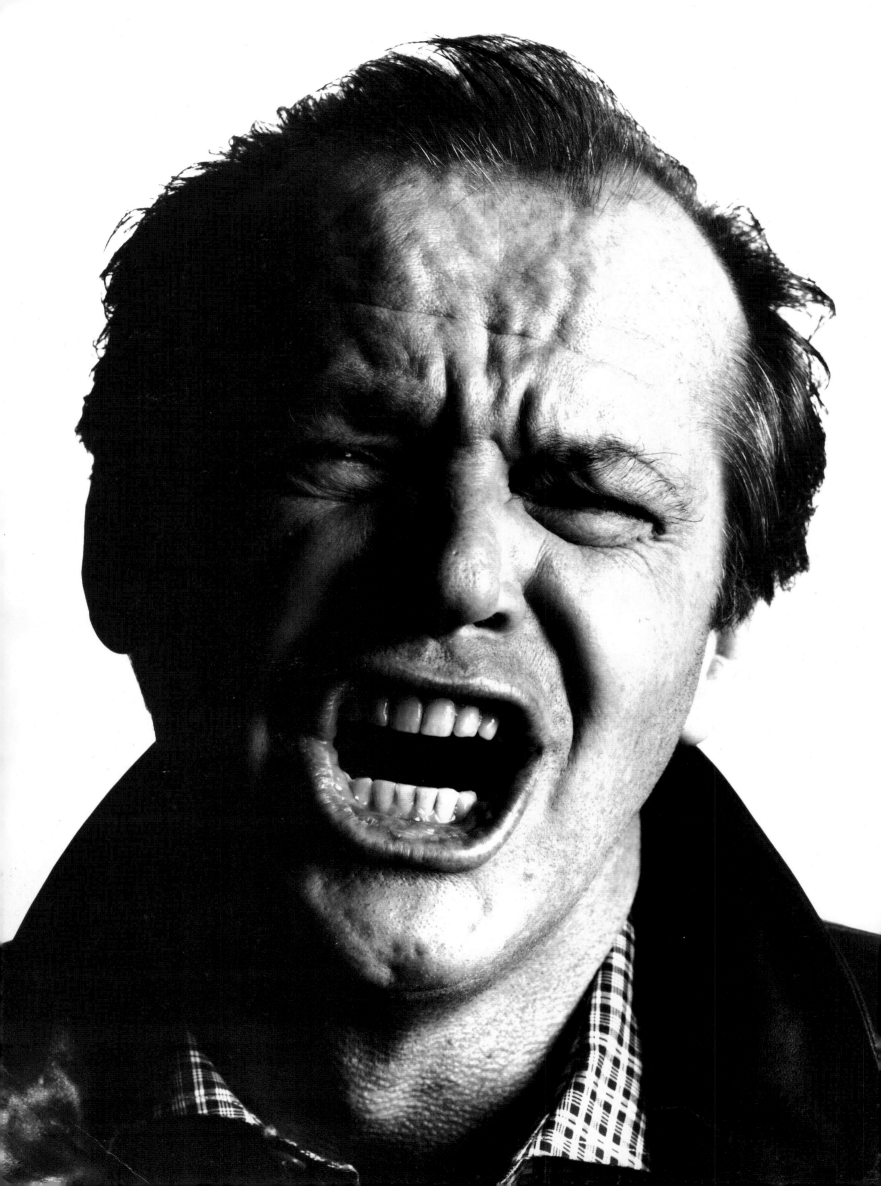

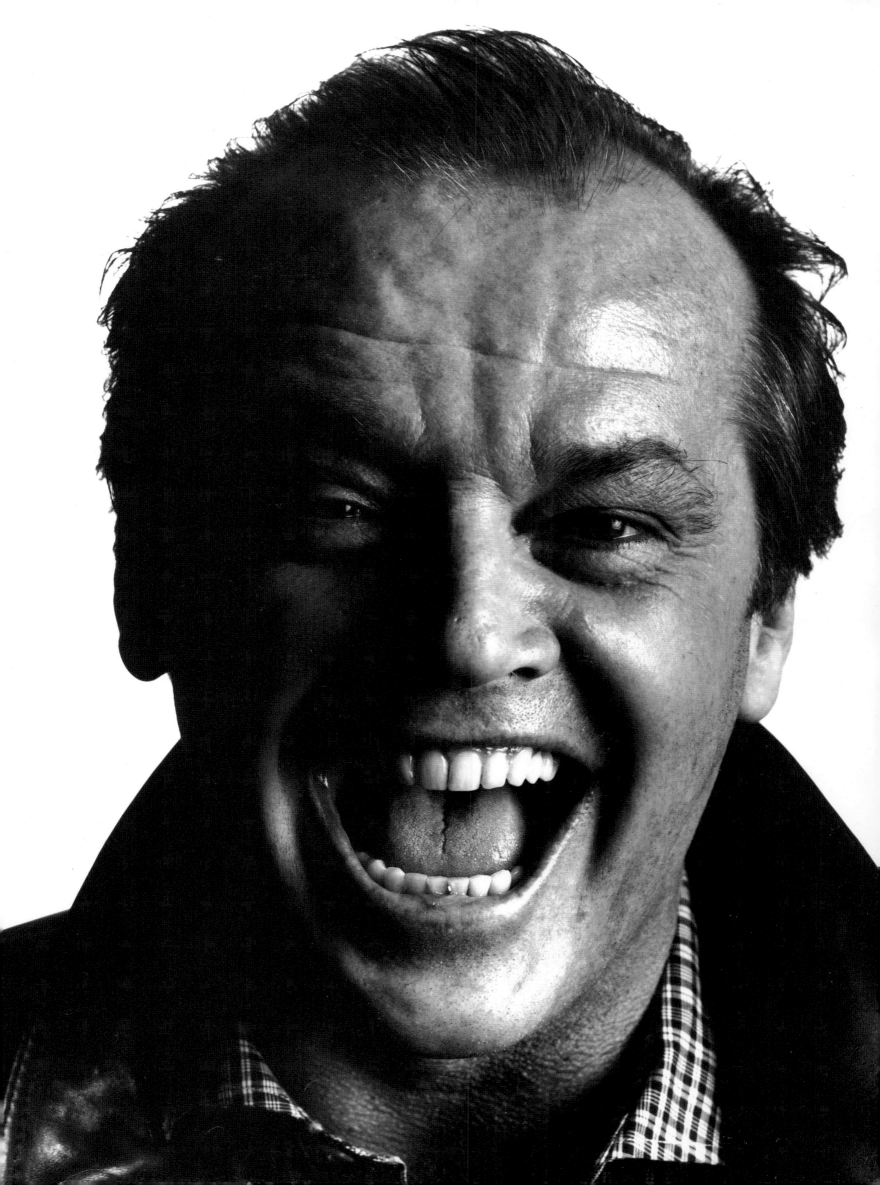

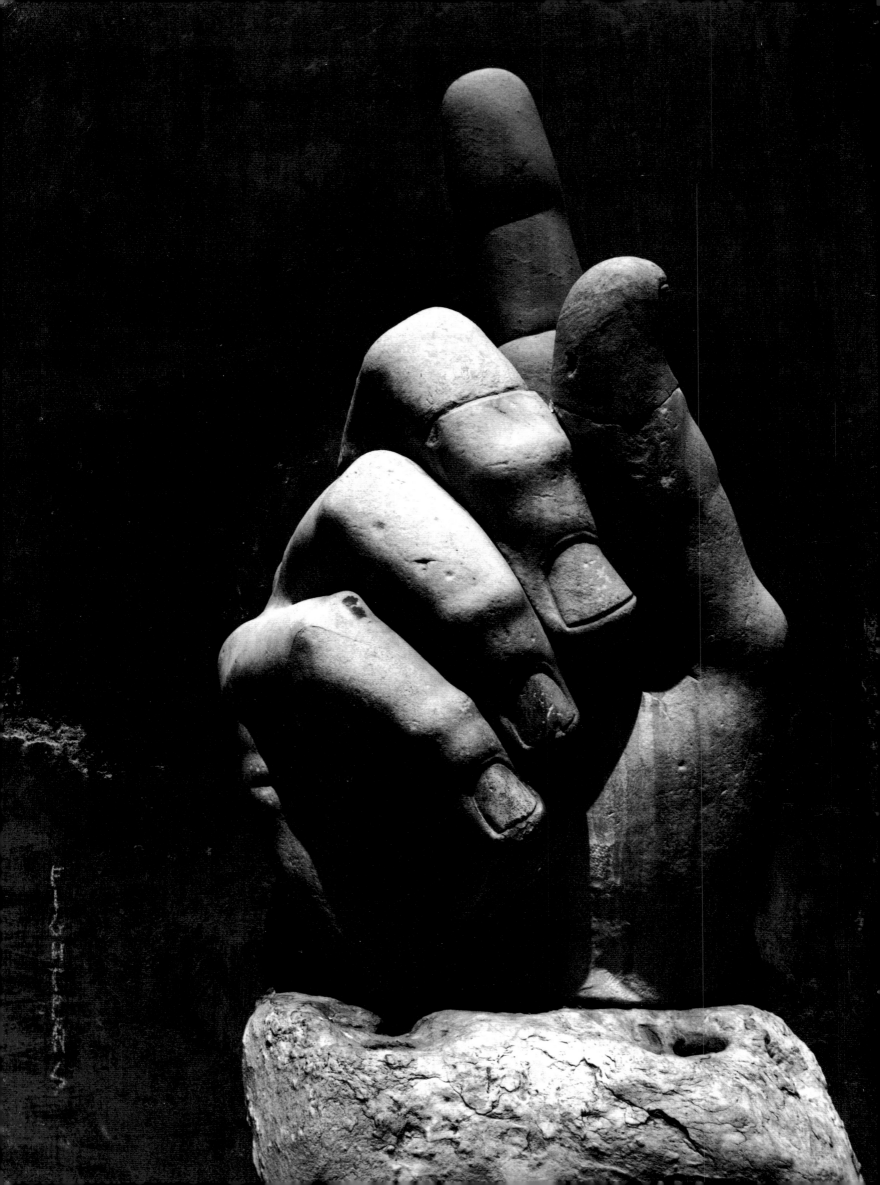

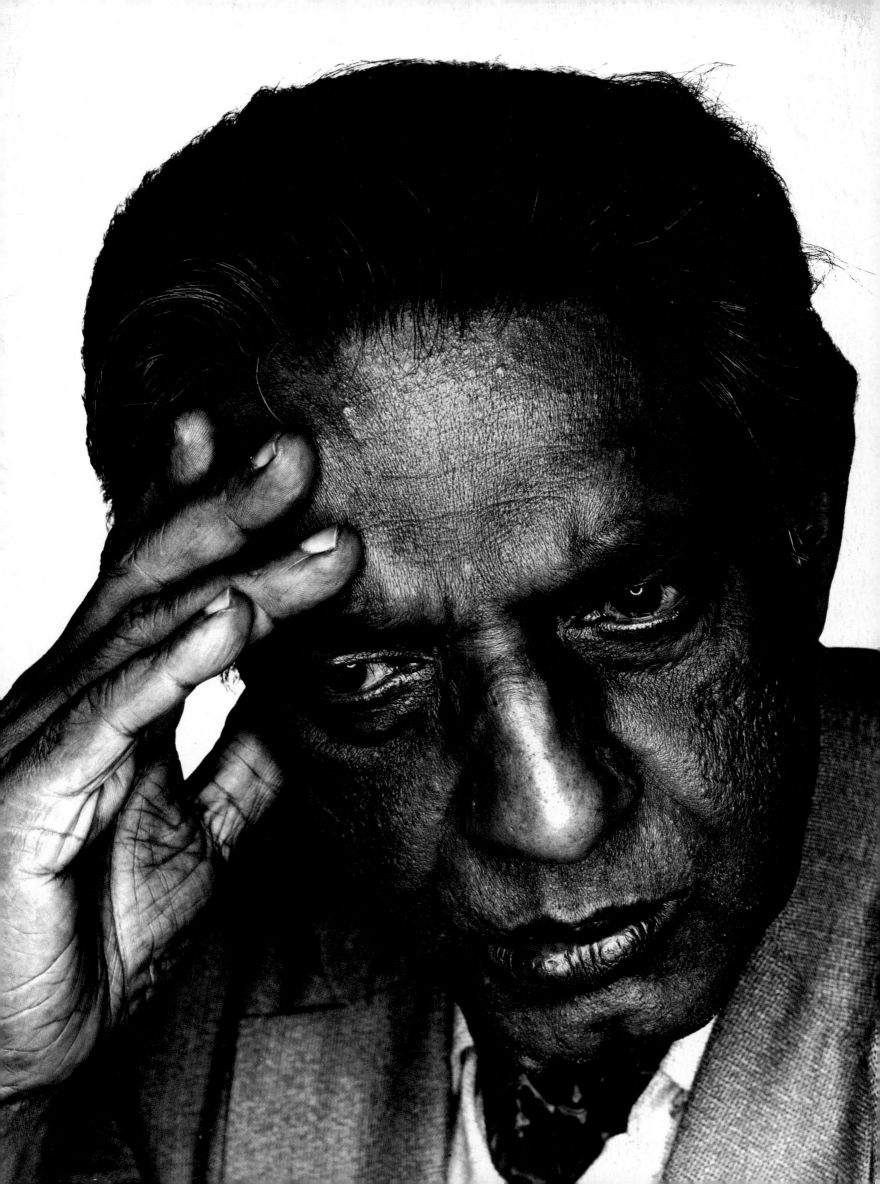

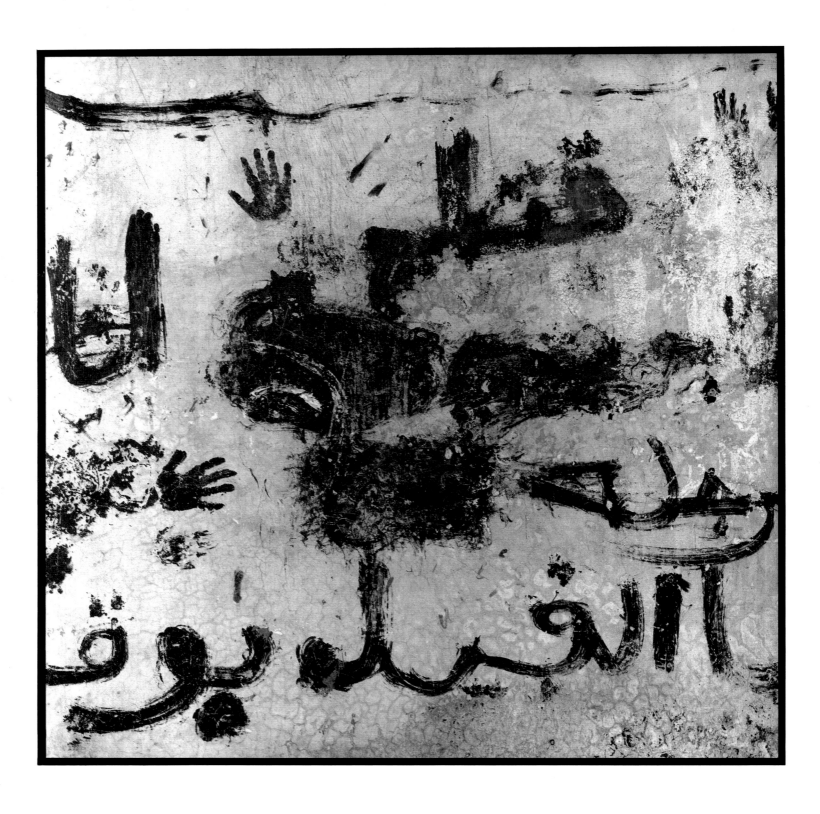

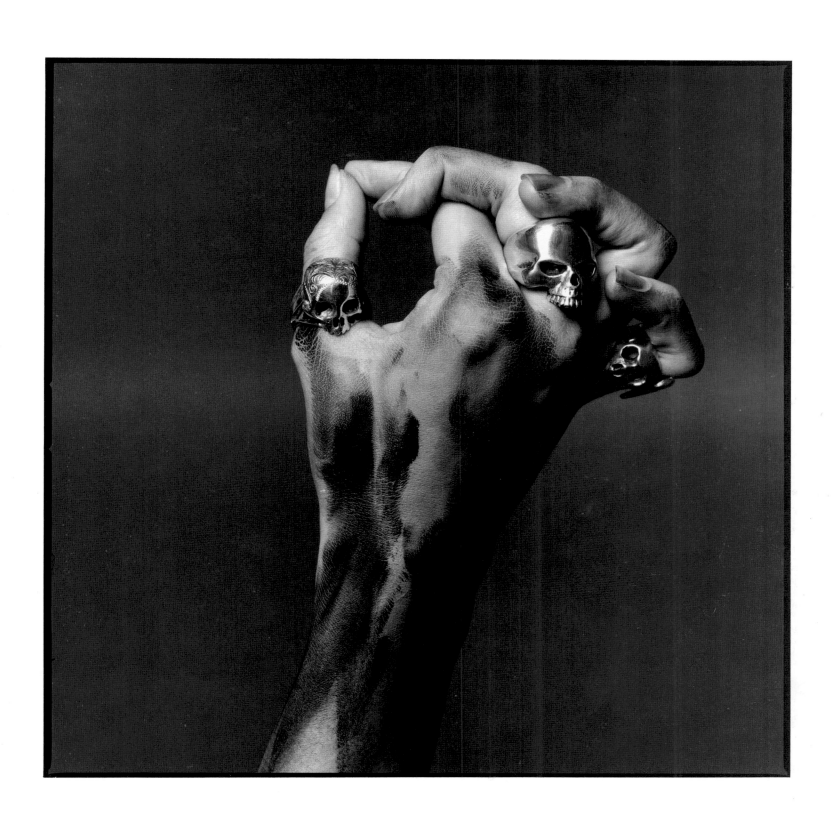

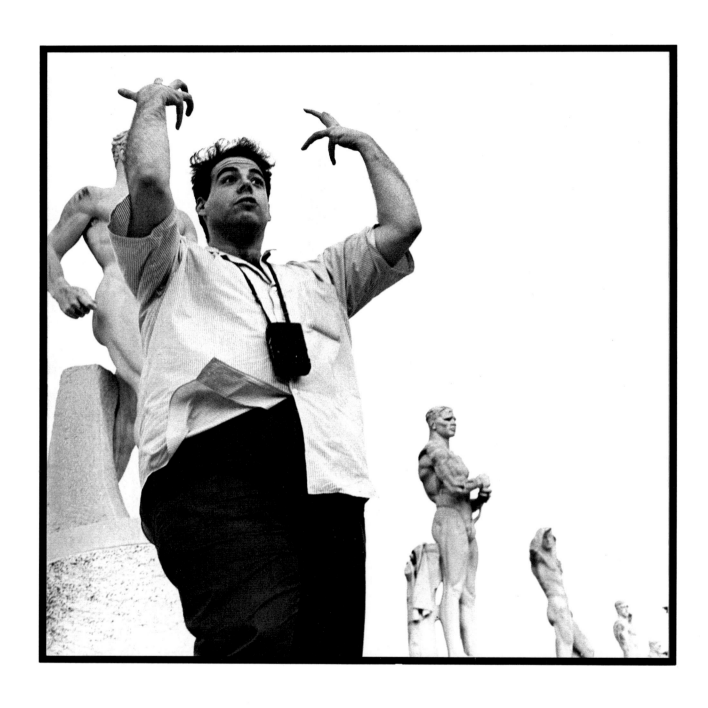

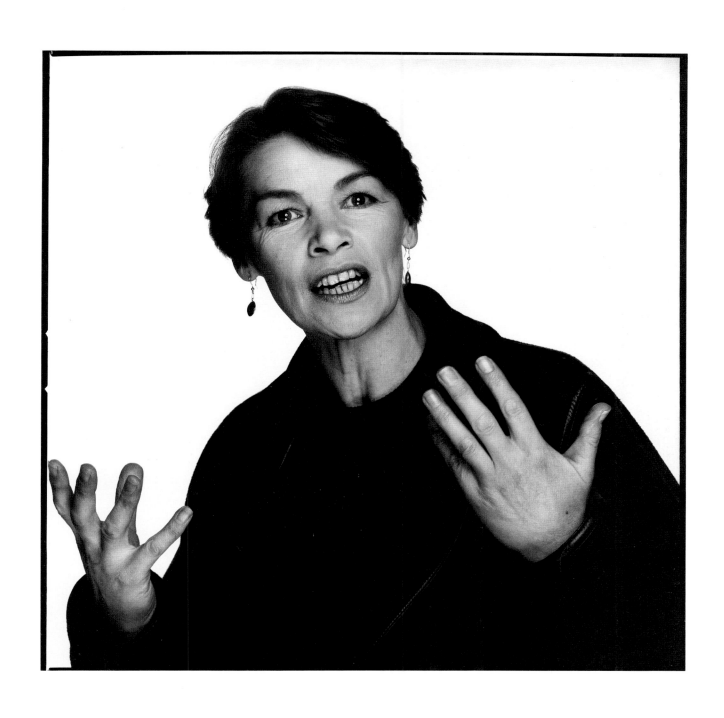

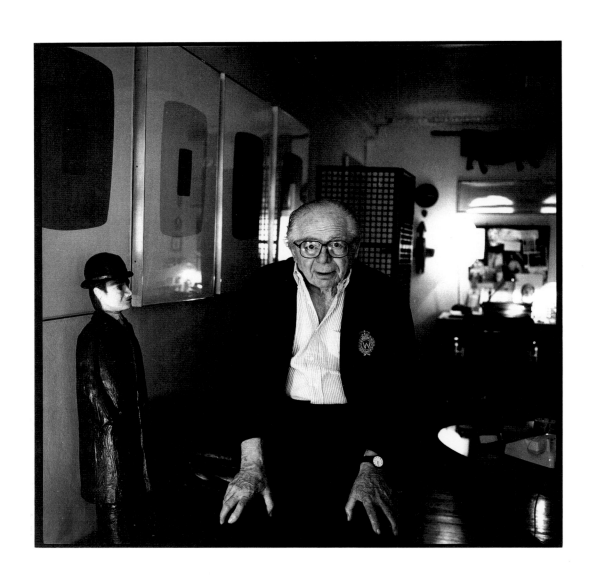

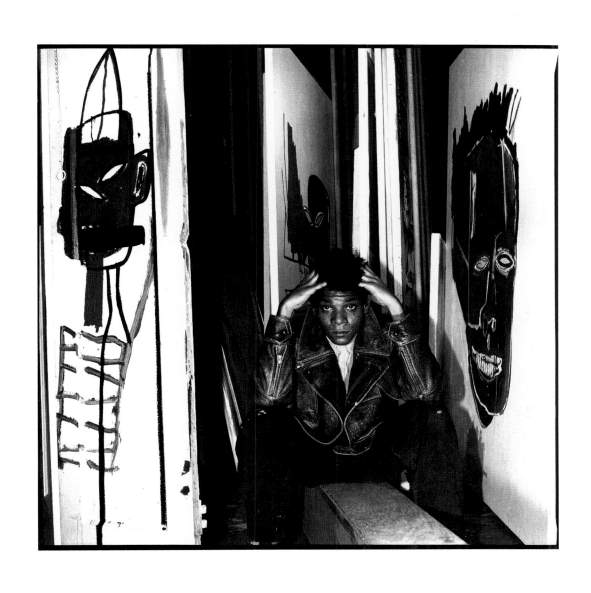

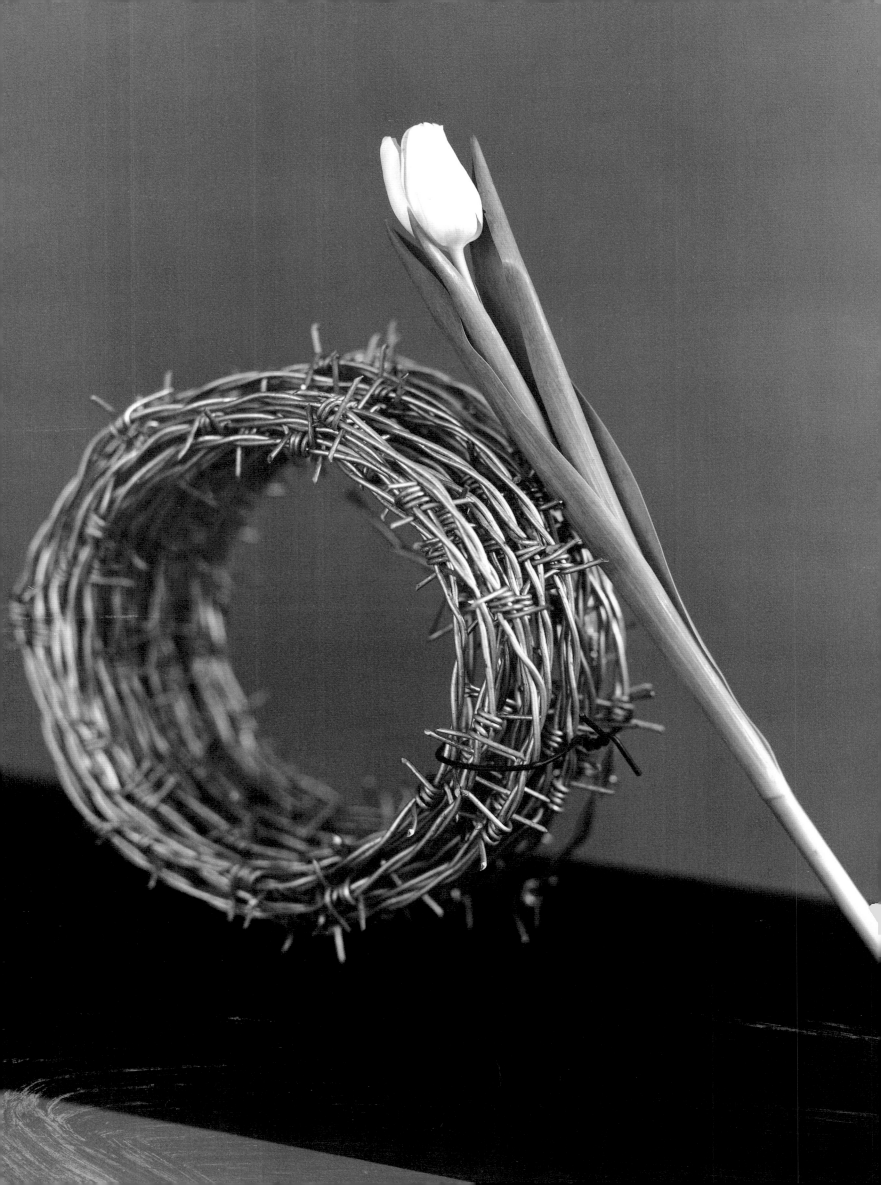

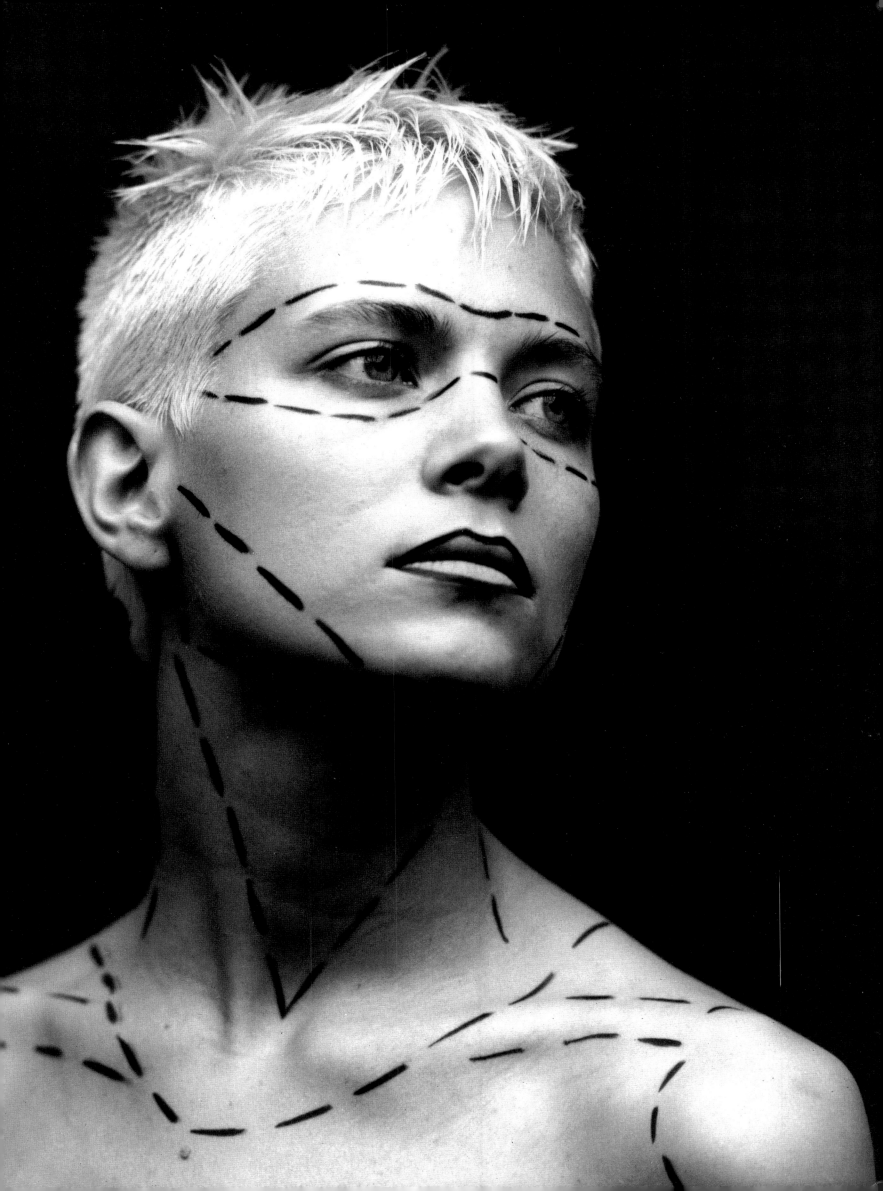

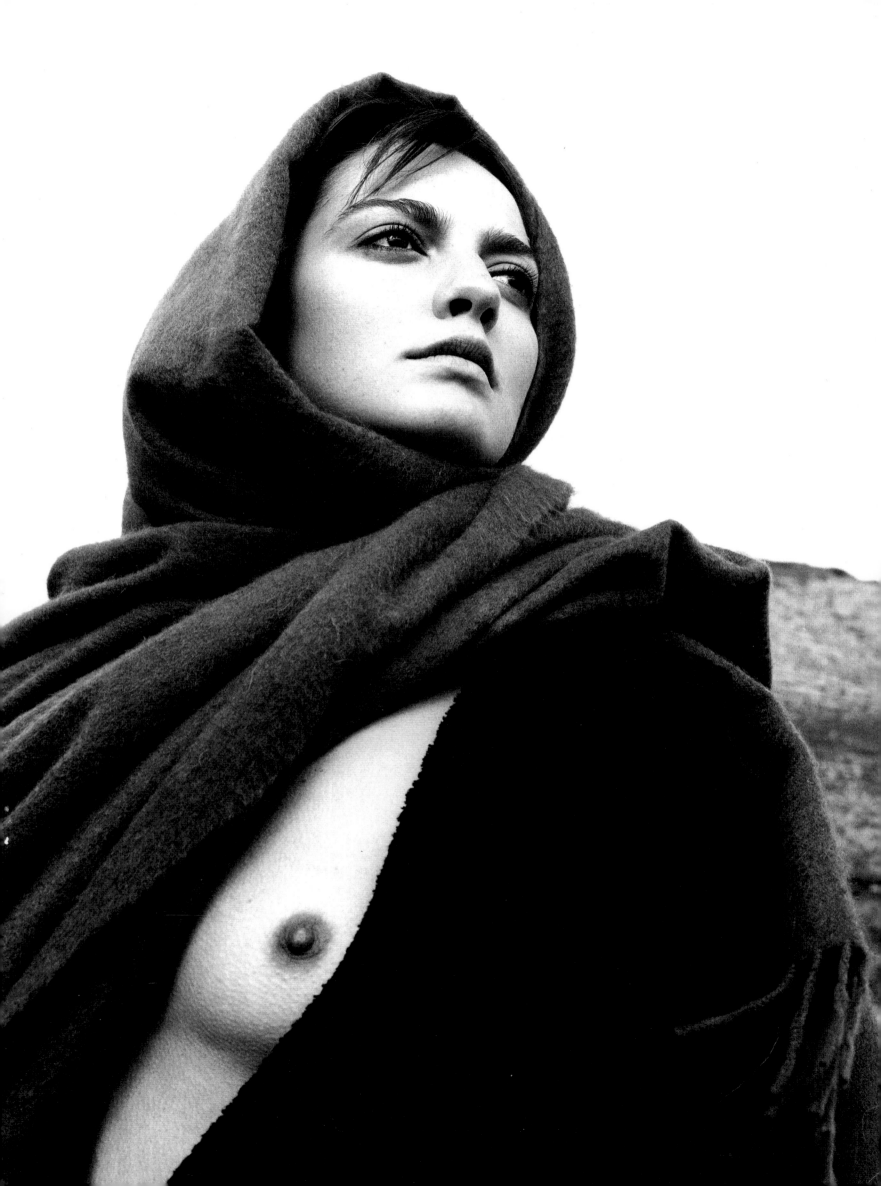

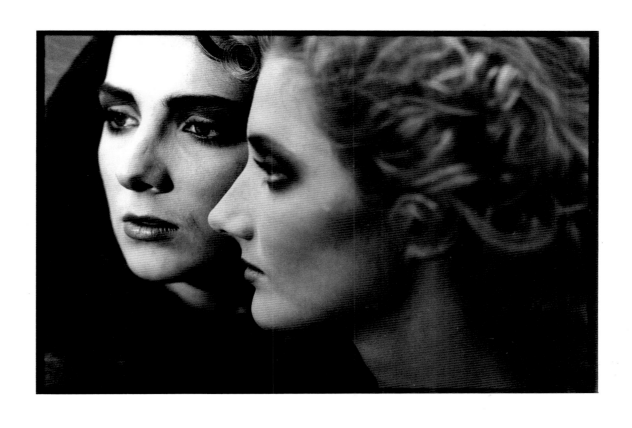

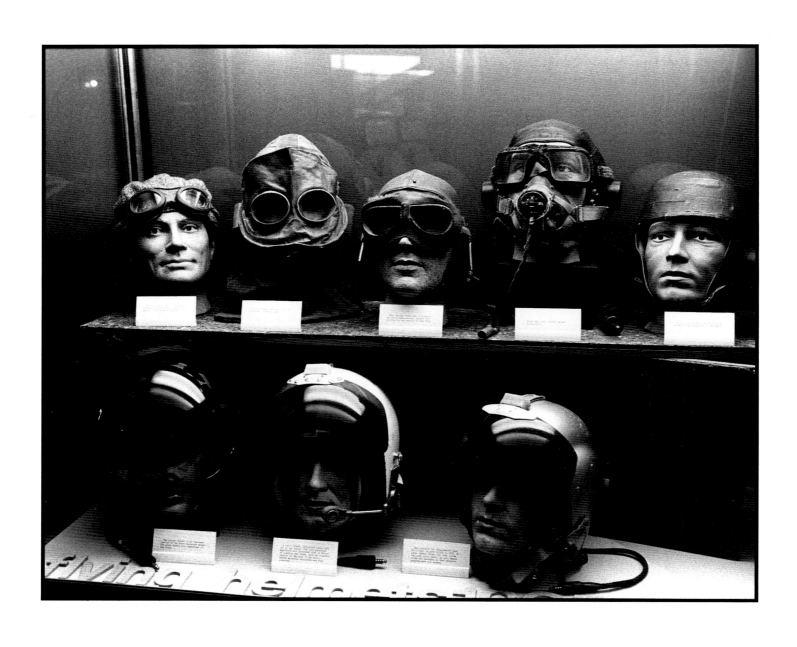

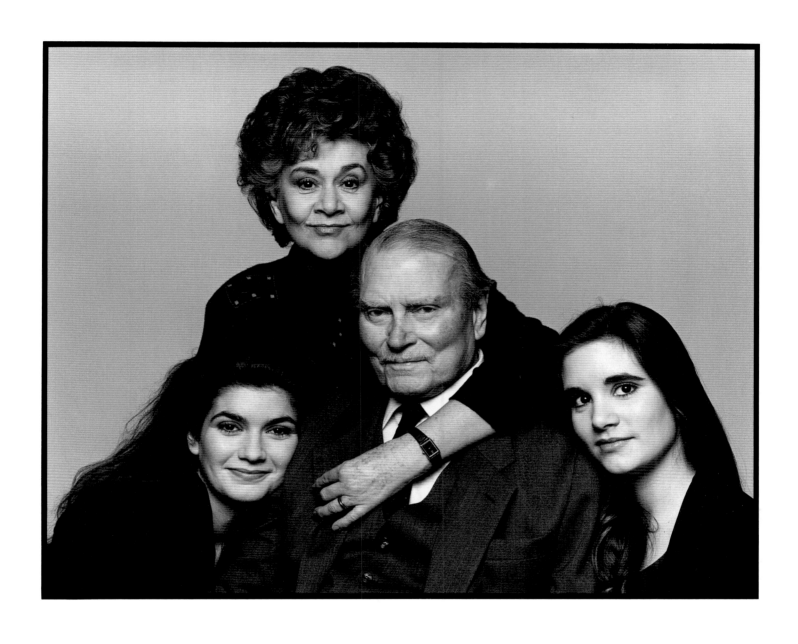

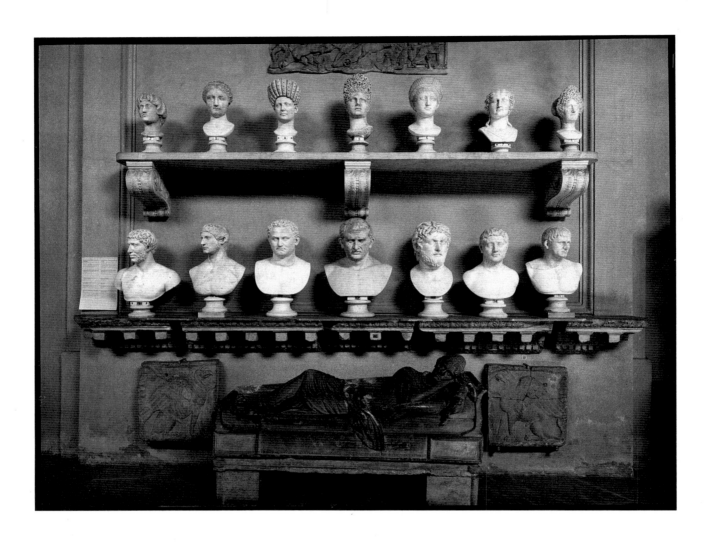

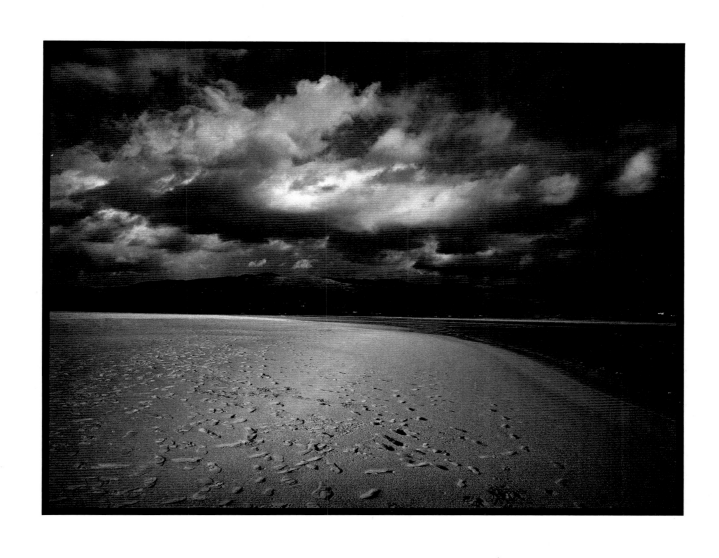

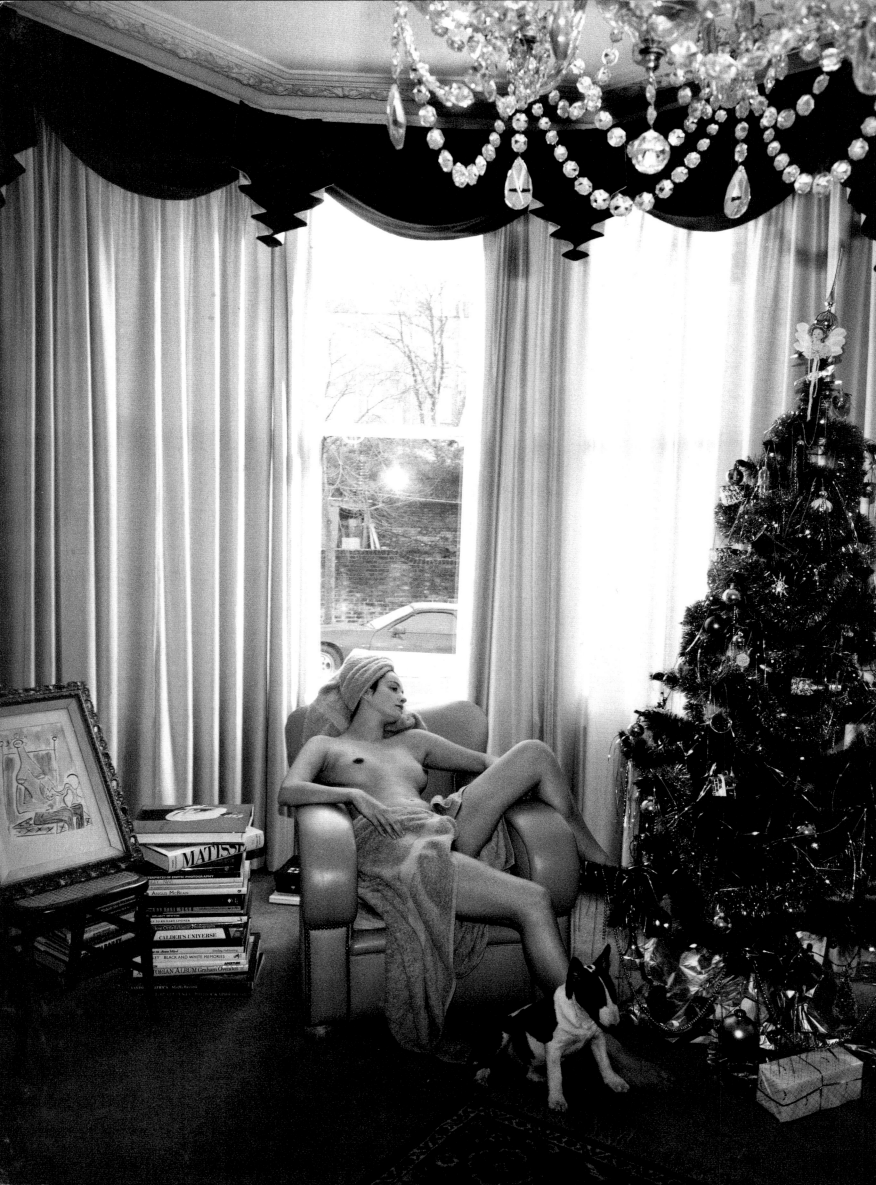

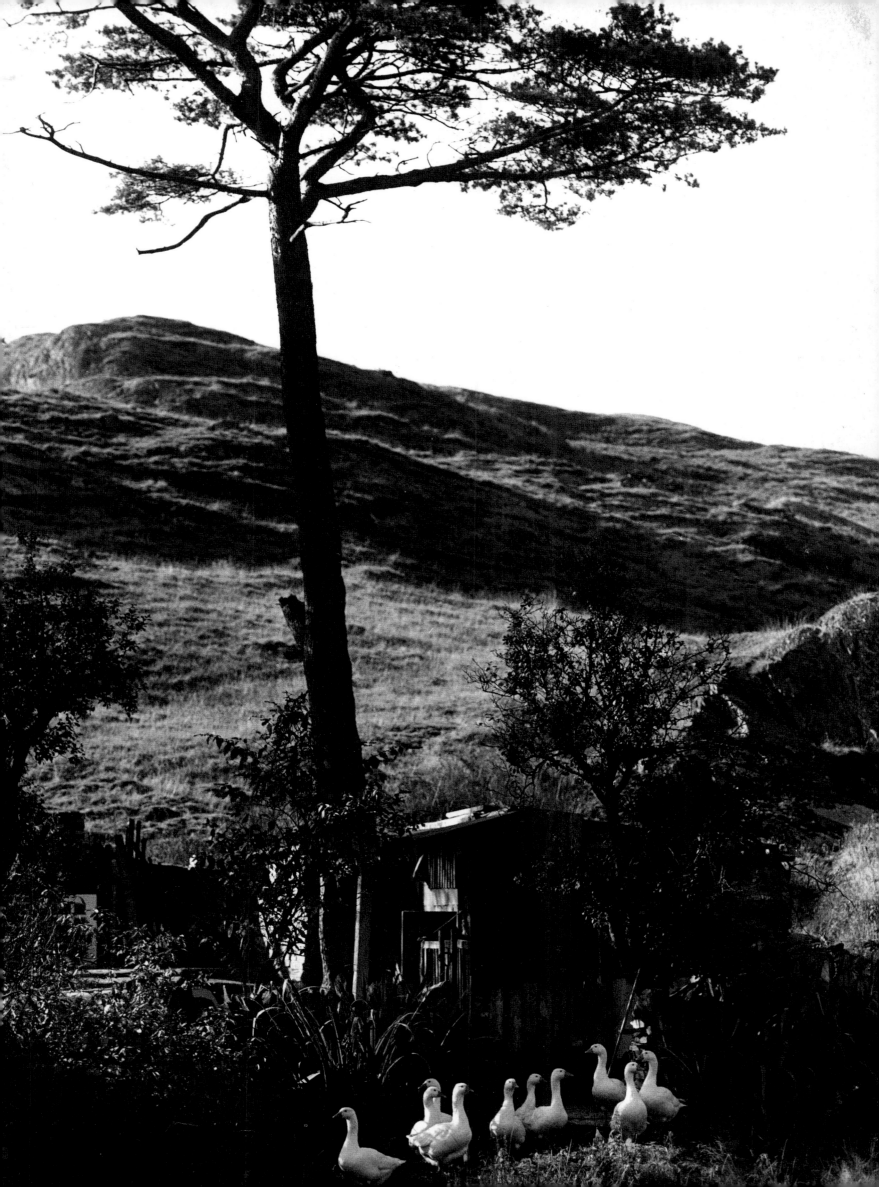

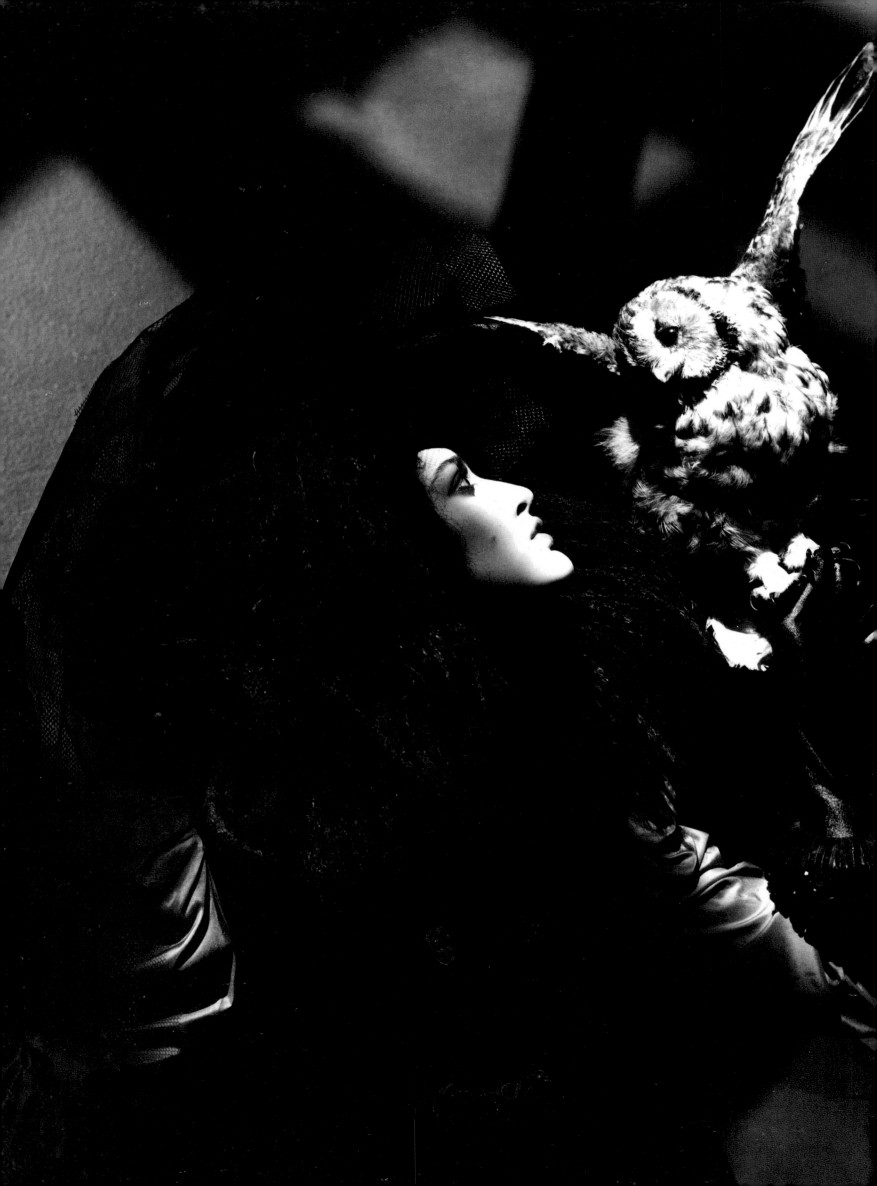

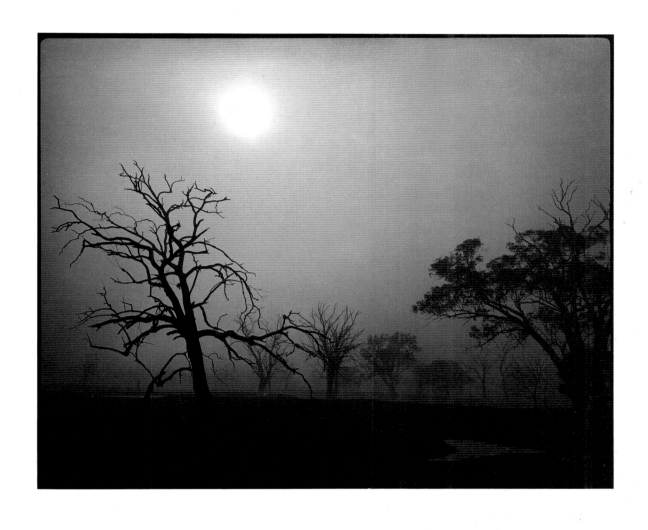

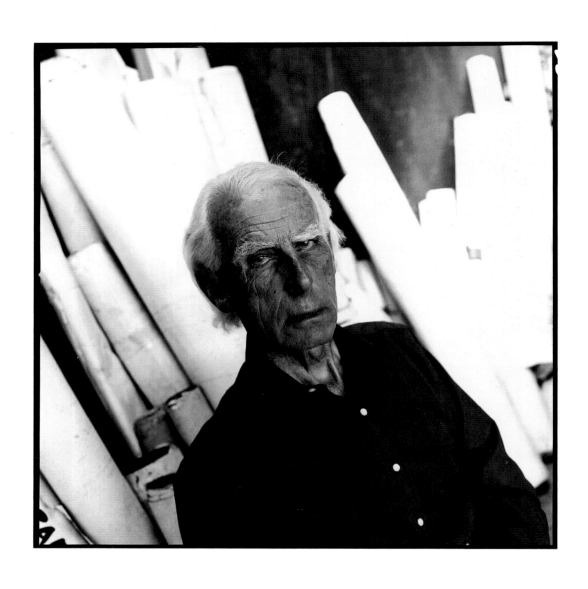

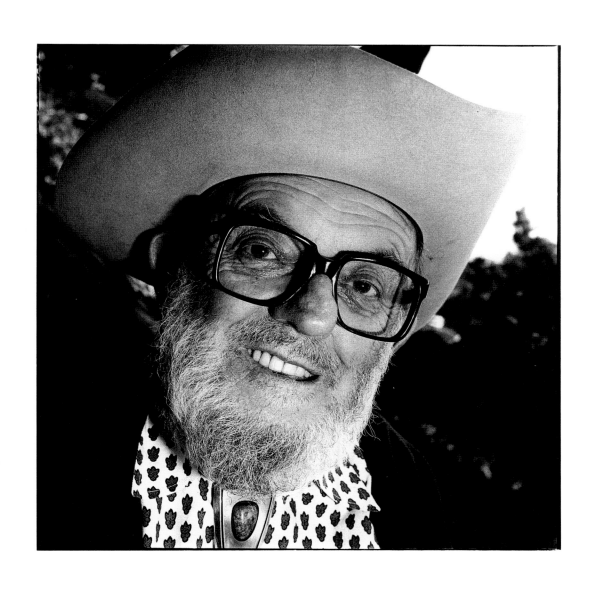

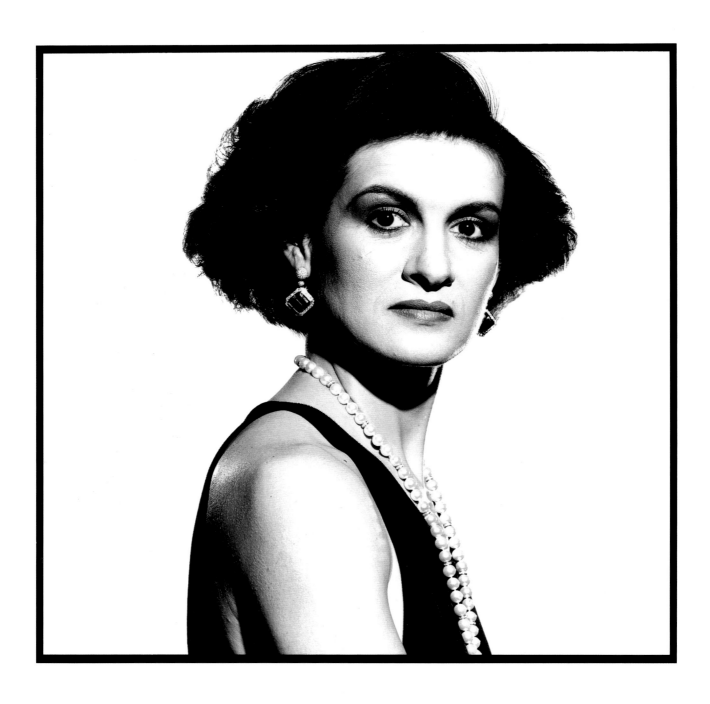

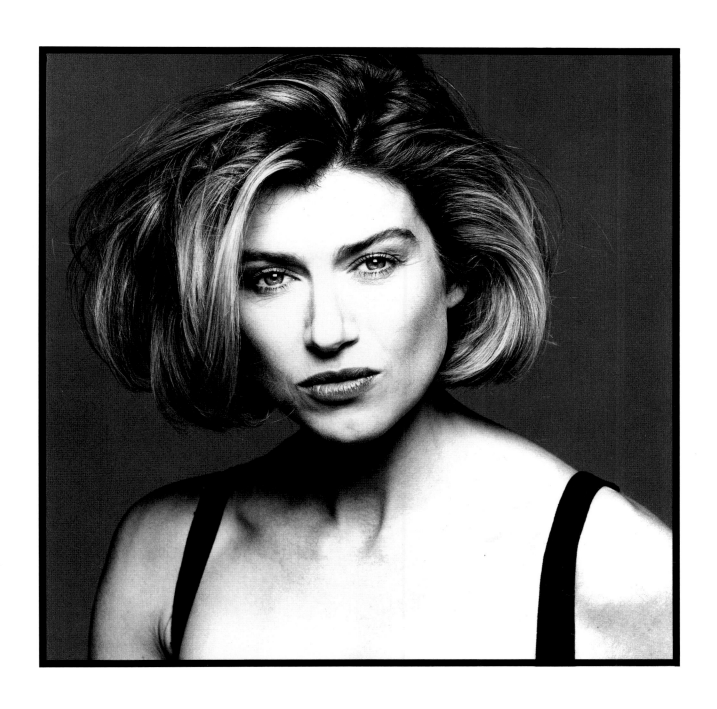

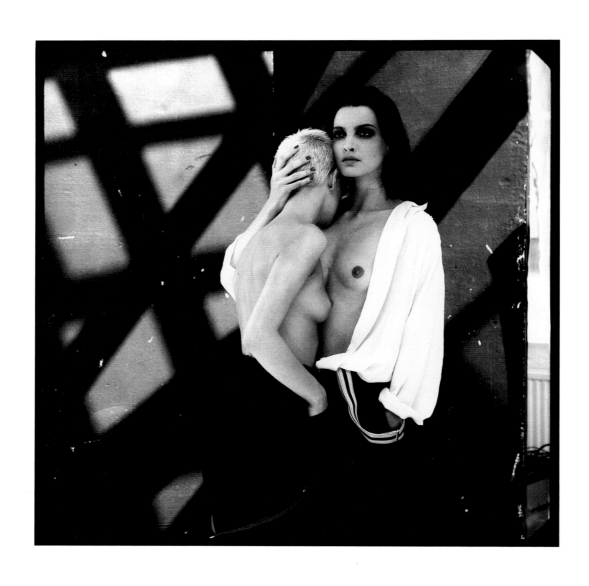

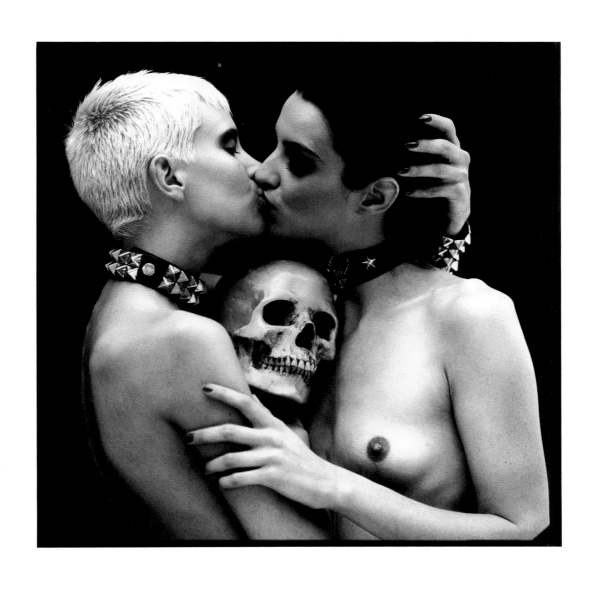

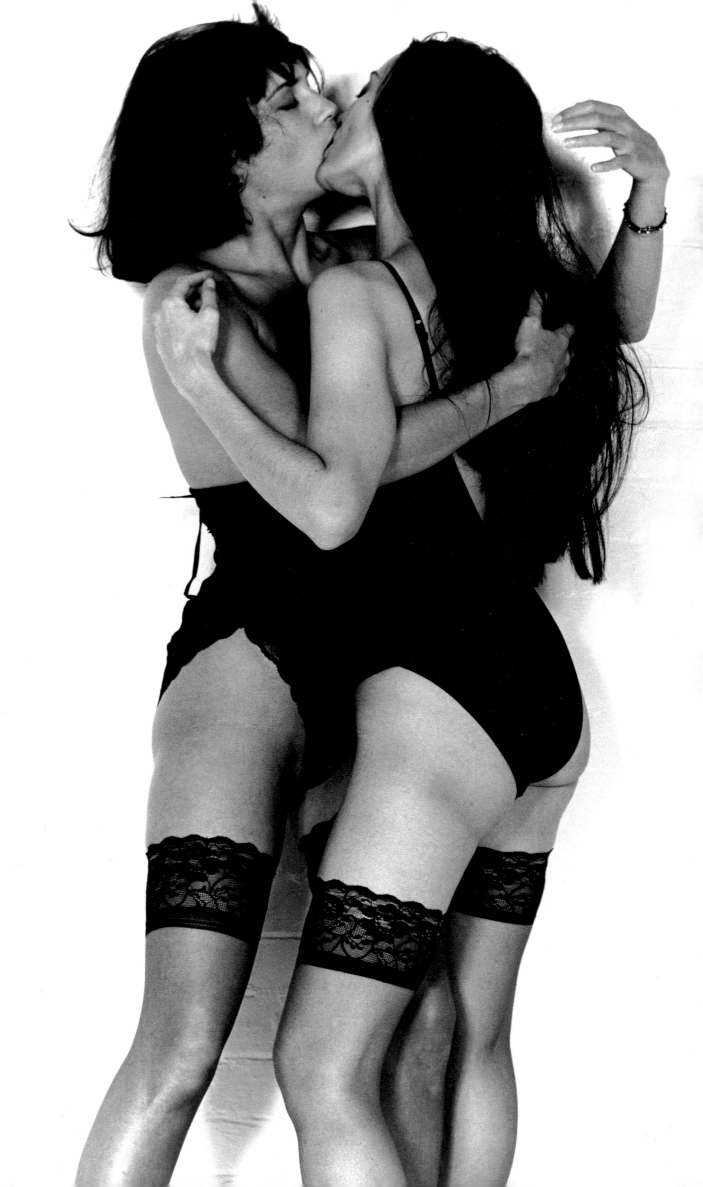

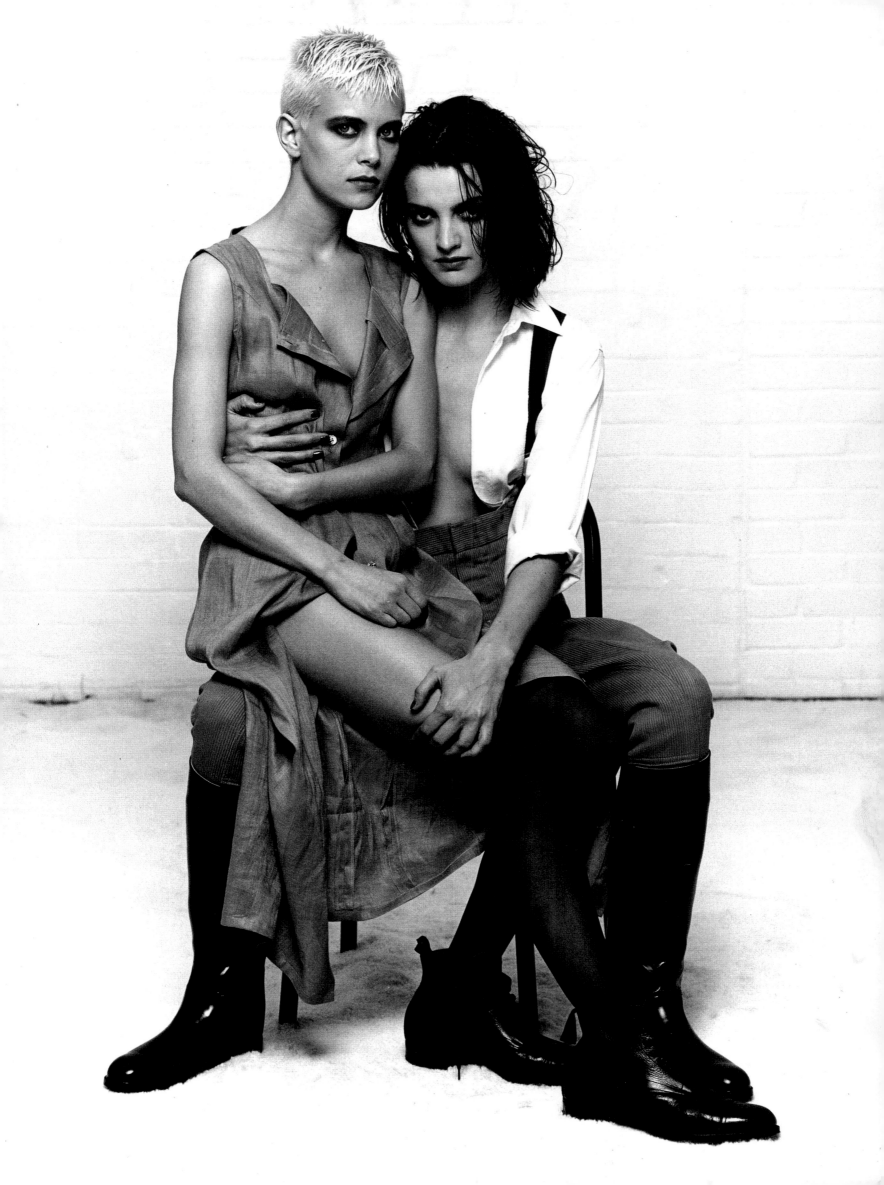

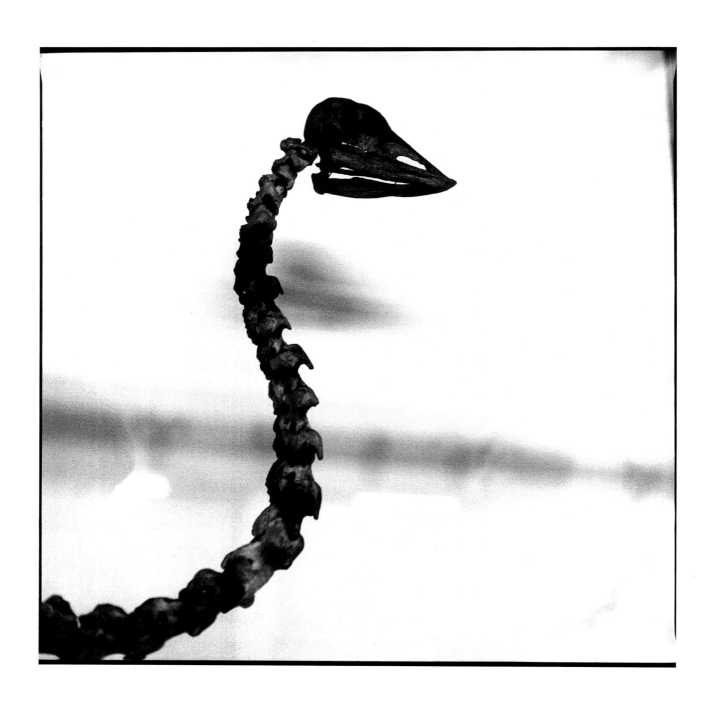

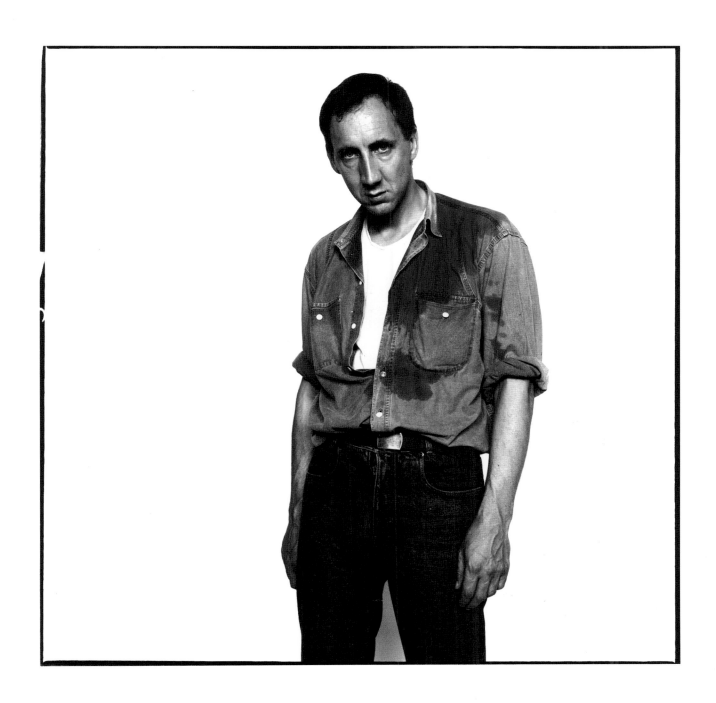

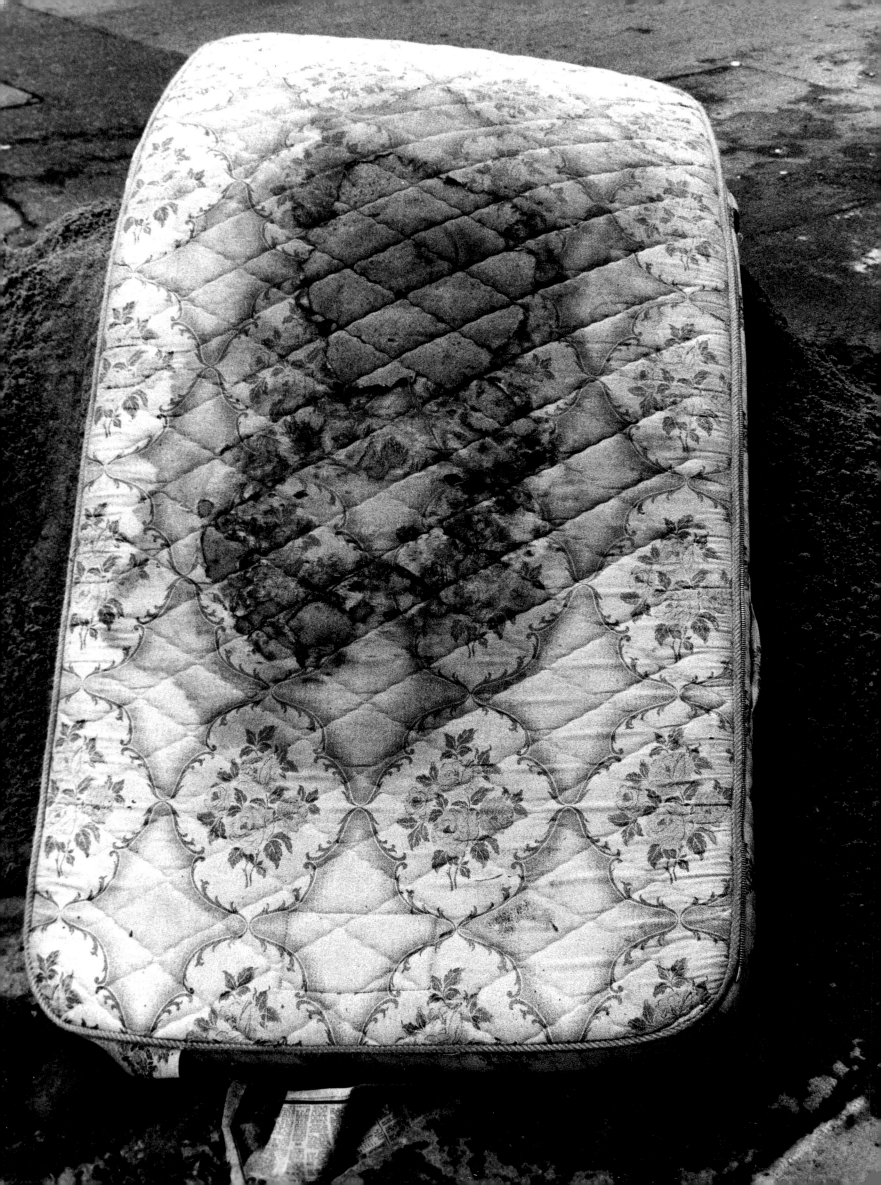

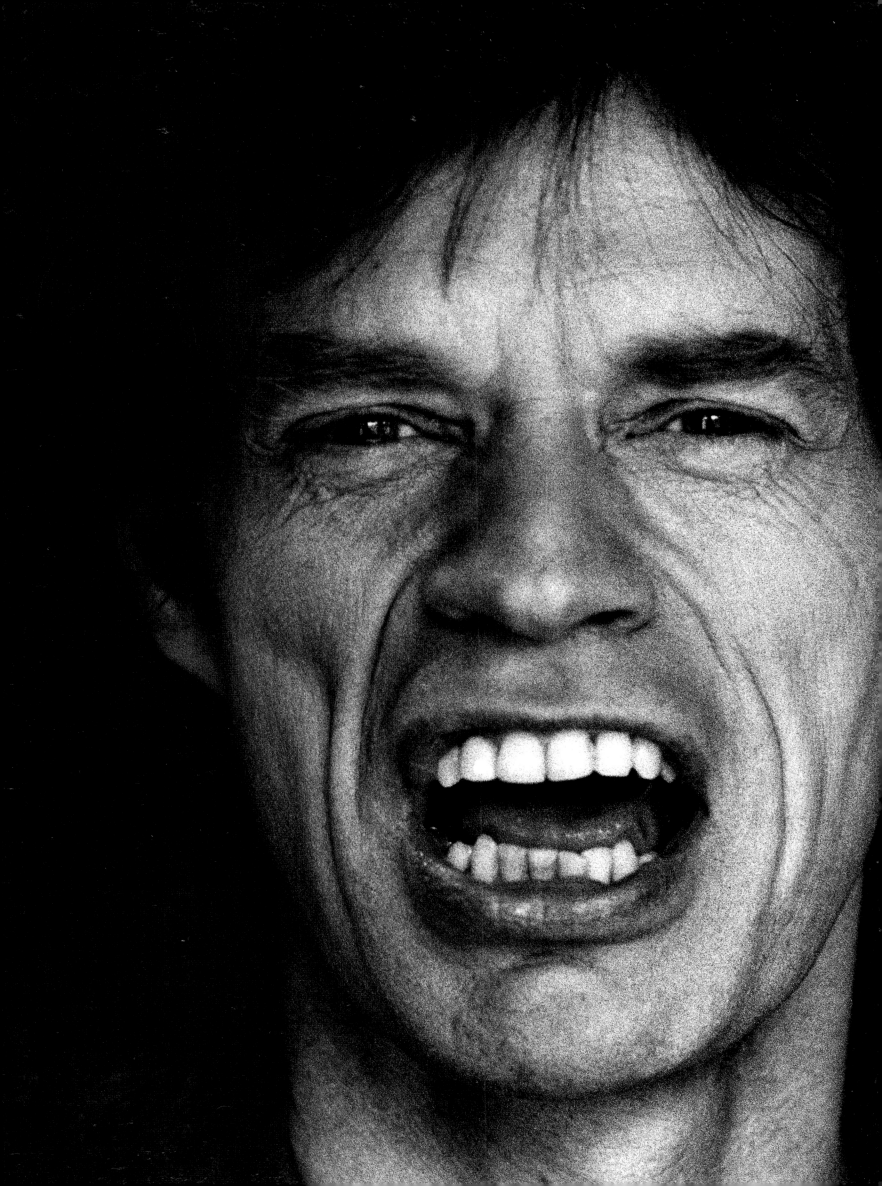

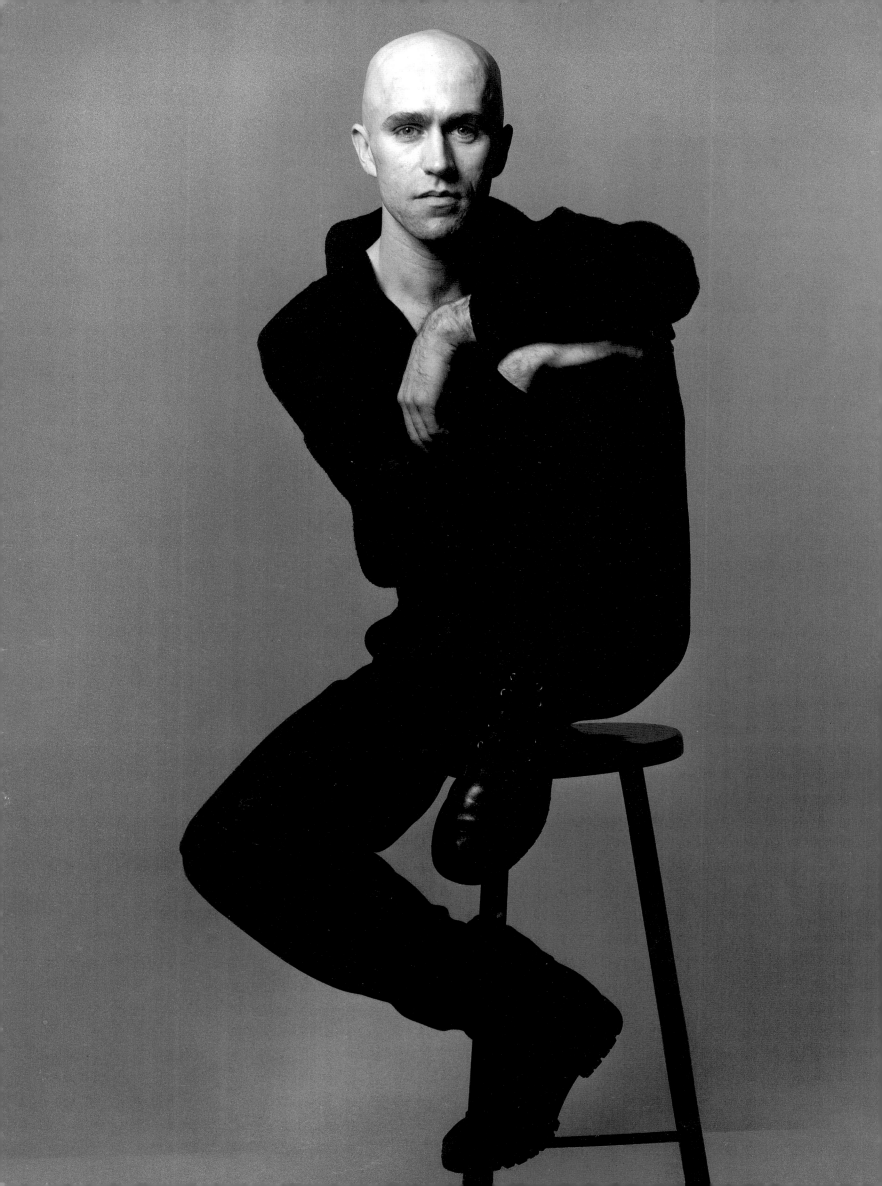

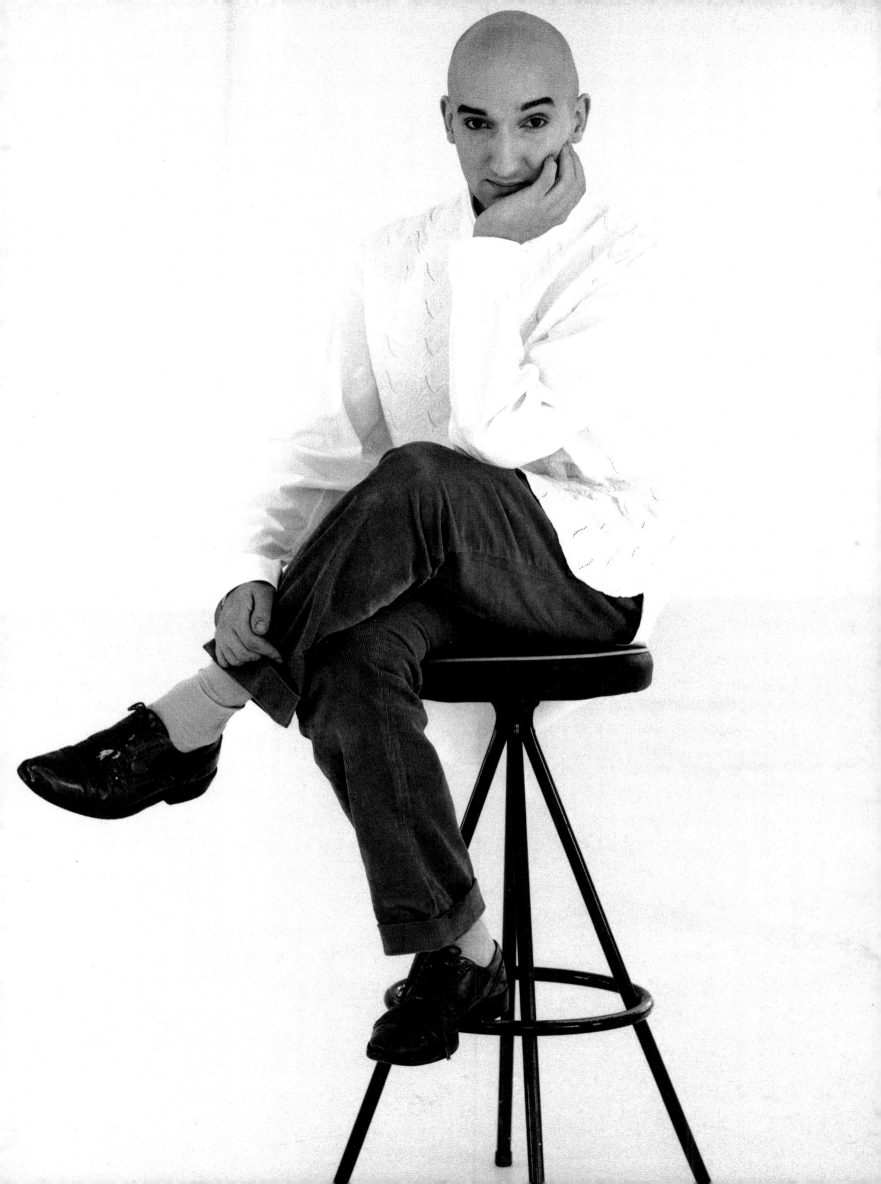

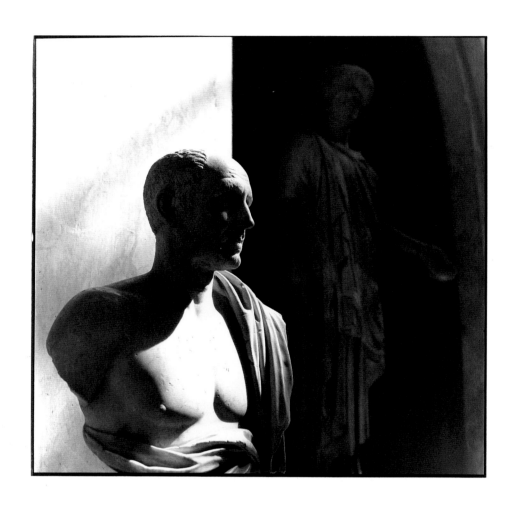

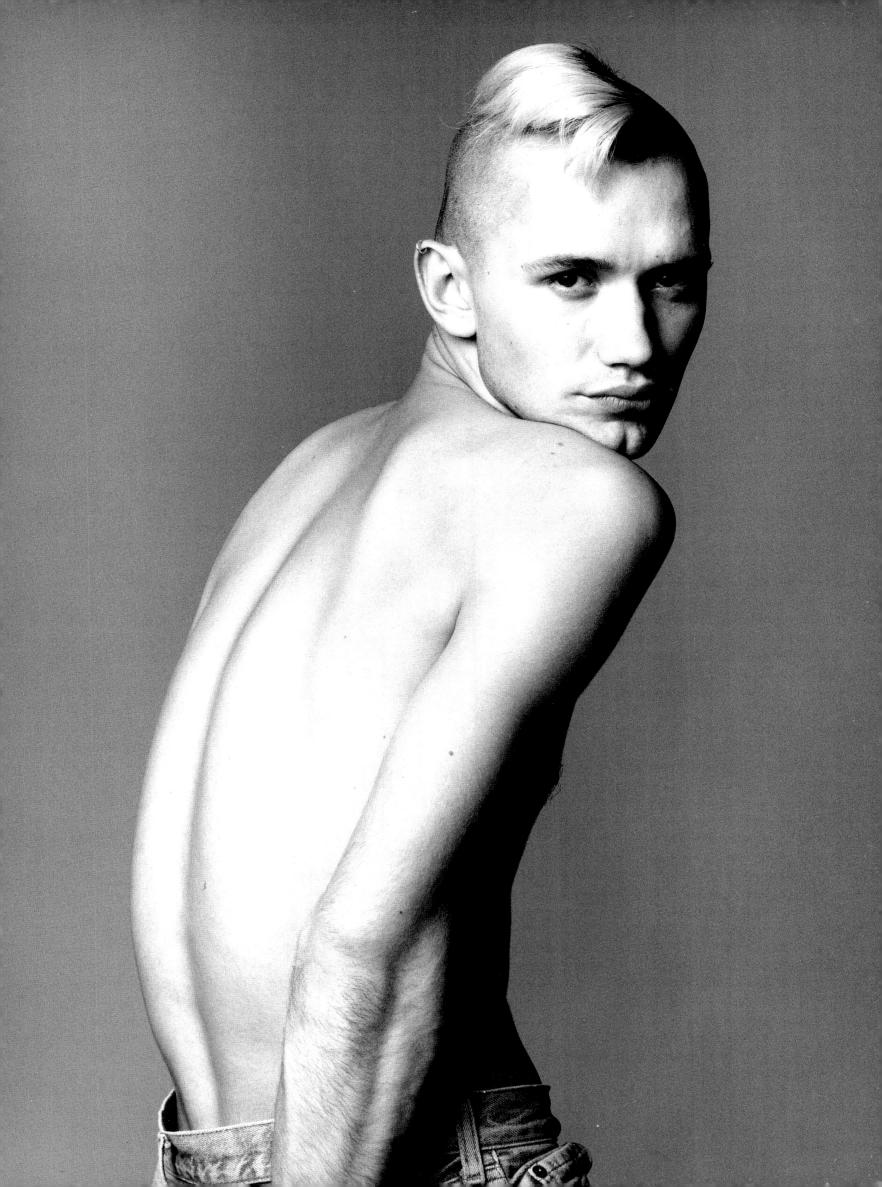

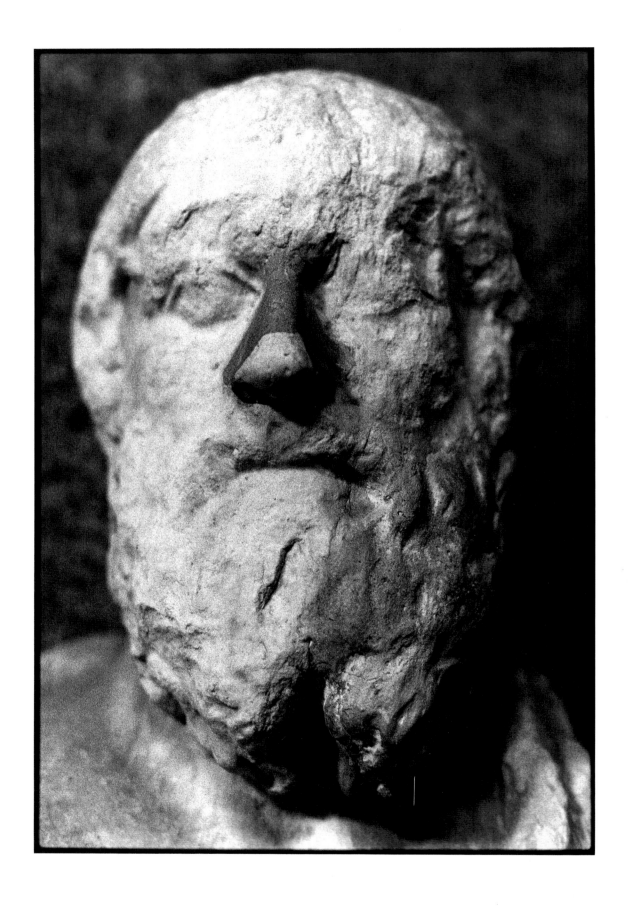

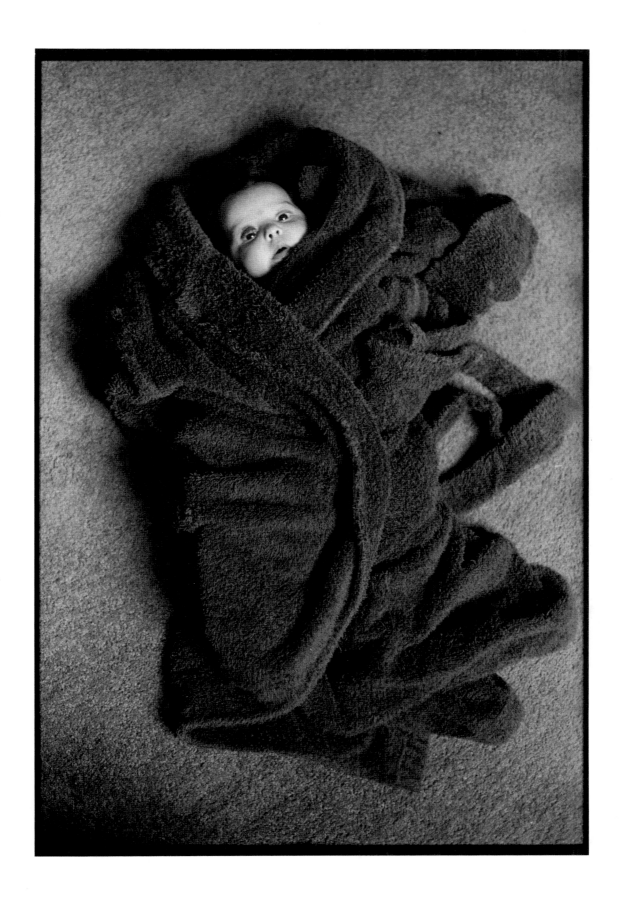

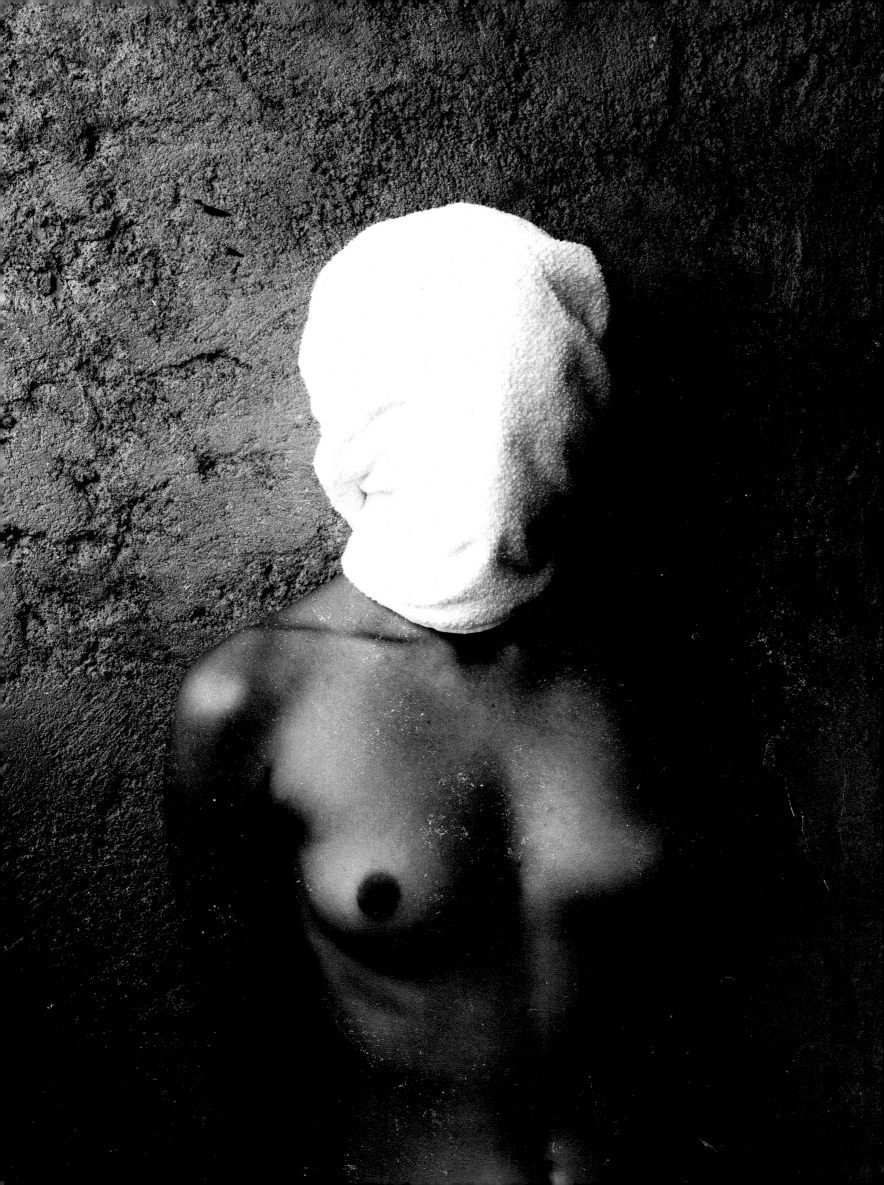

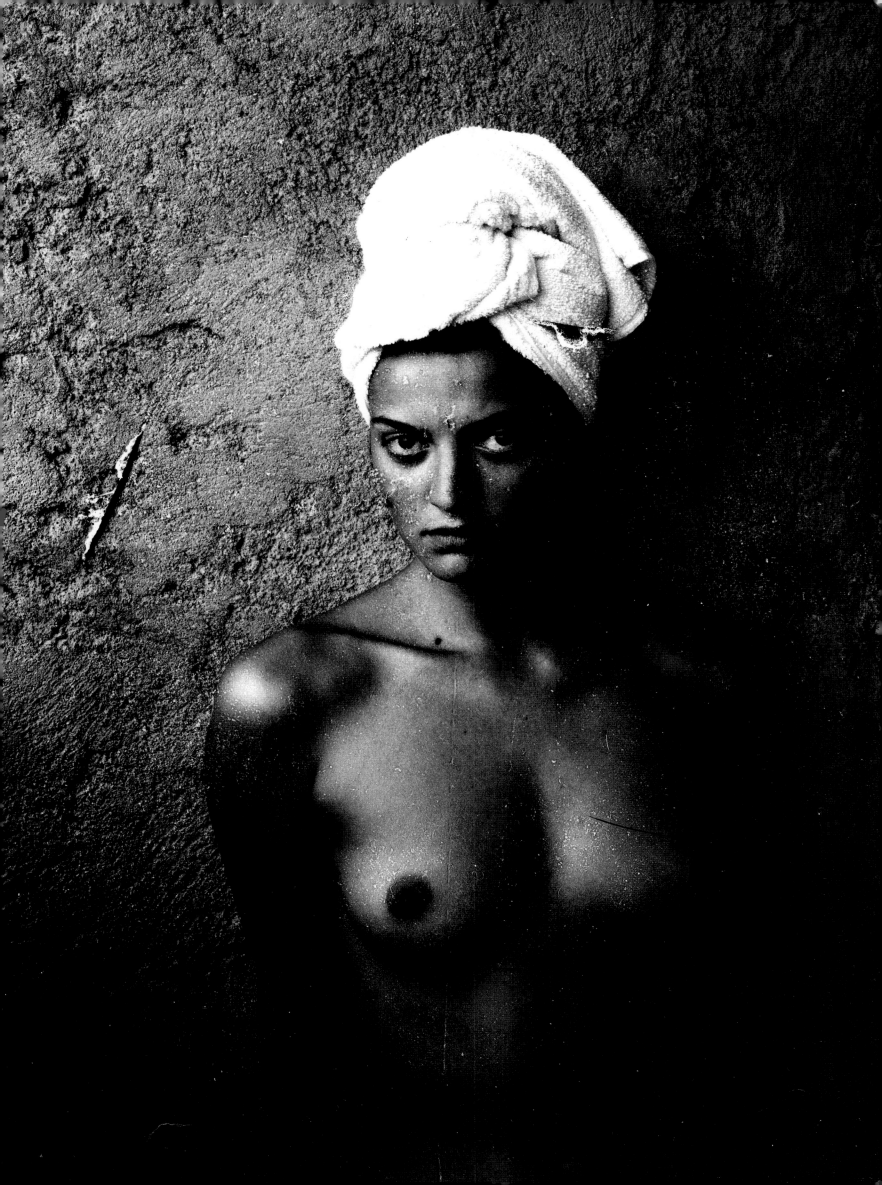

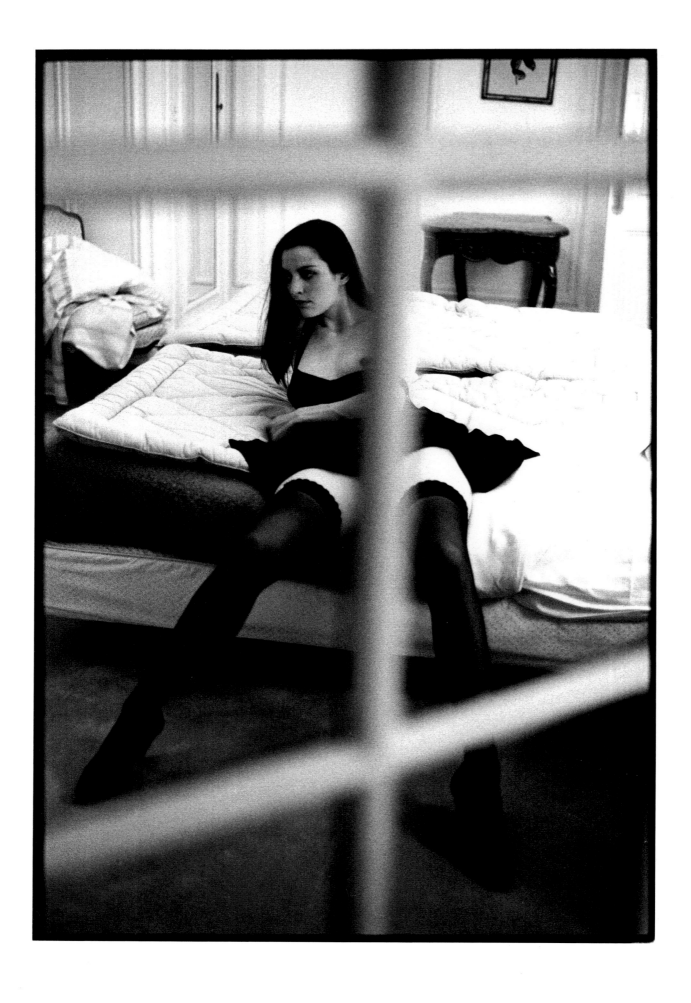

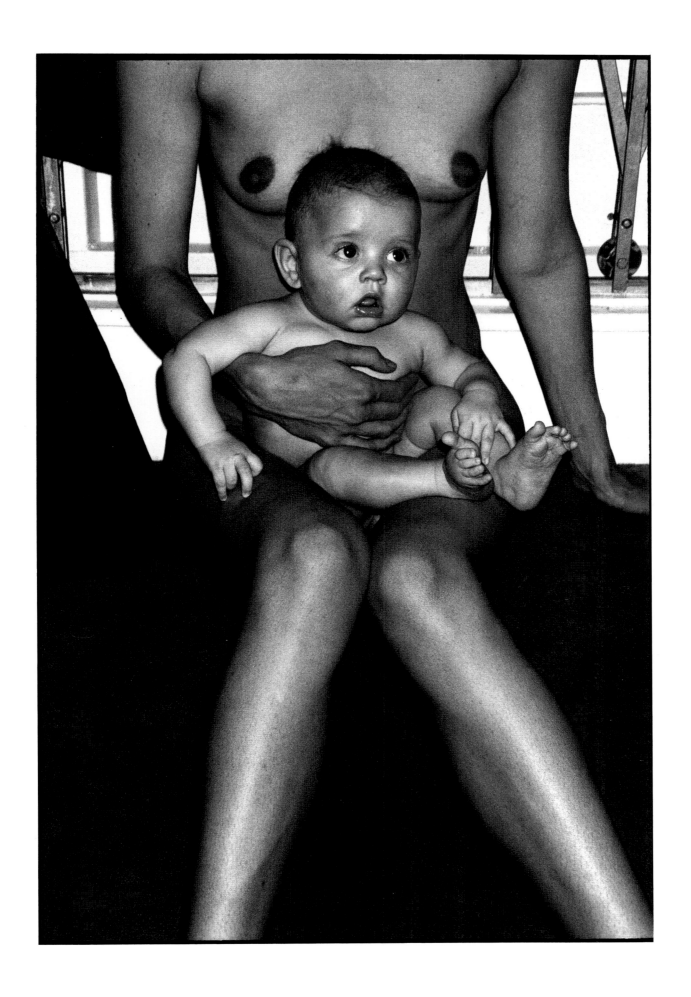

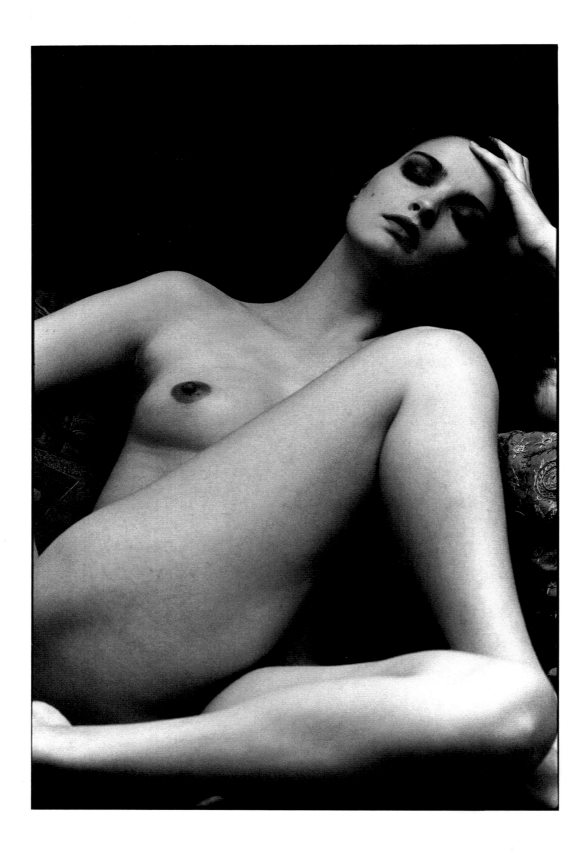

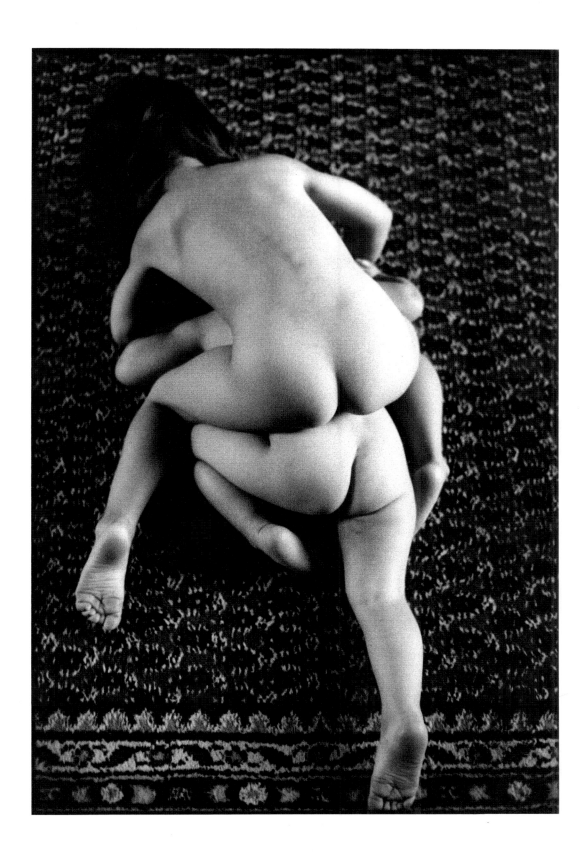

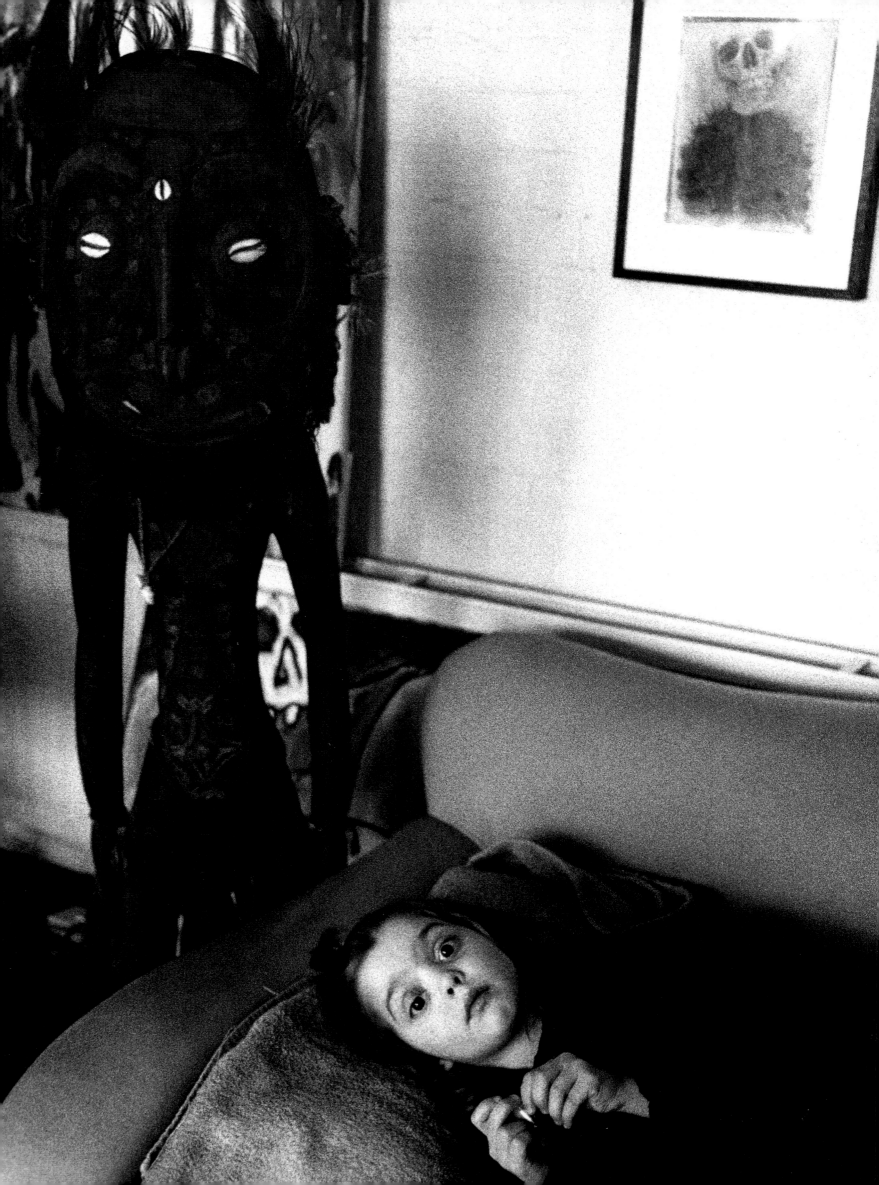

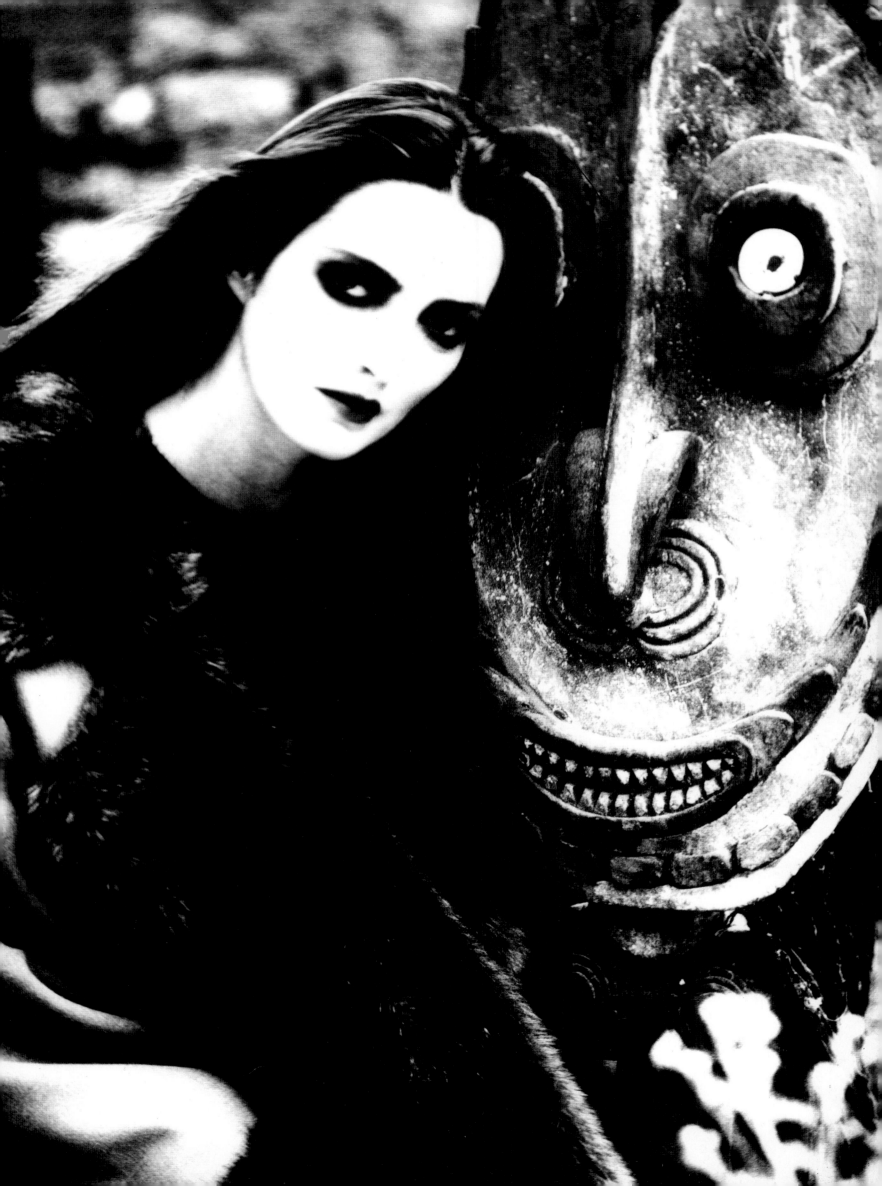

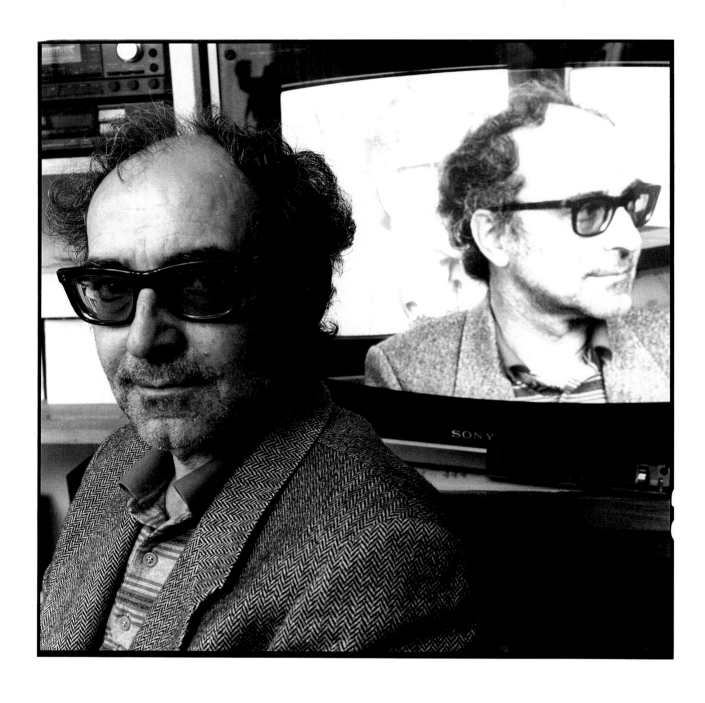

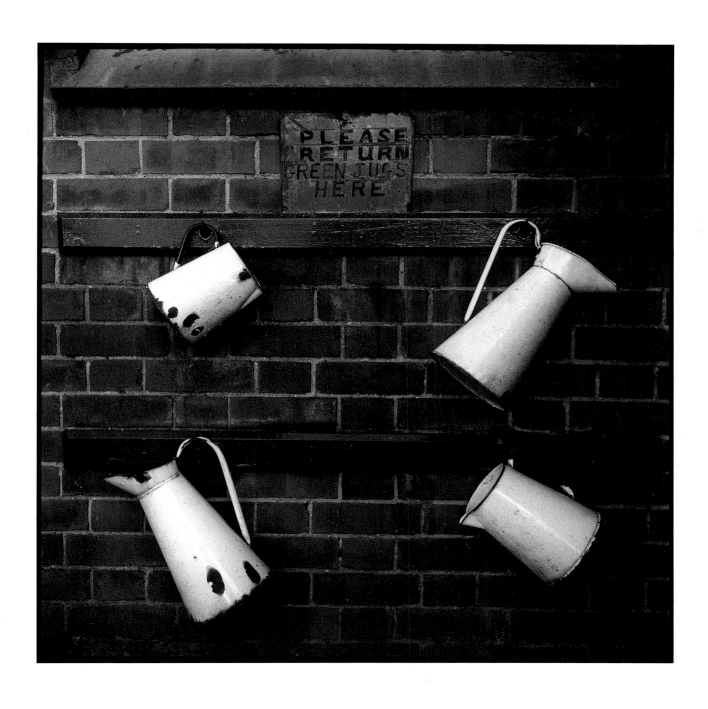

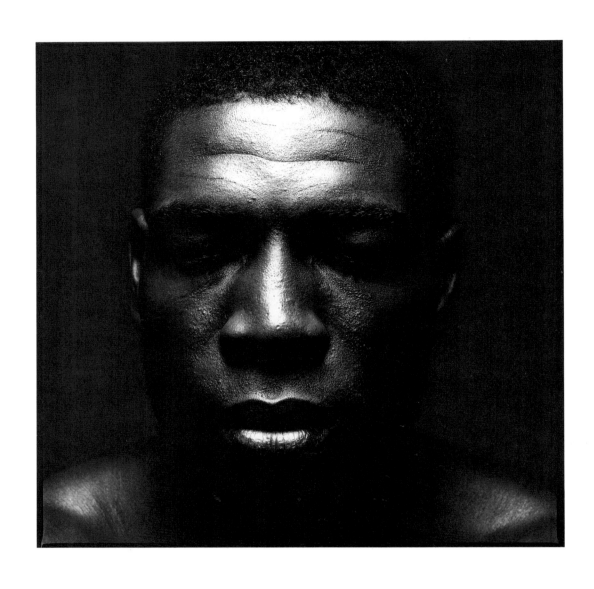

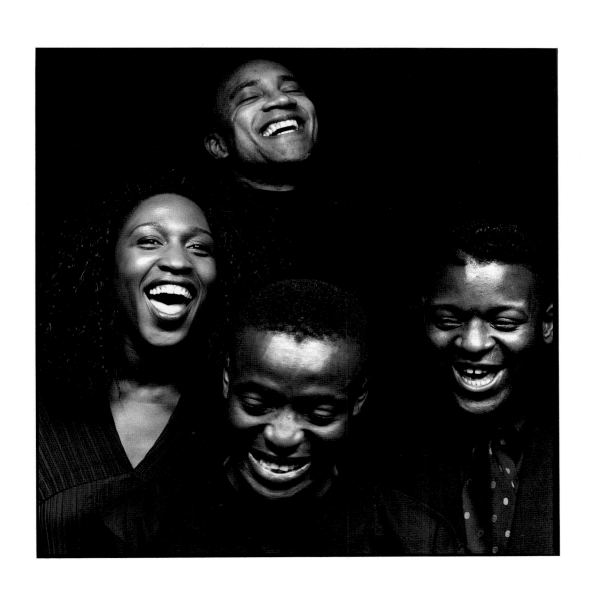

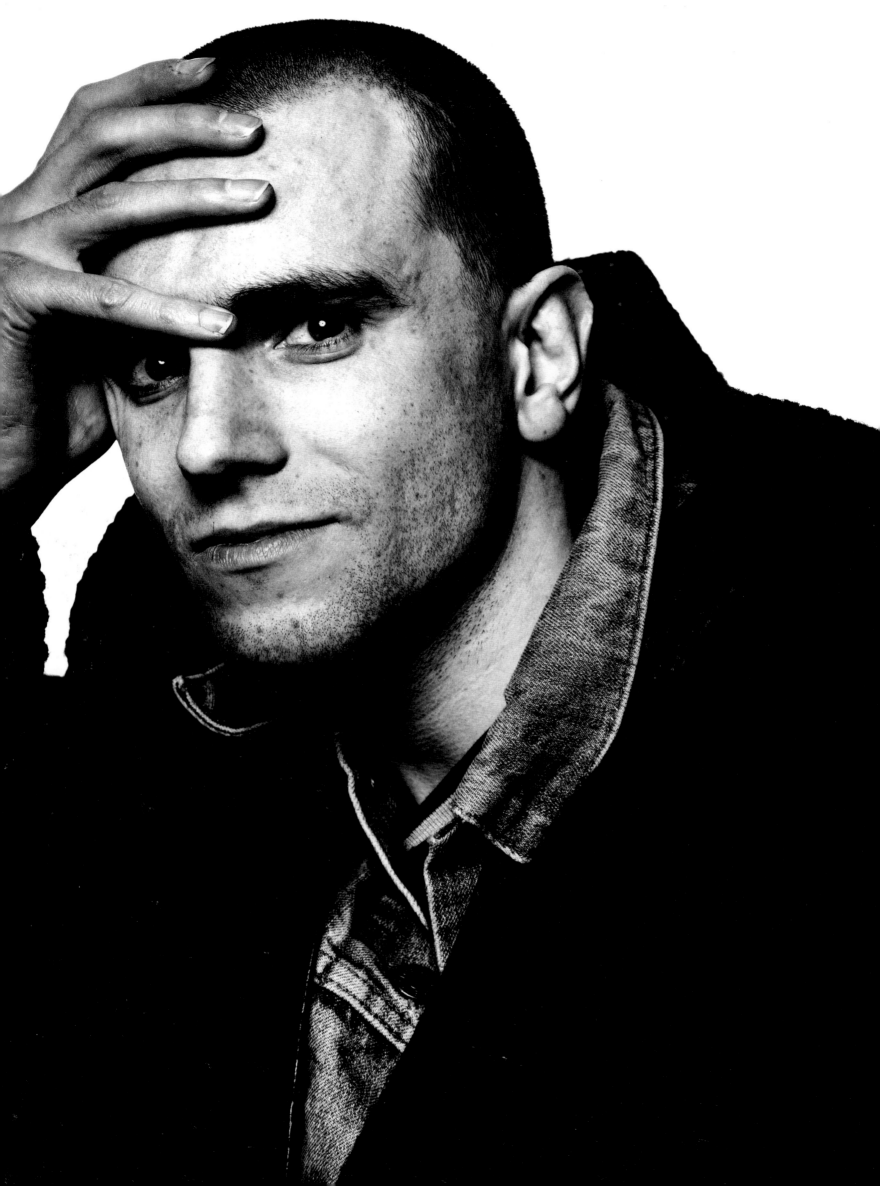

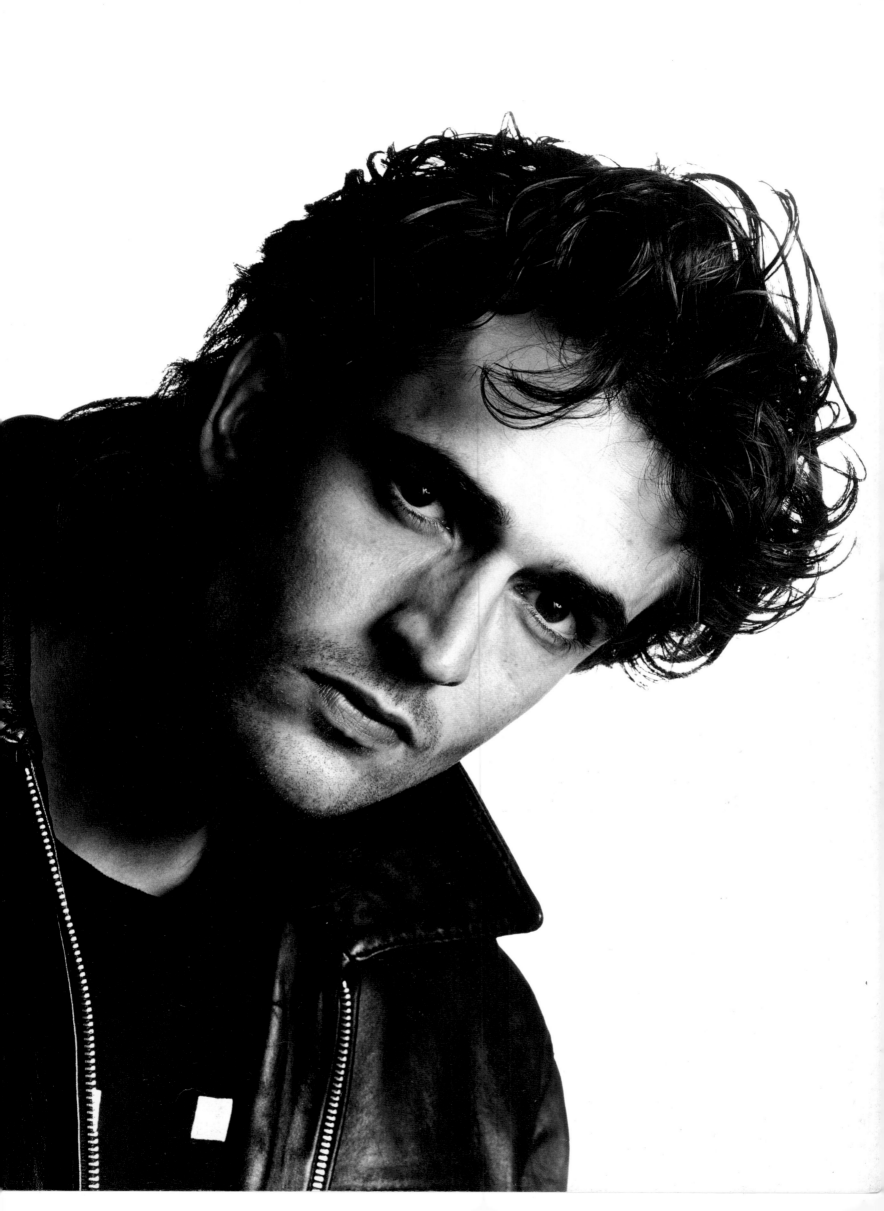

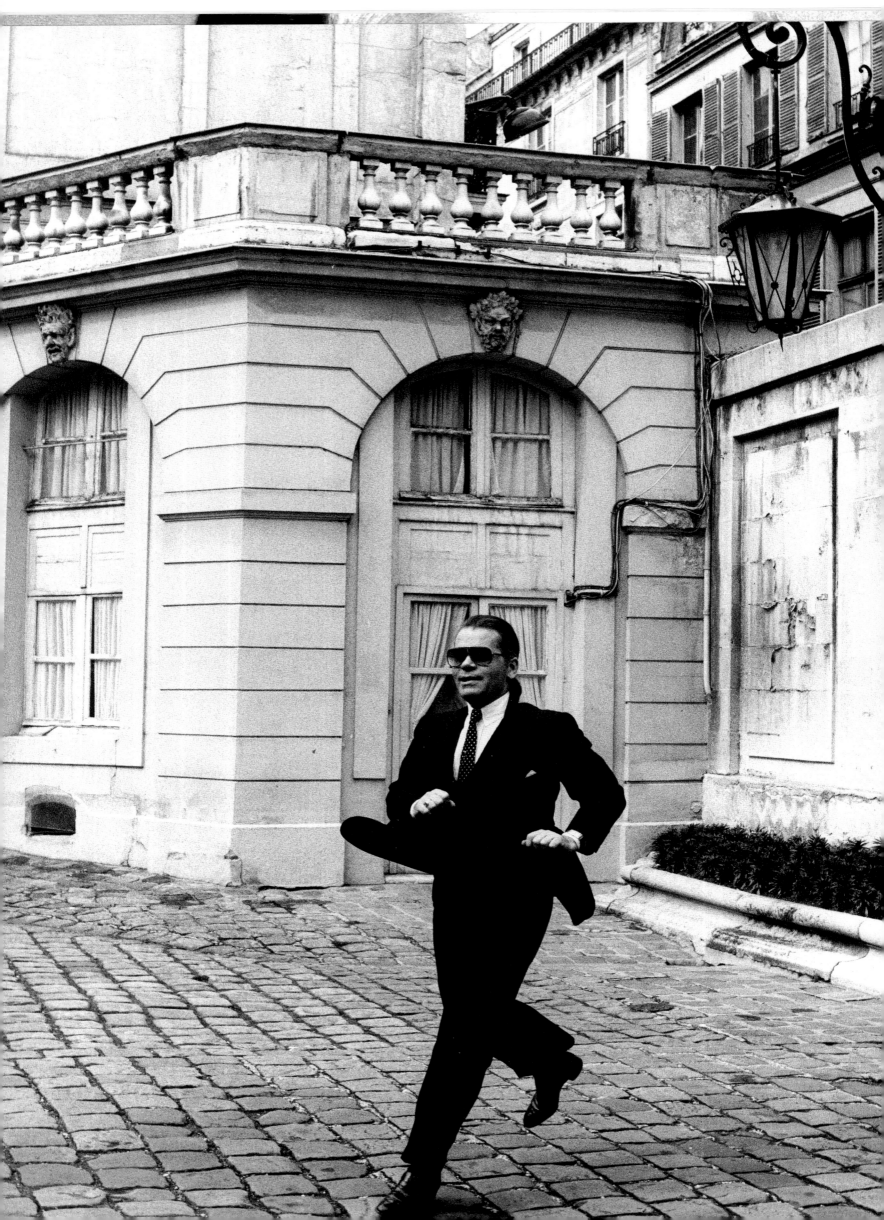

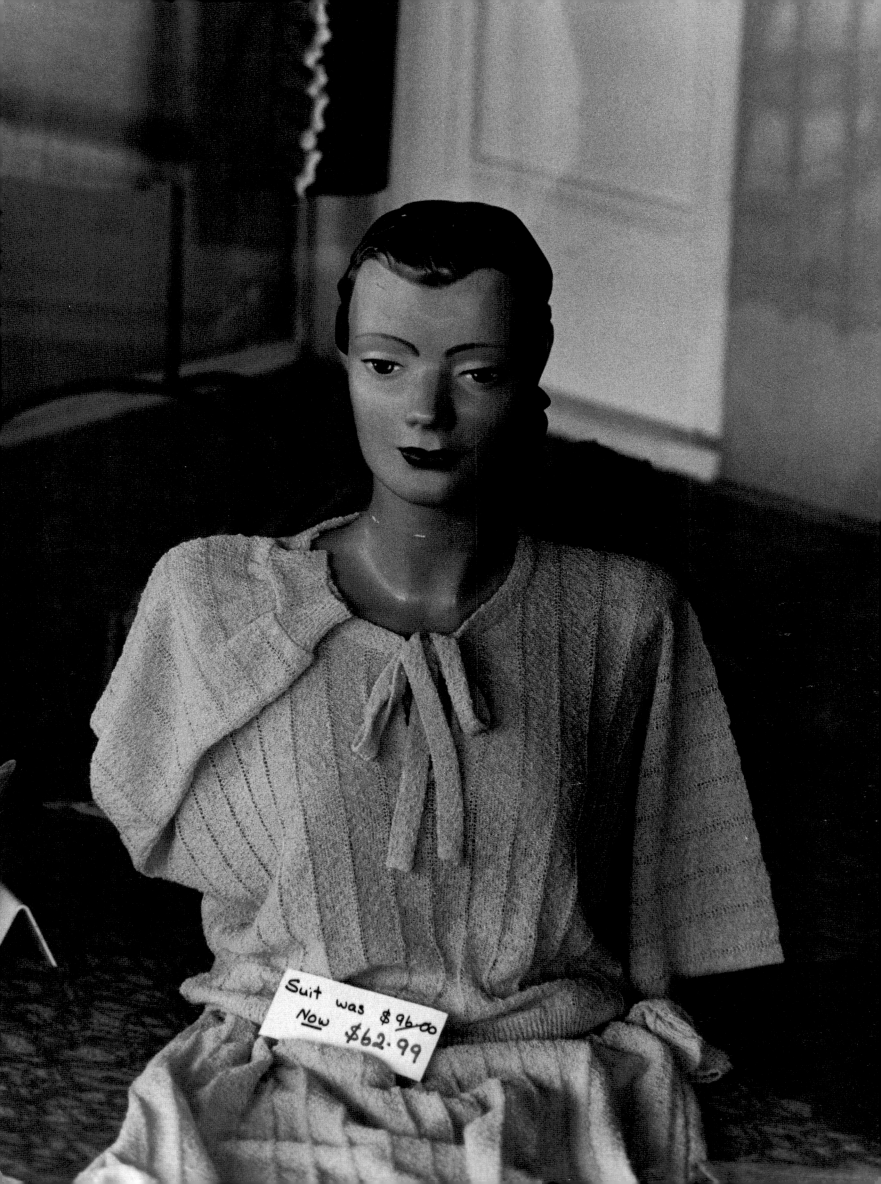

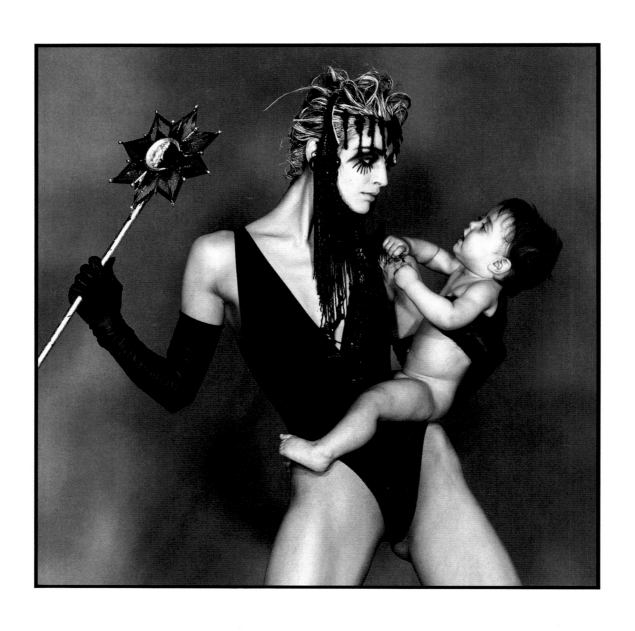

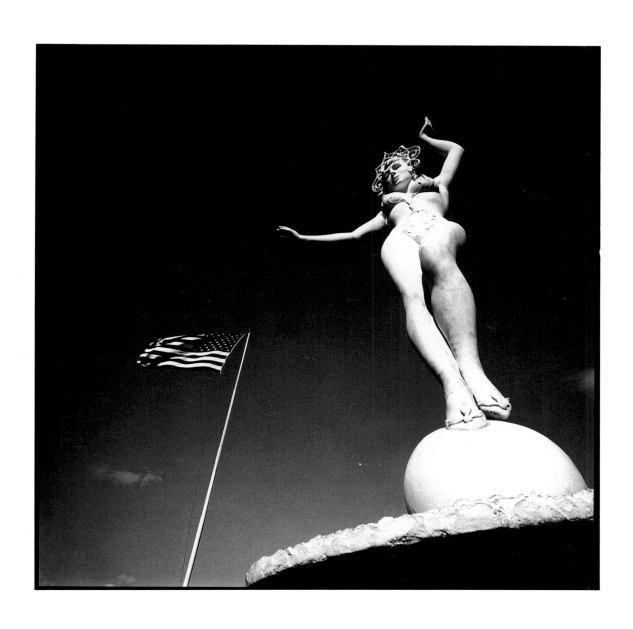

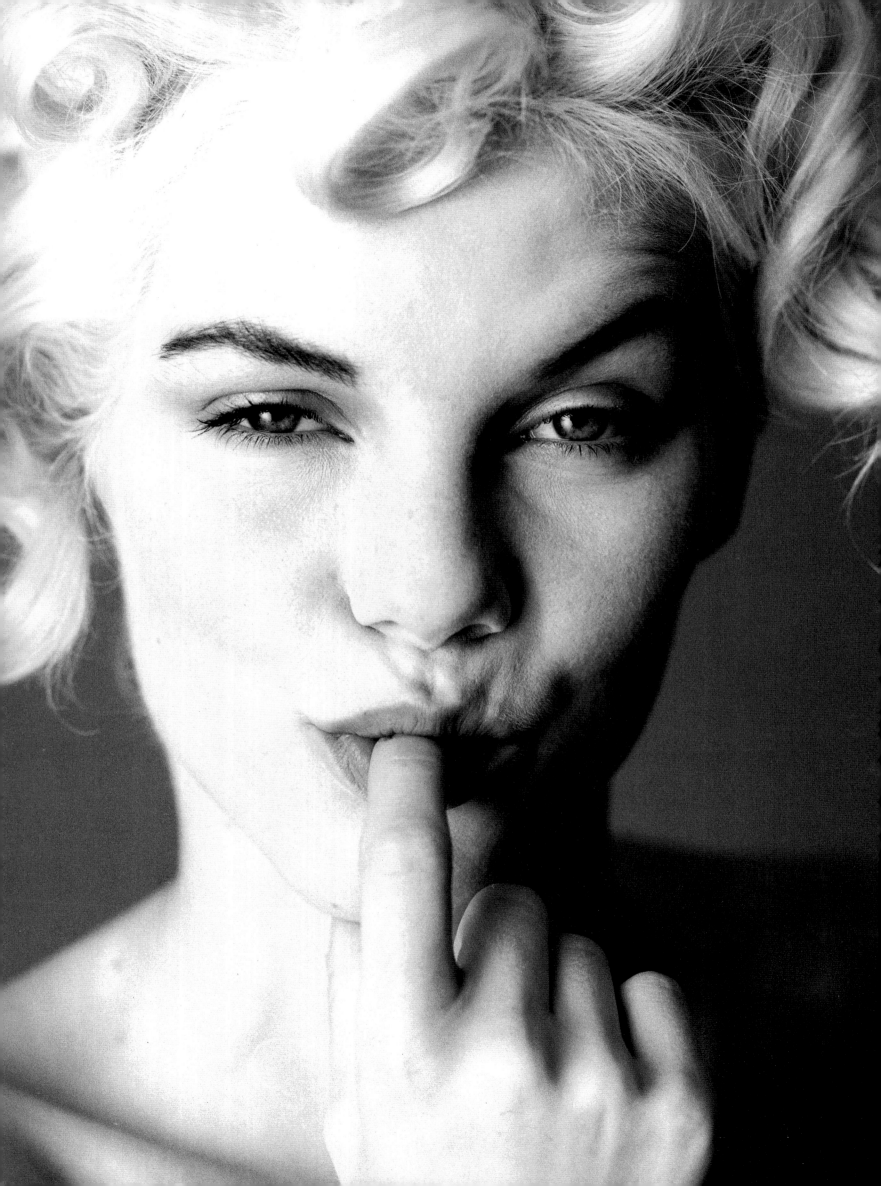

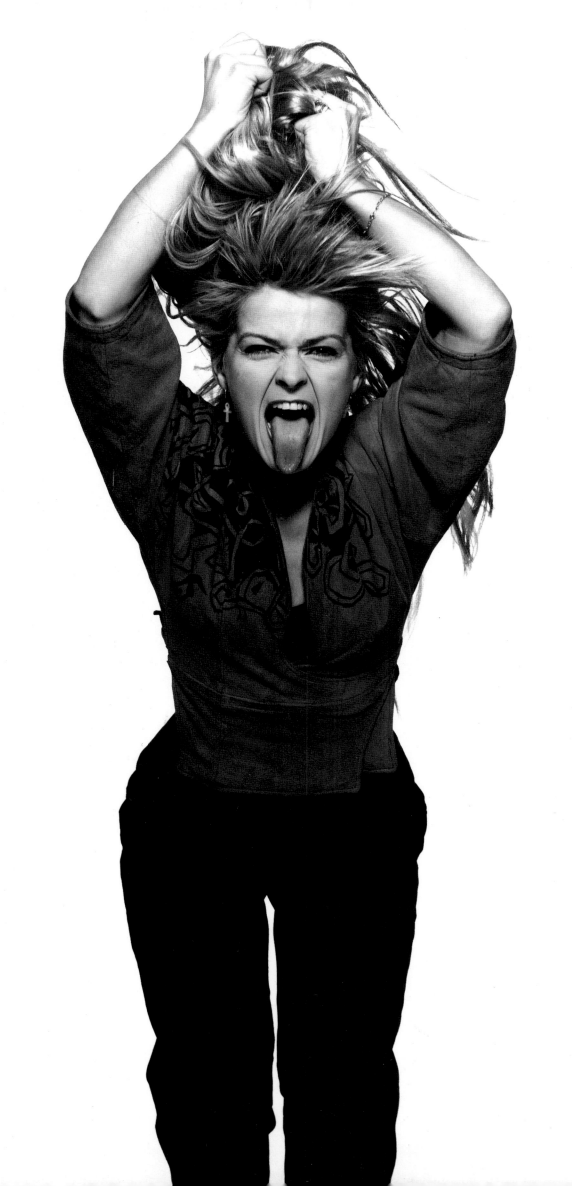

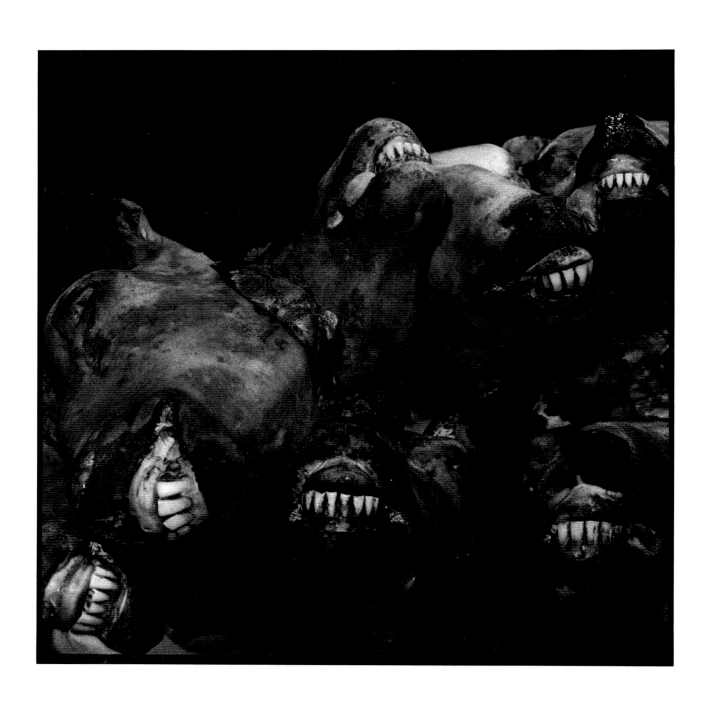

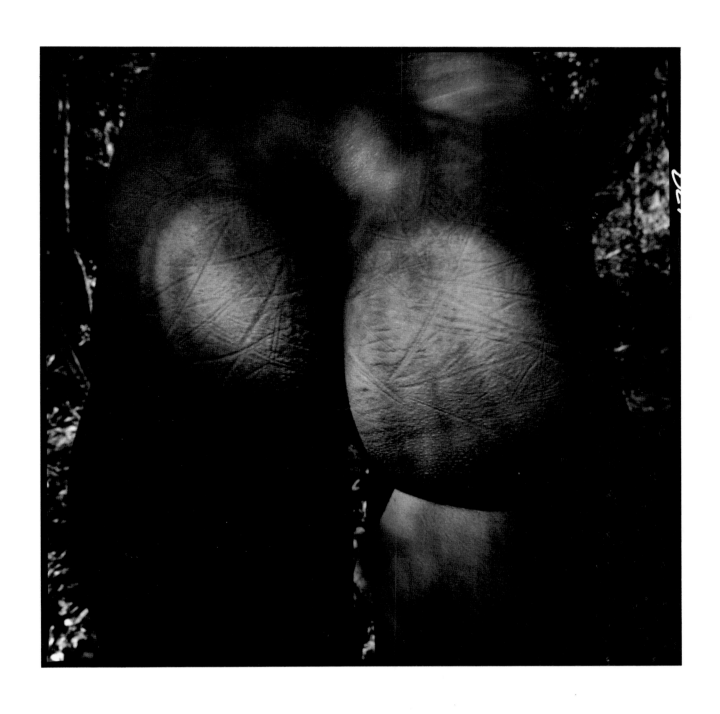

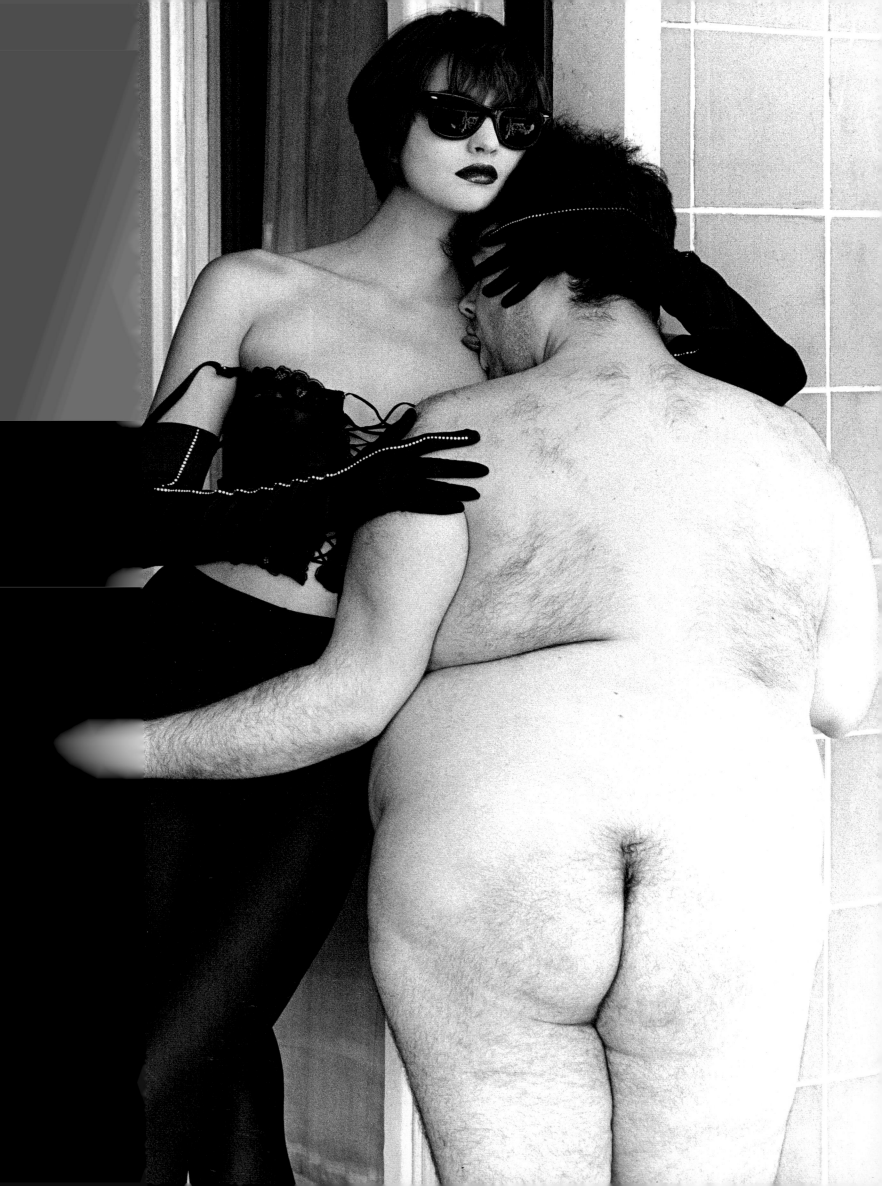

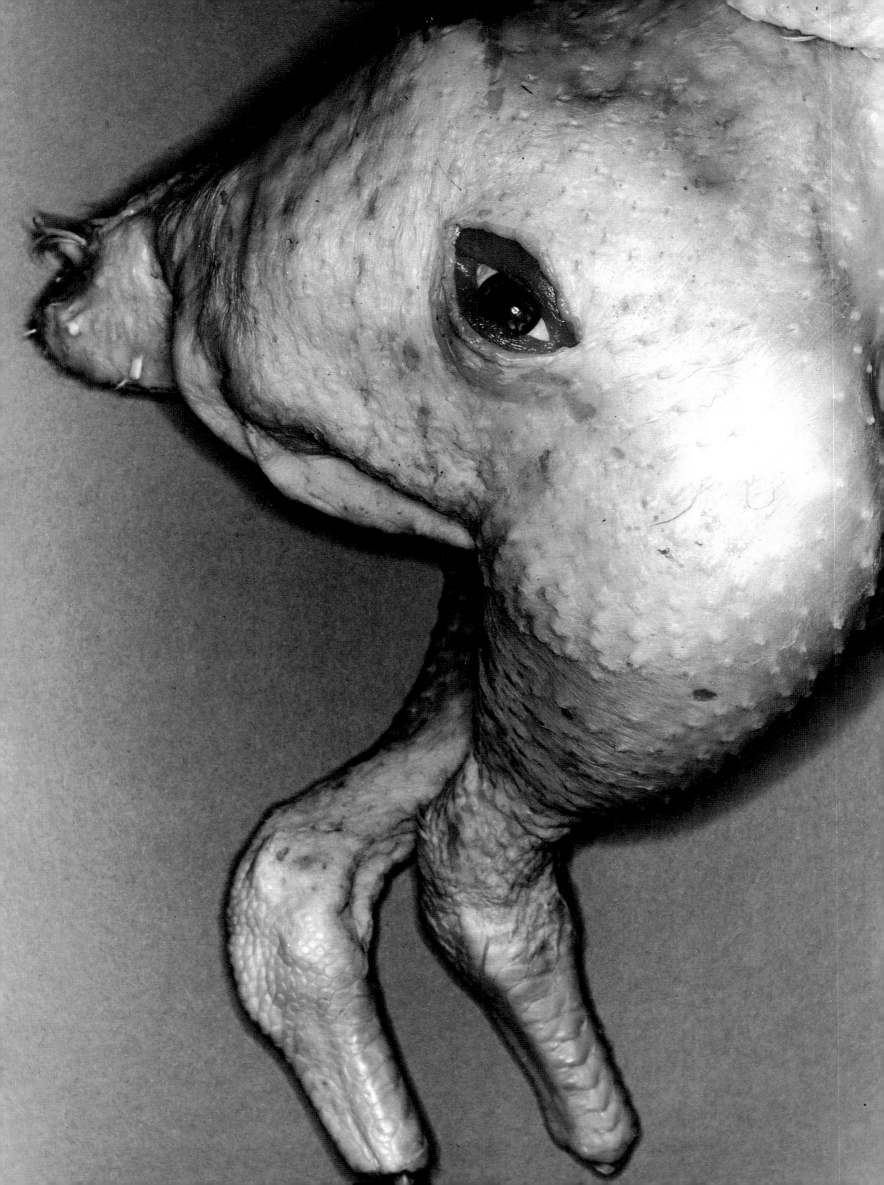

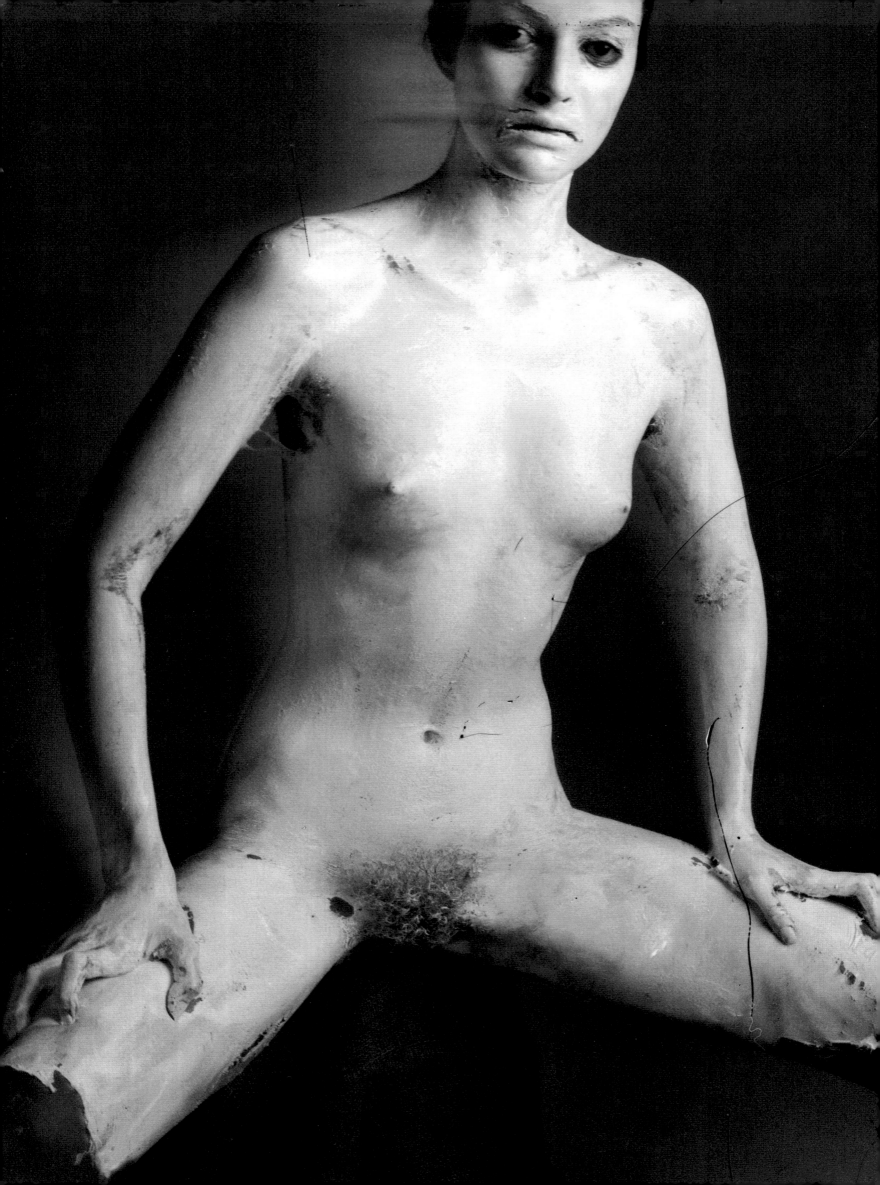

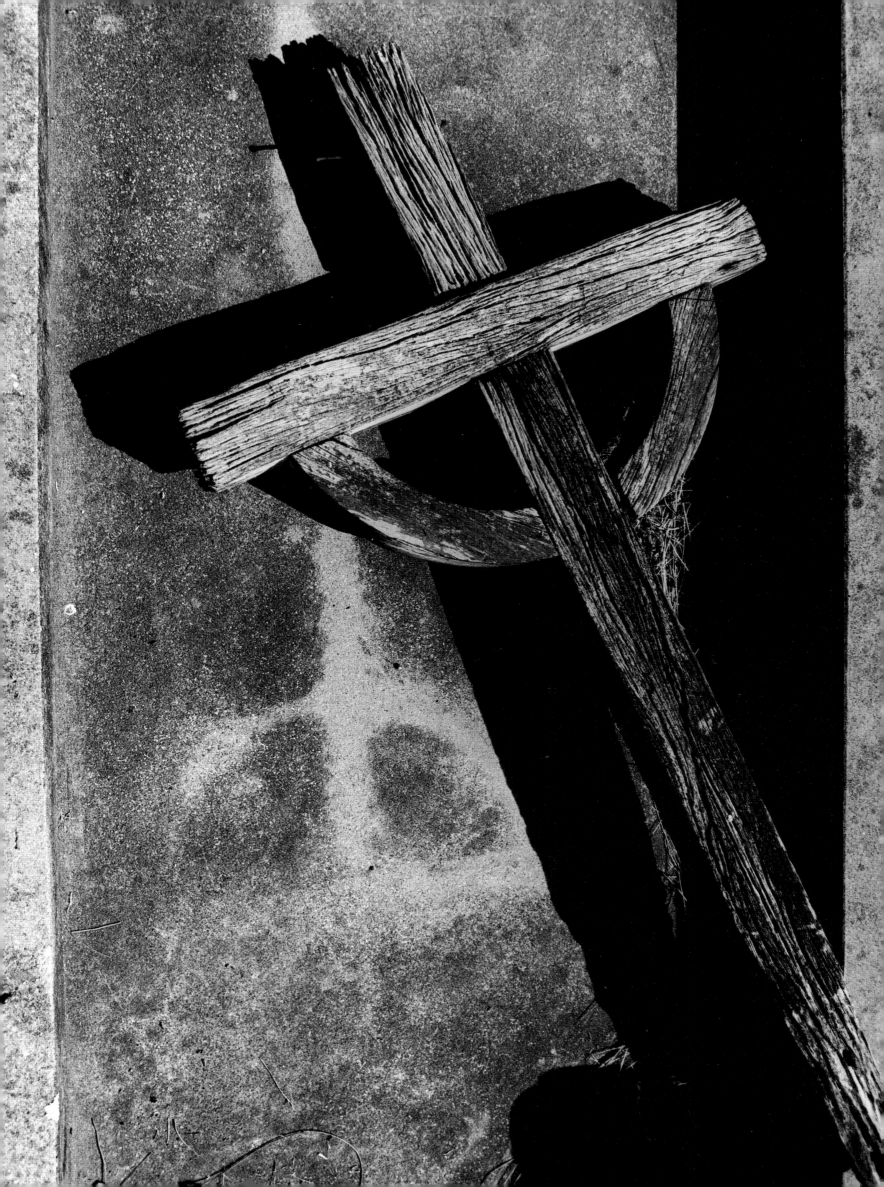

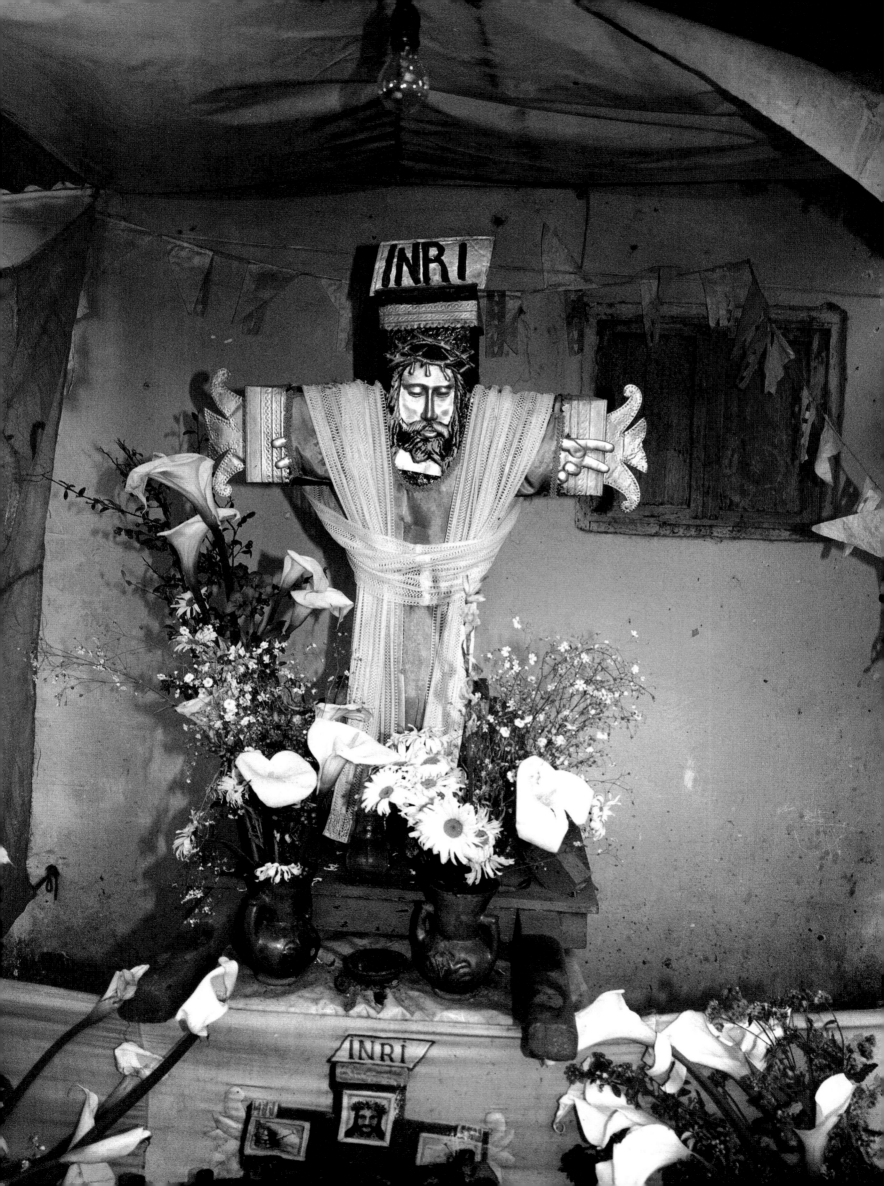

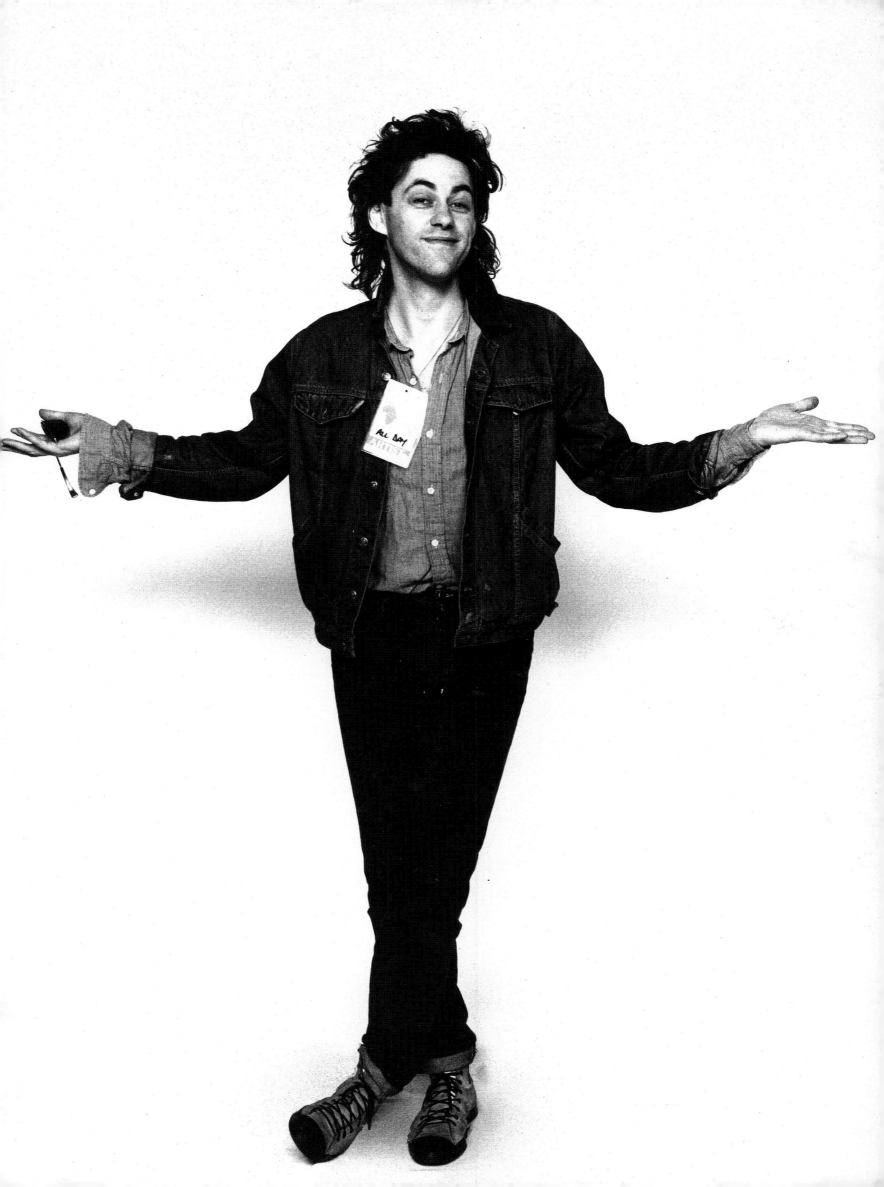

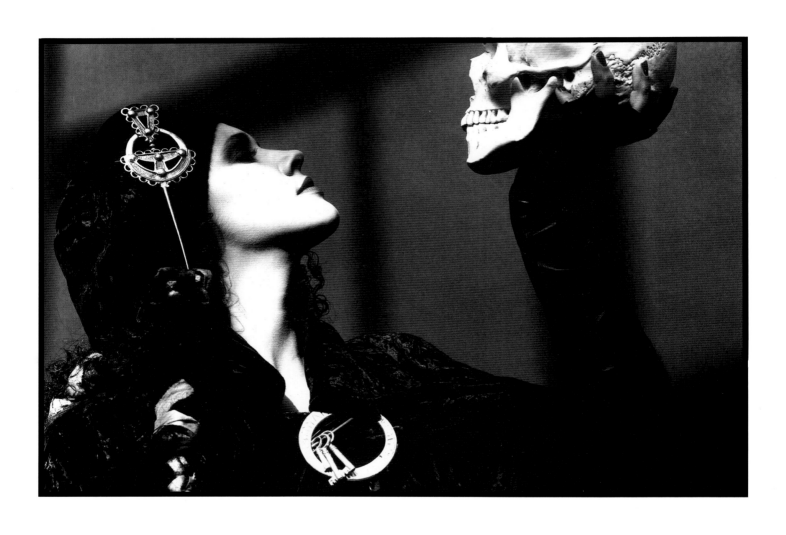

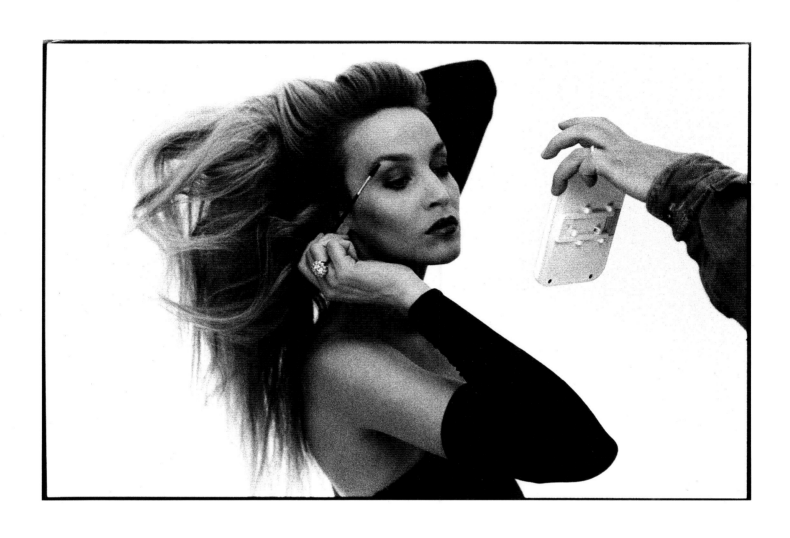

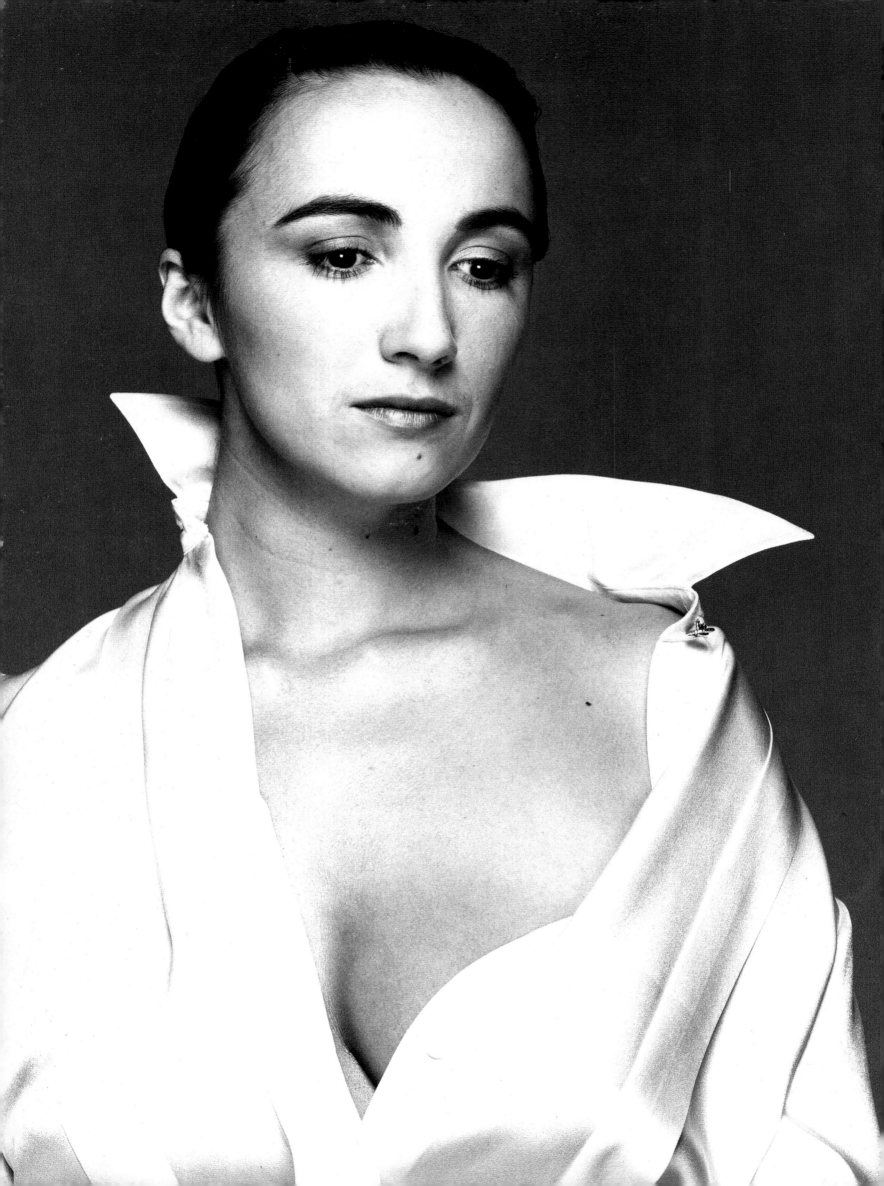

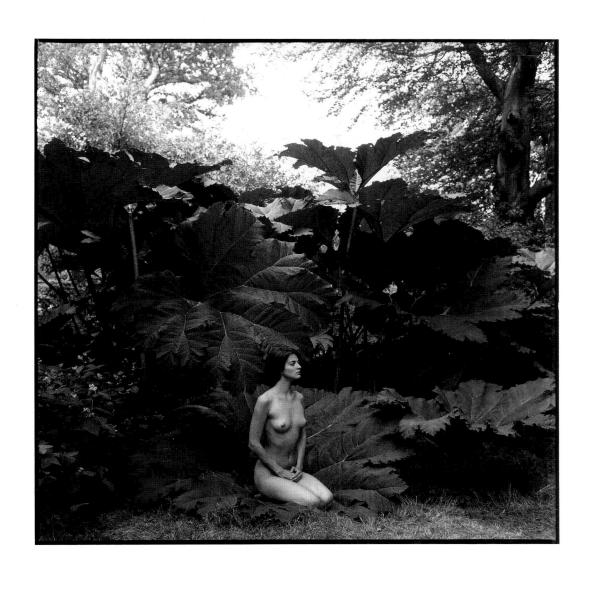

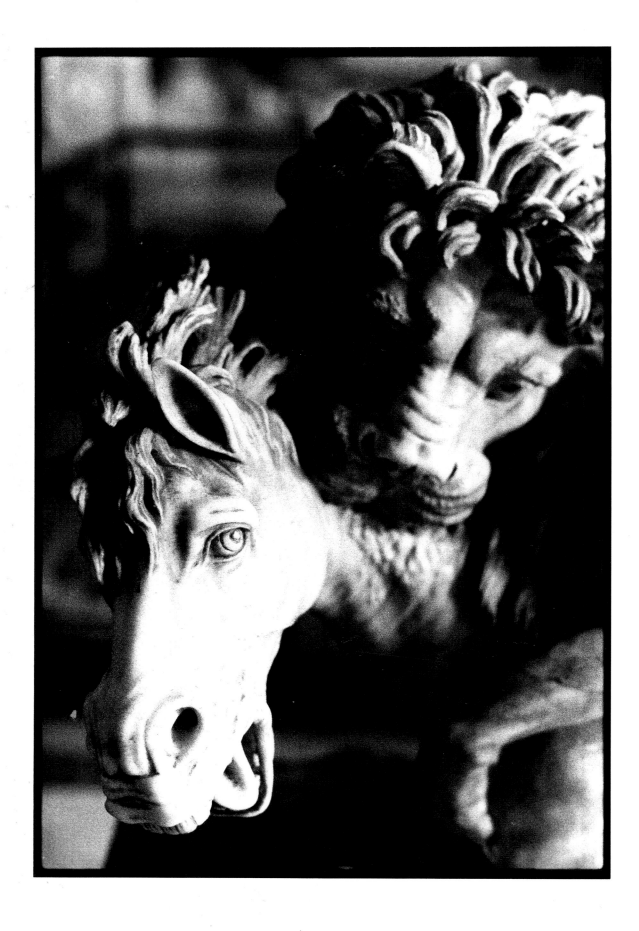

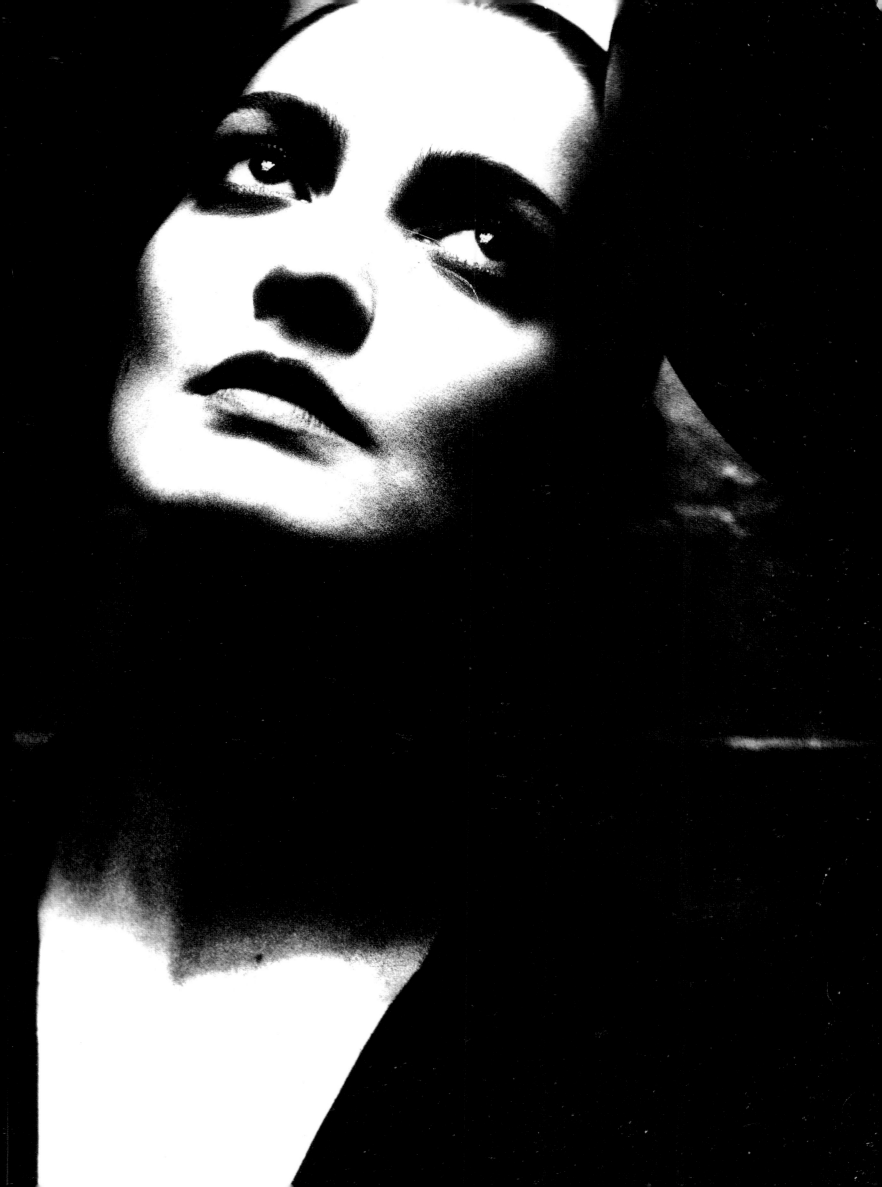

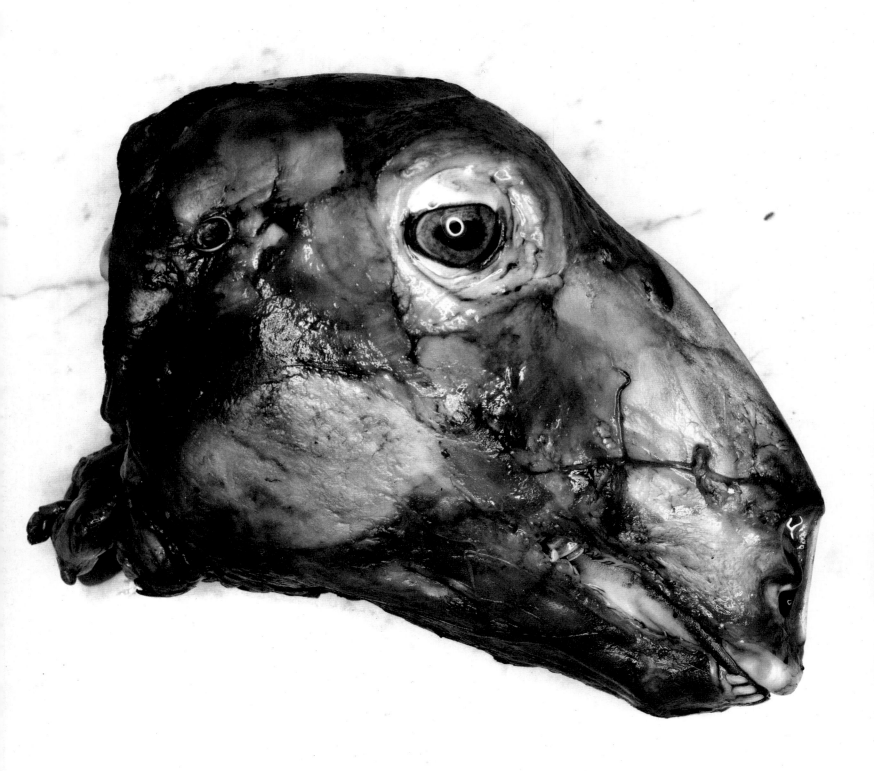

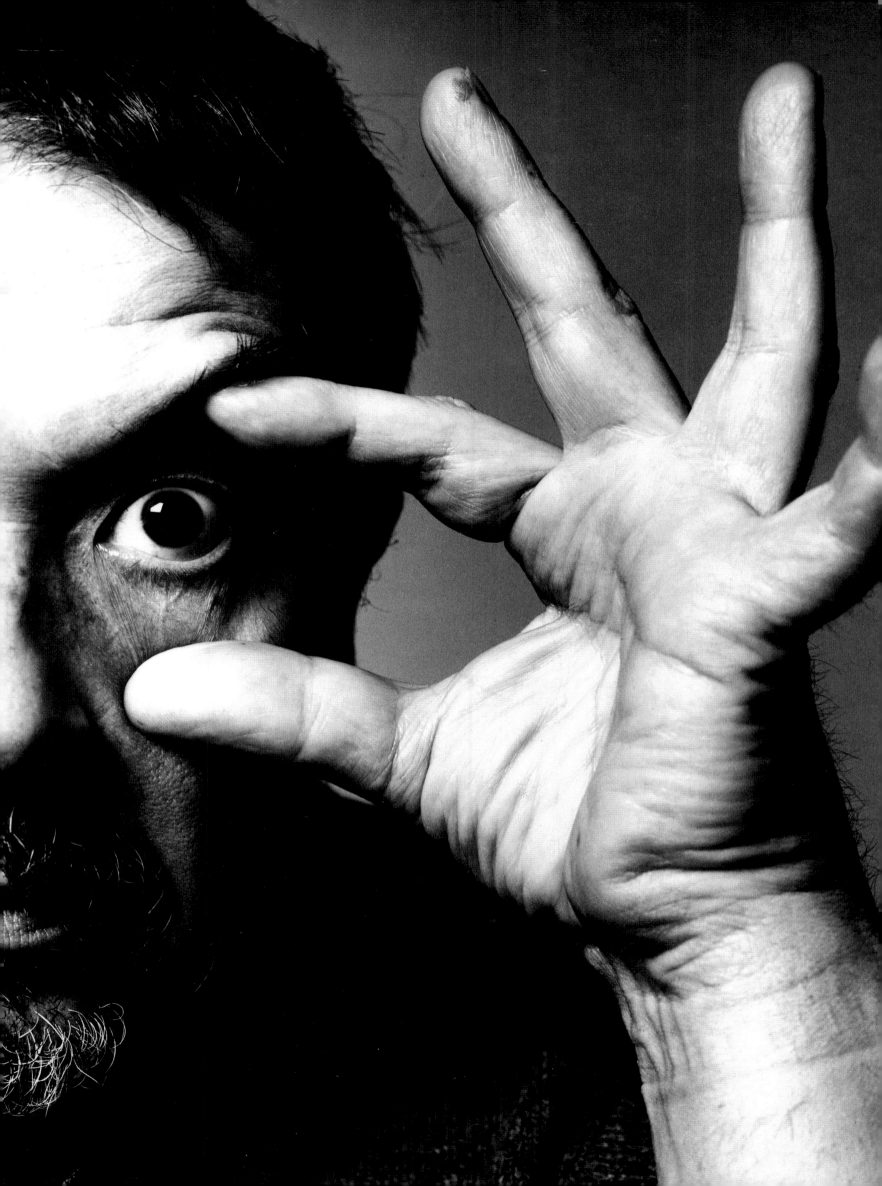

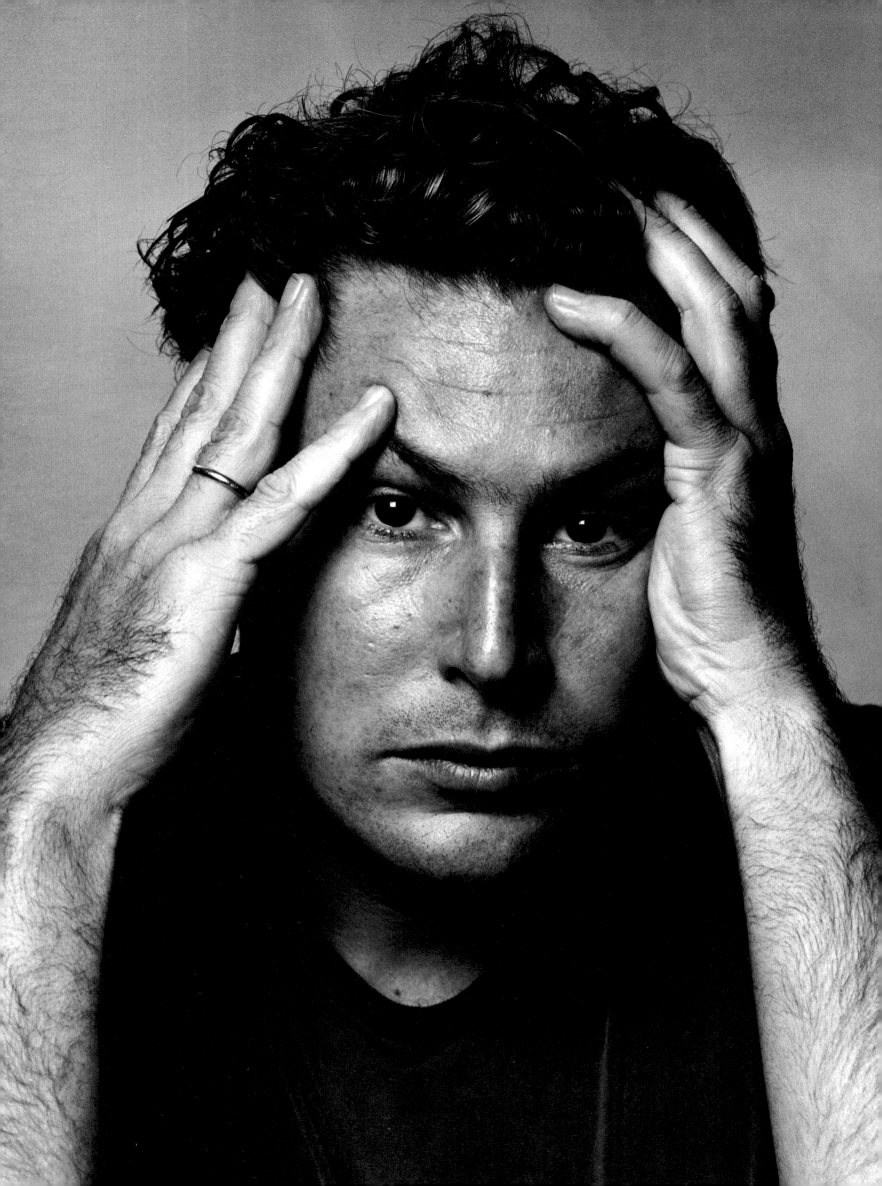

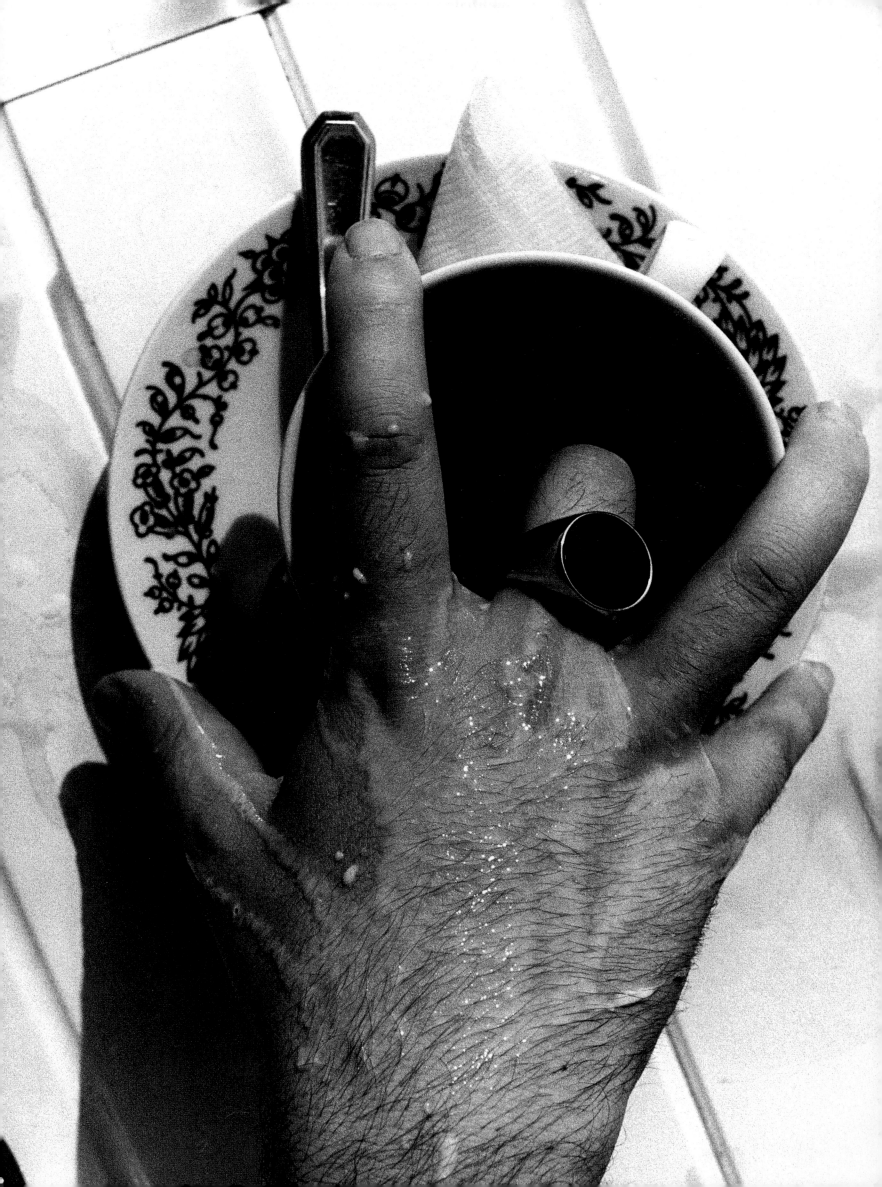

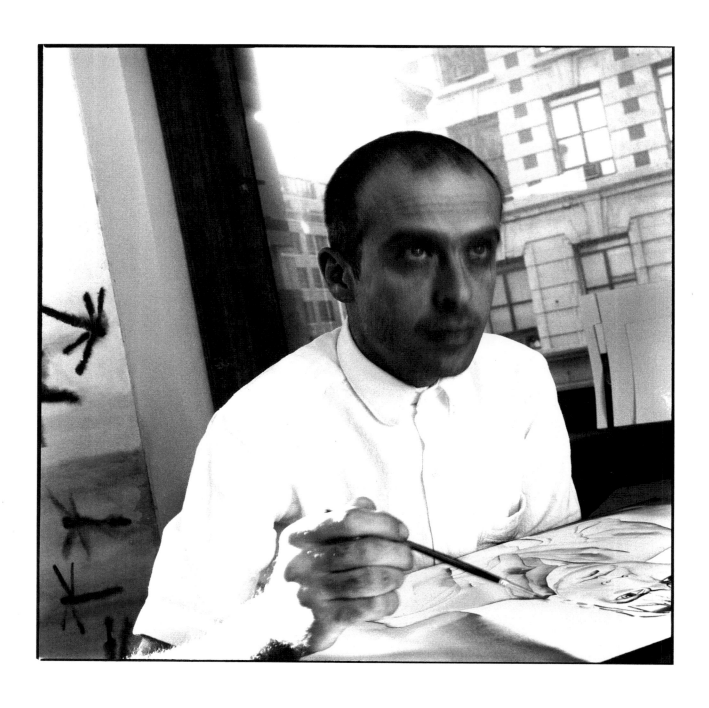

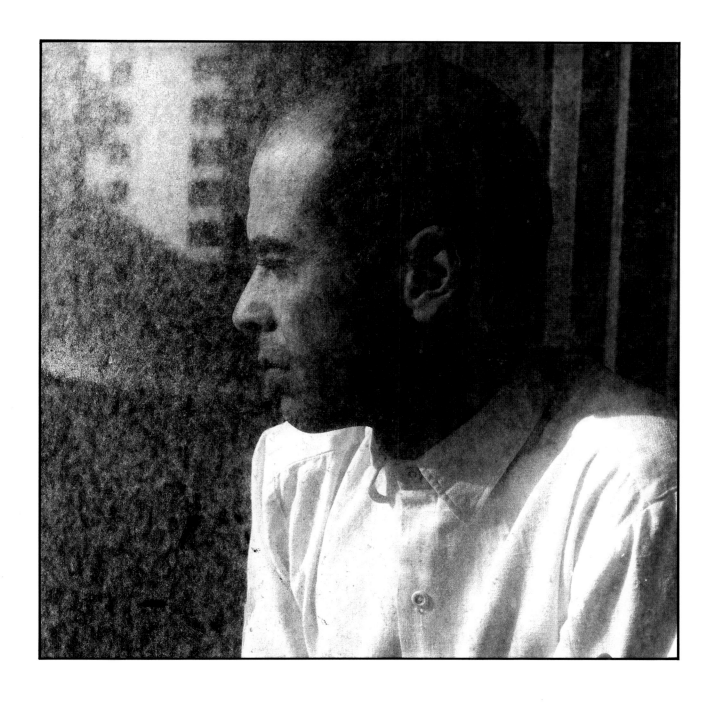

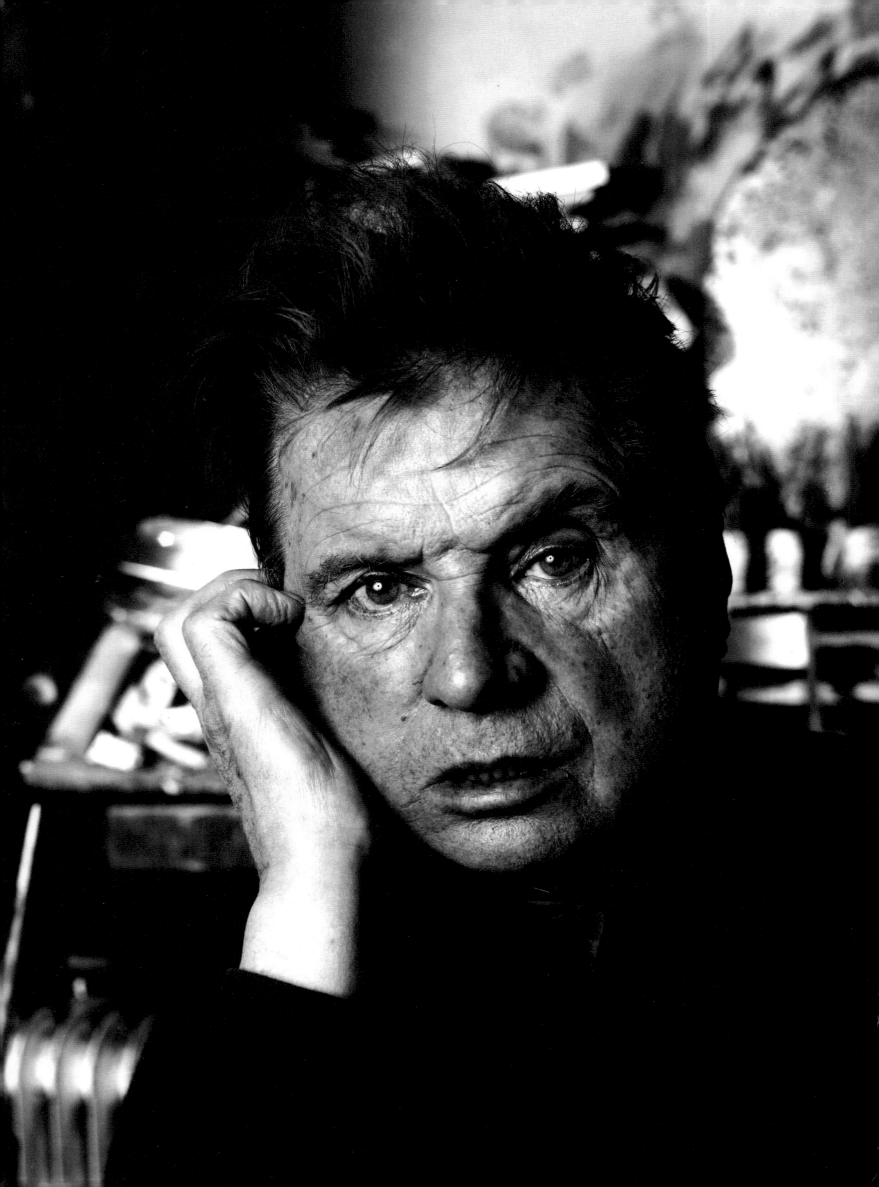

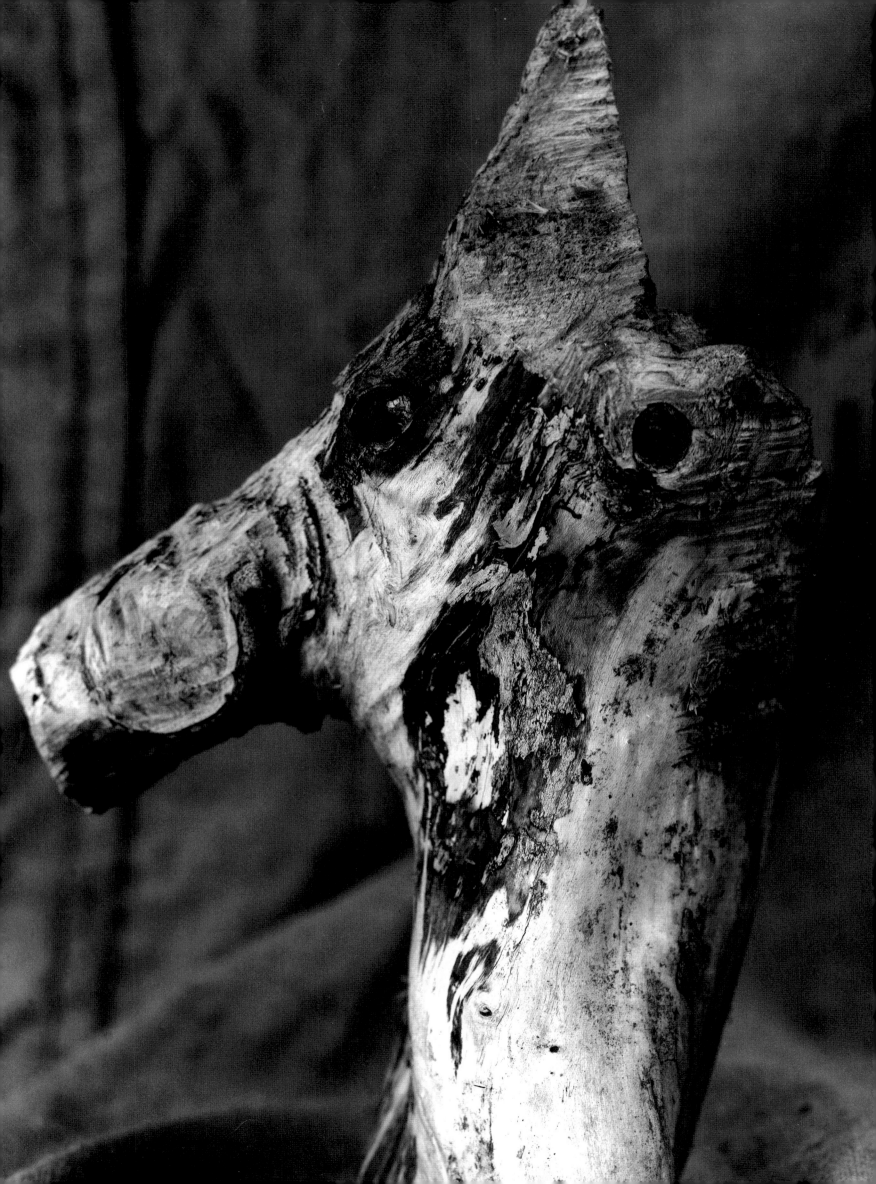

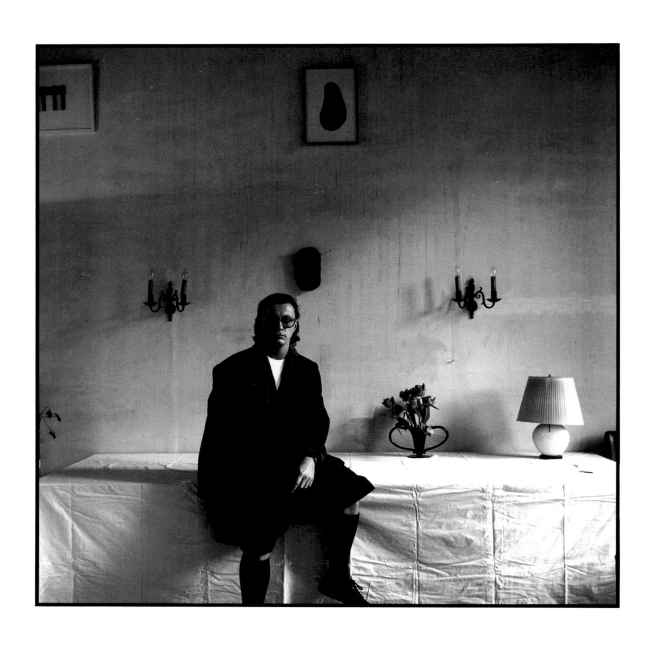

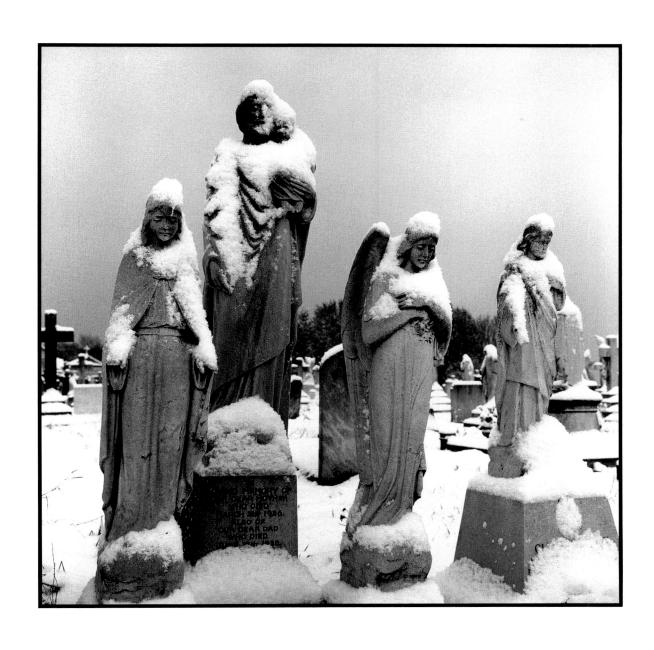

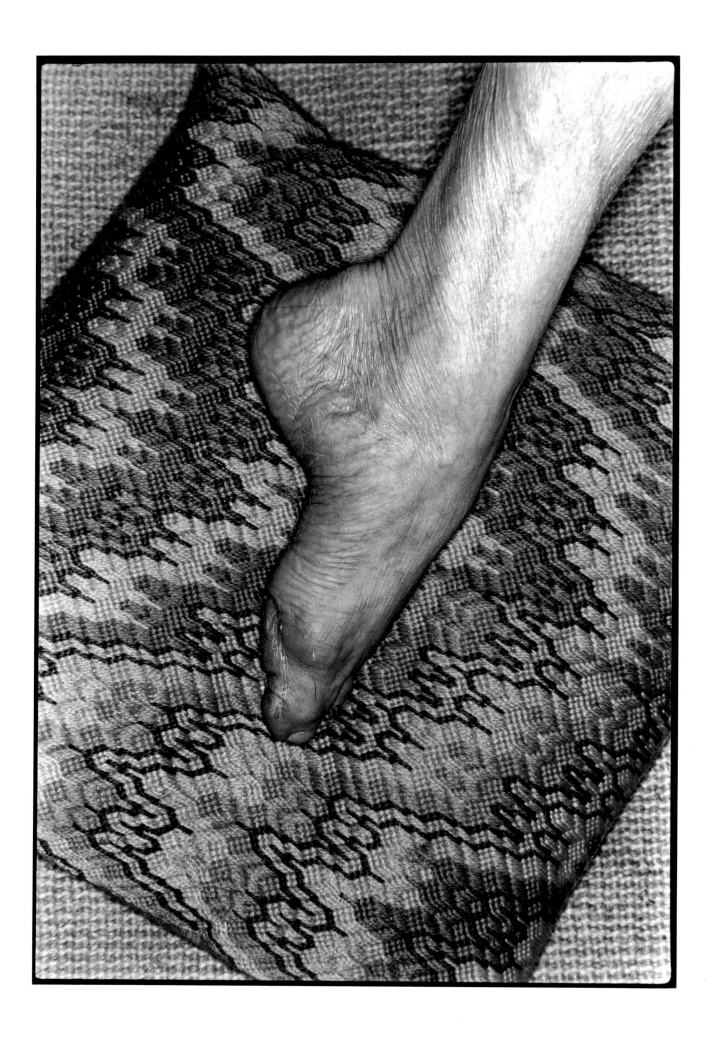

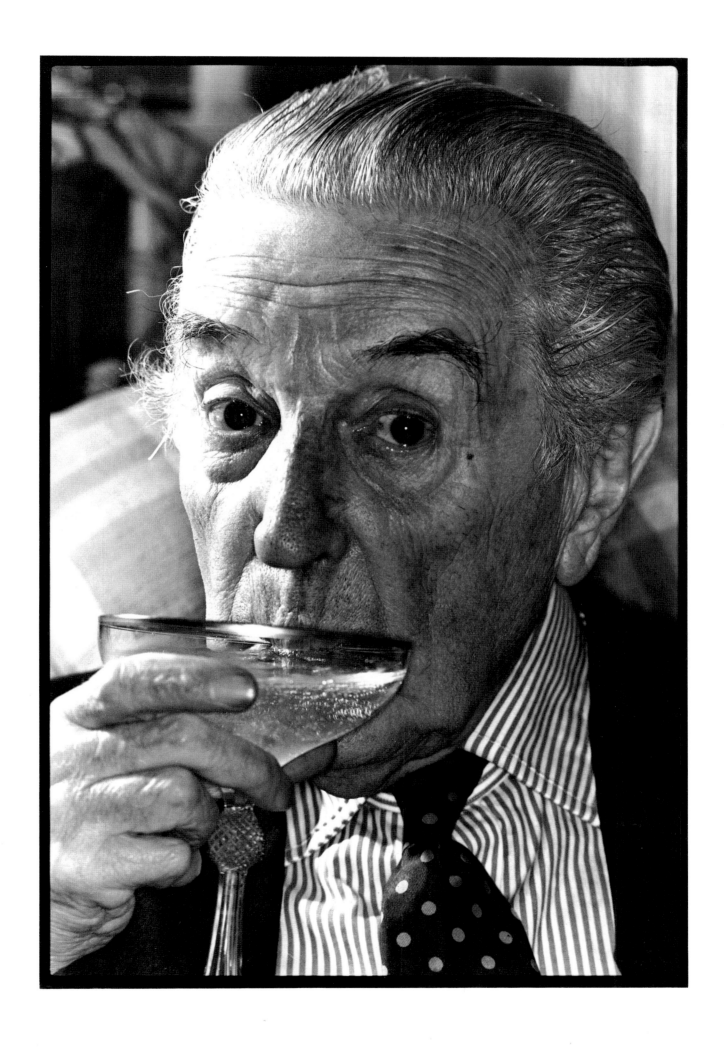

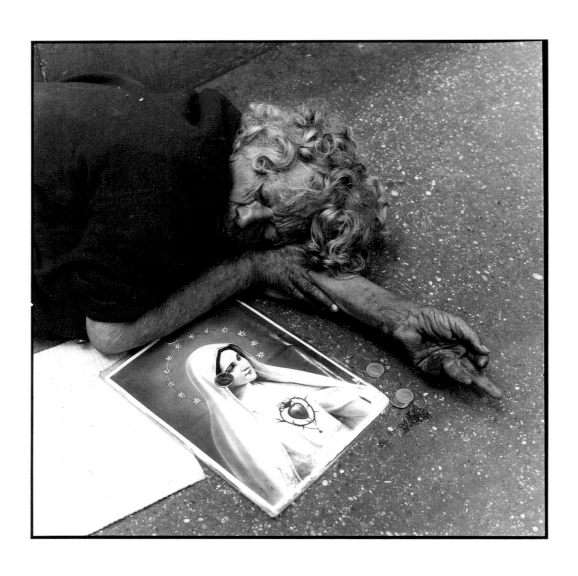

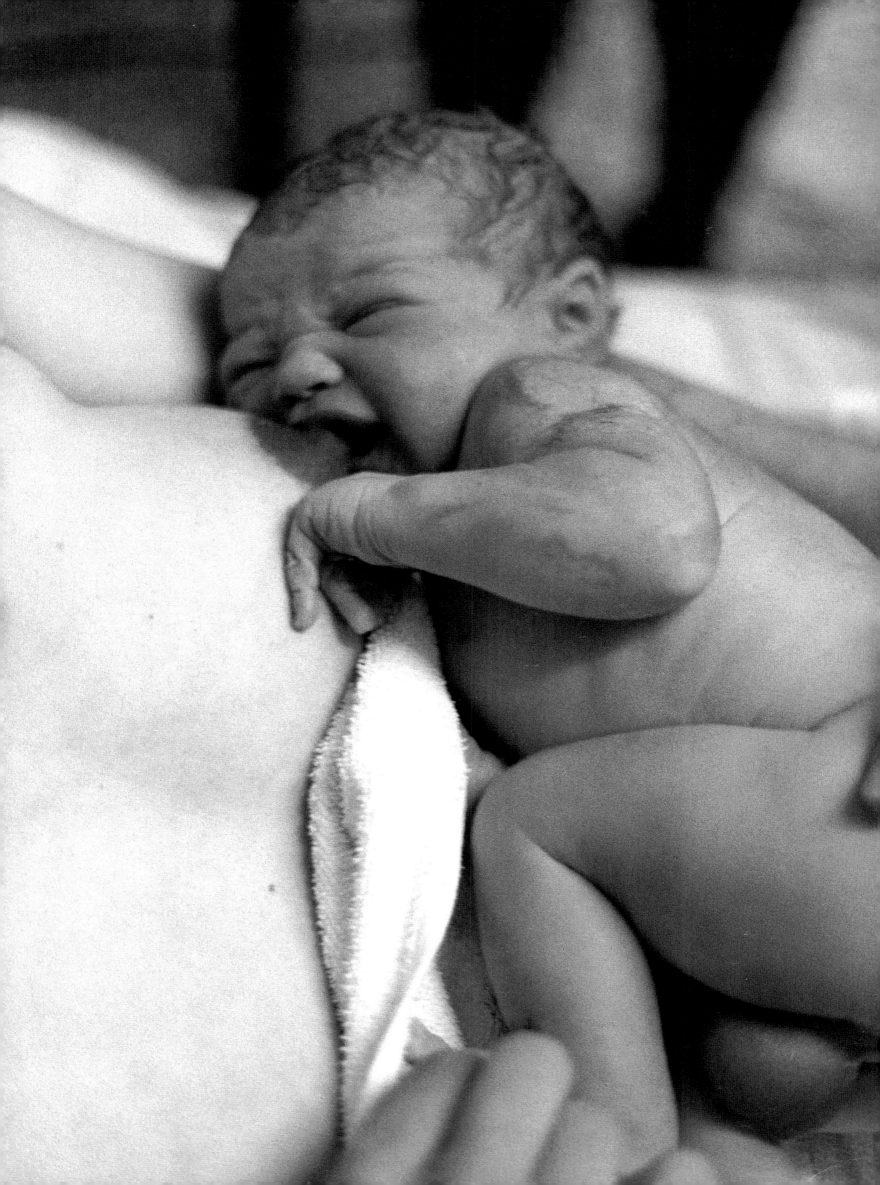

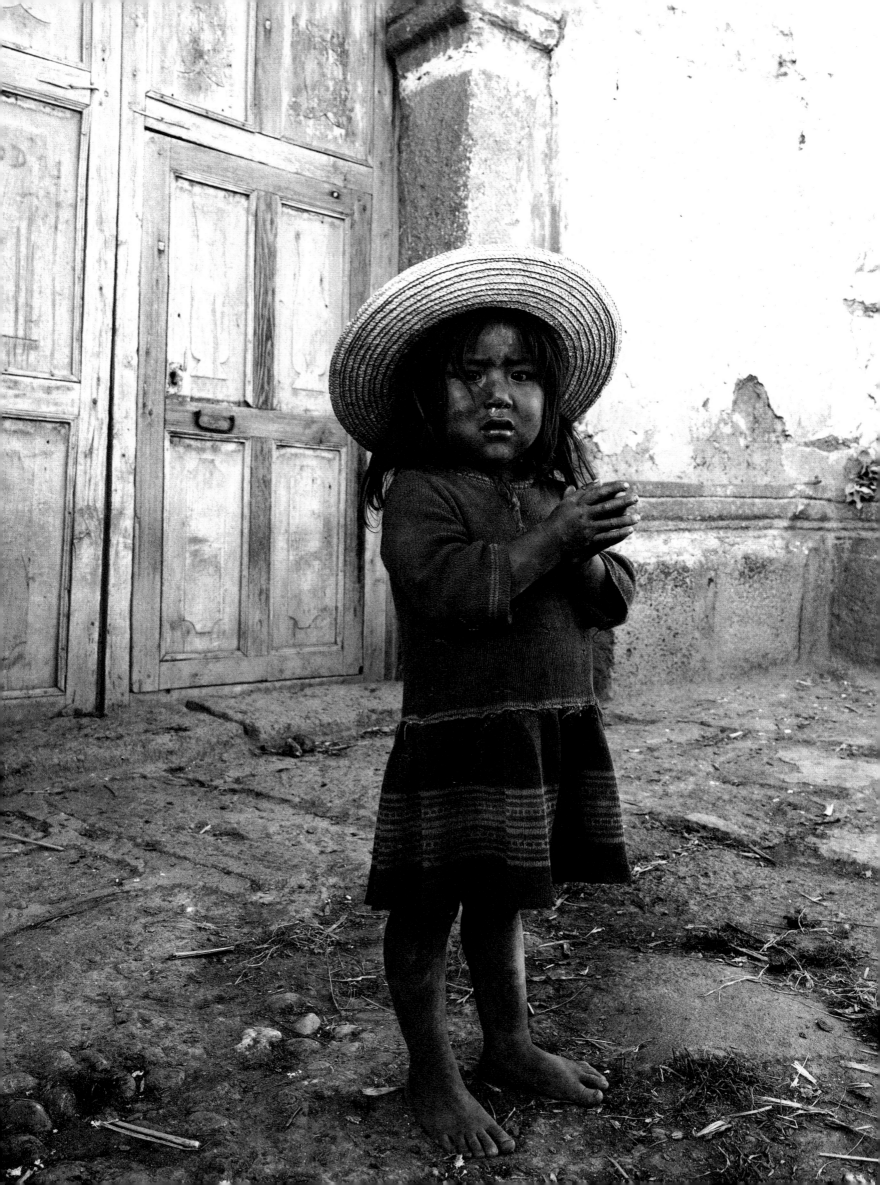

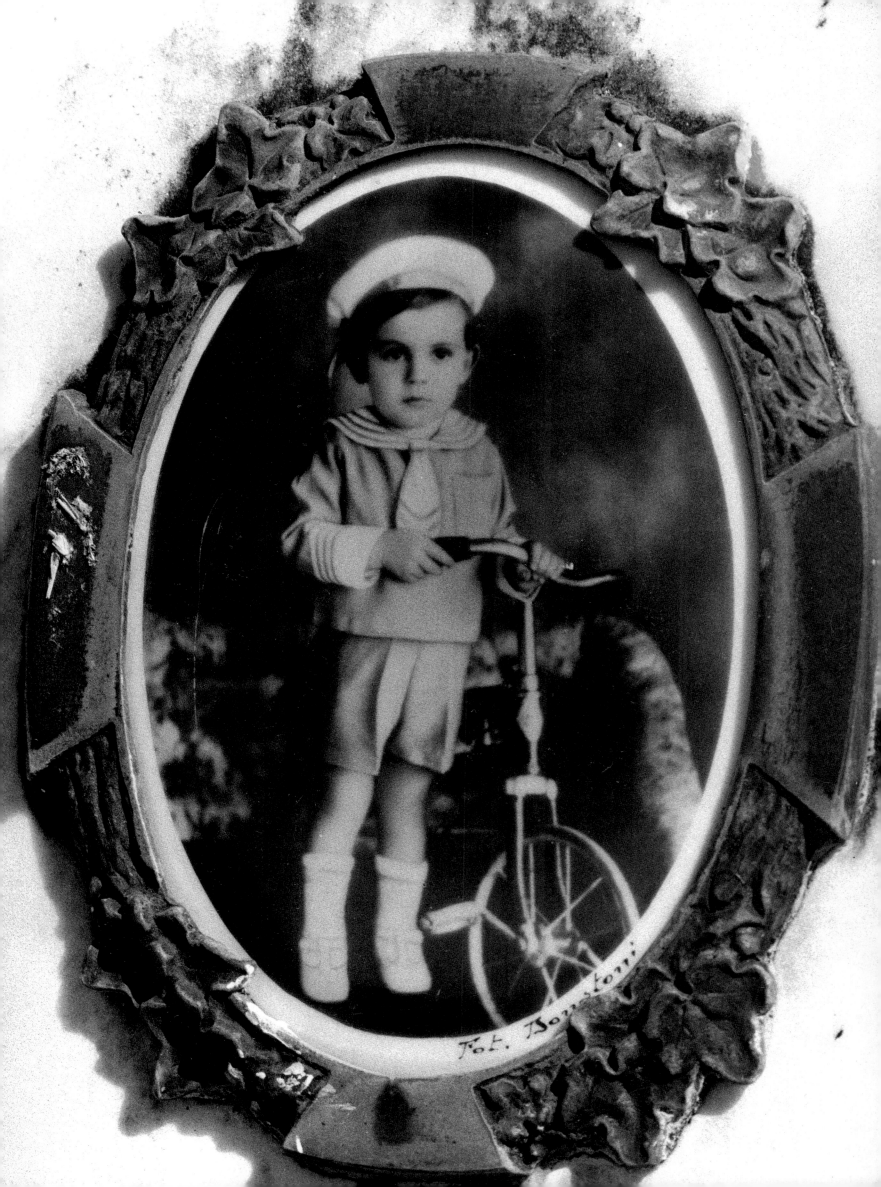

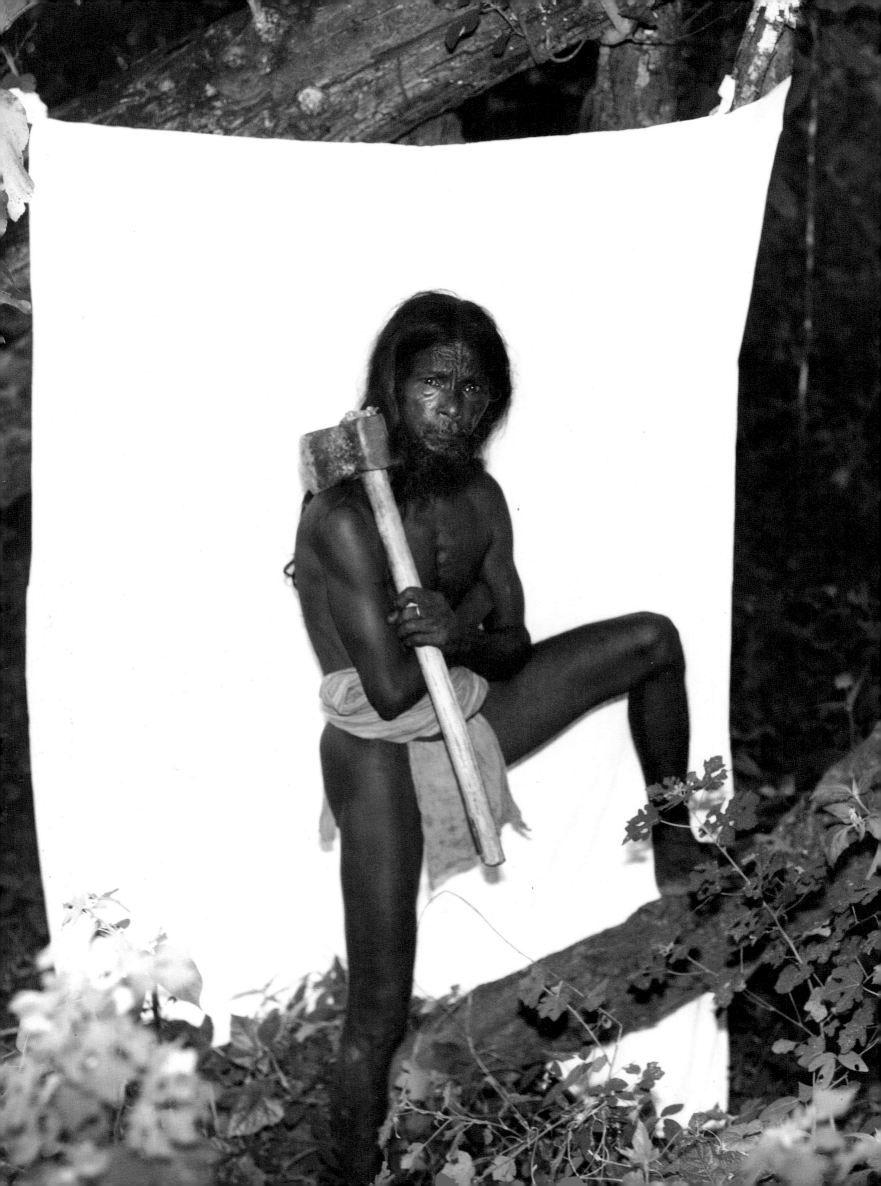

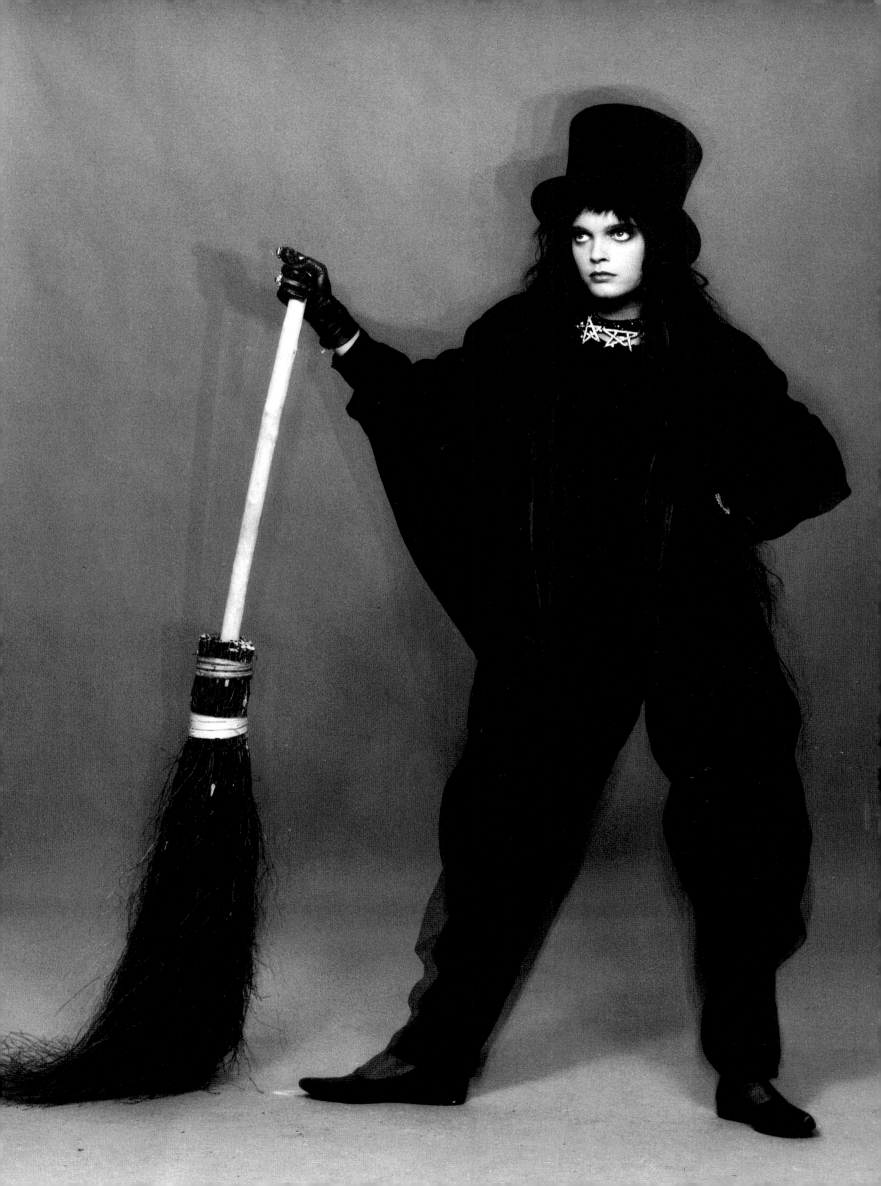

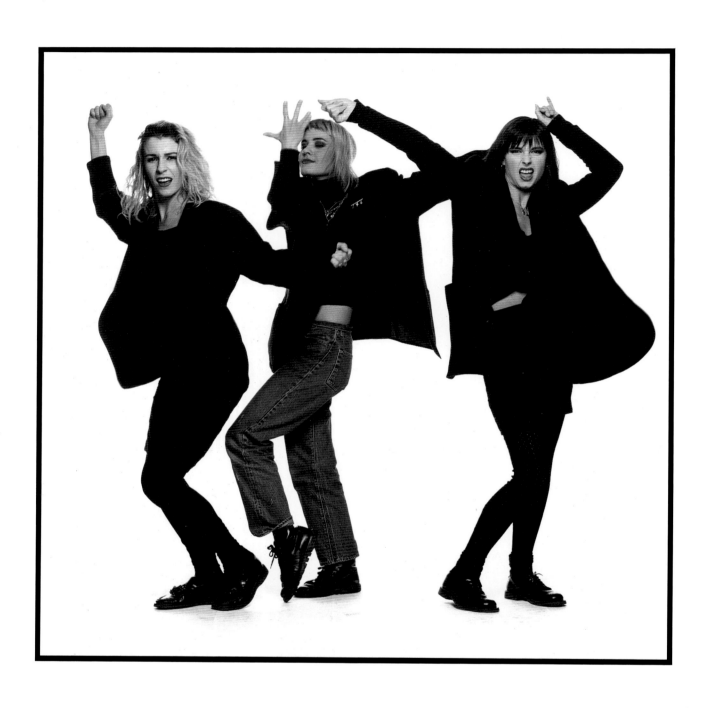

118

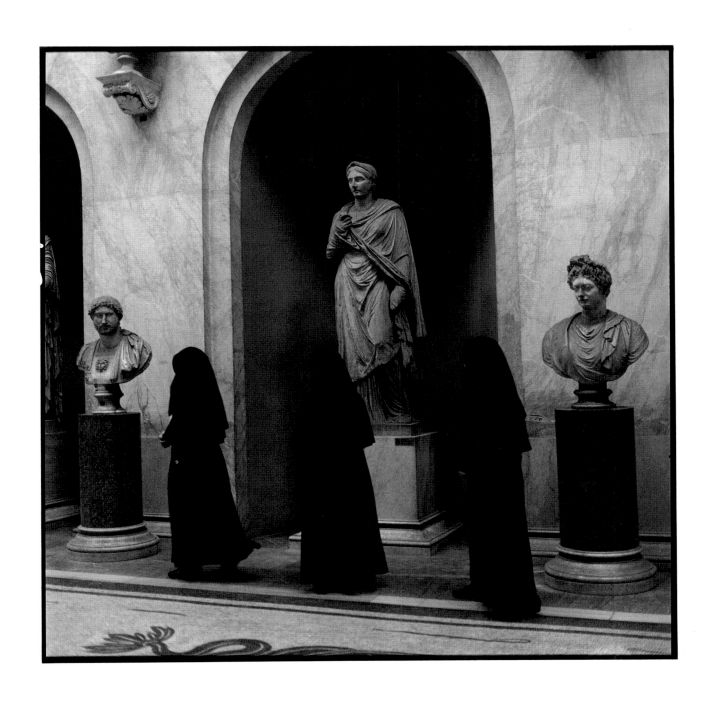

119

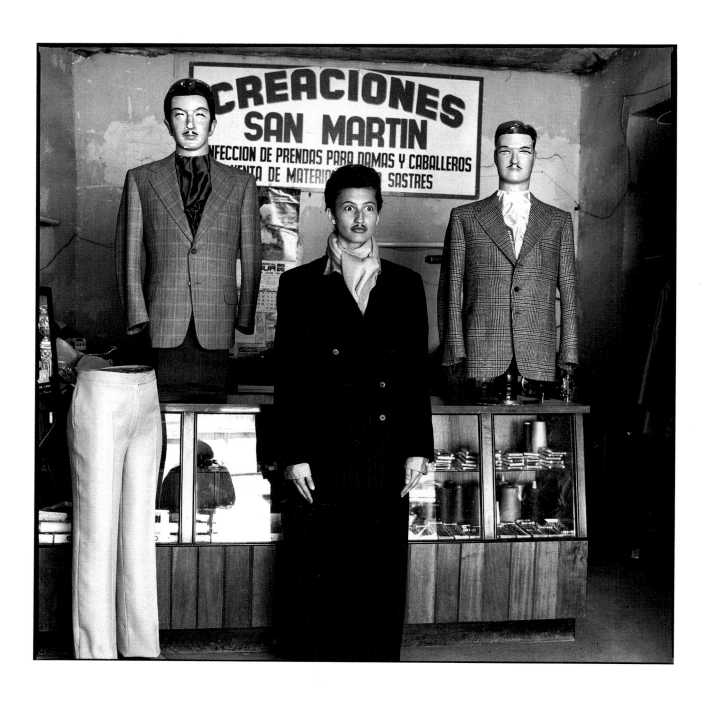

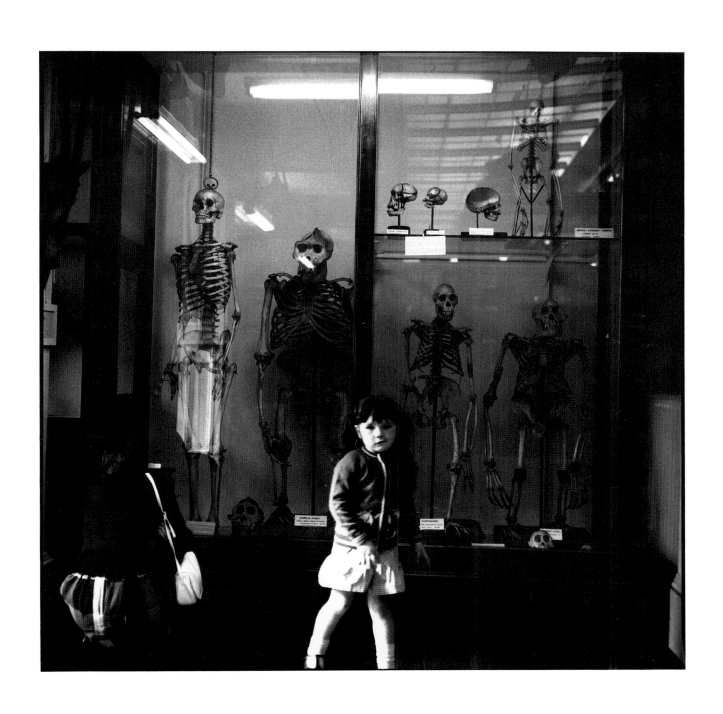

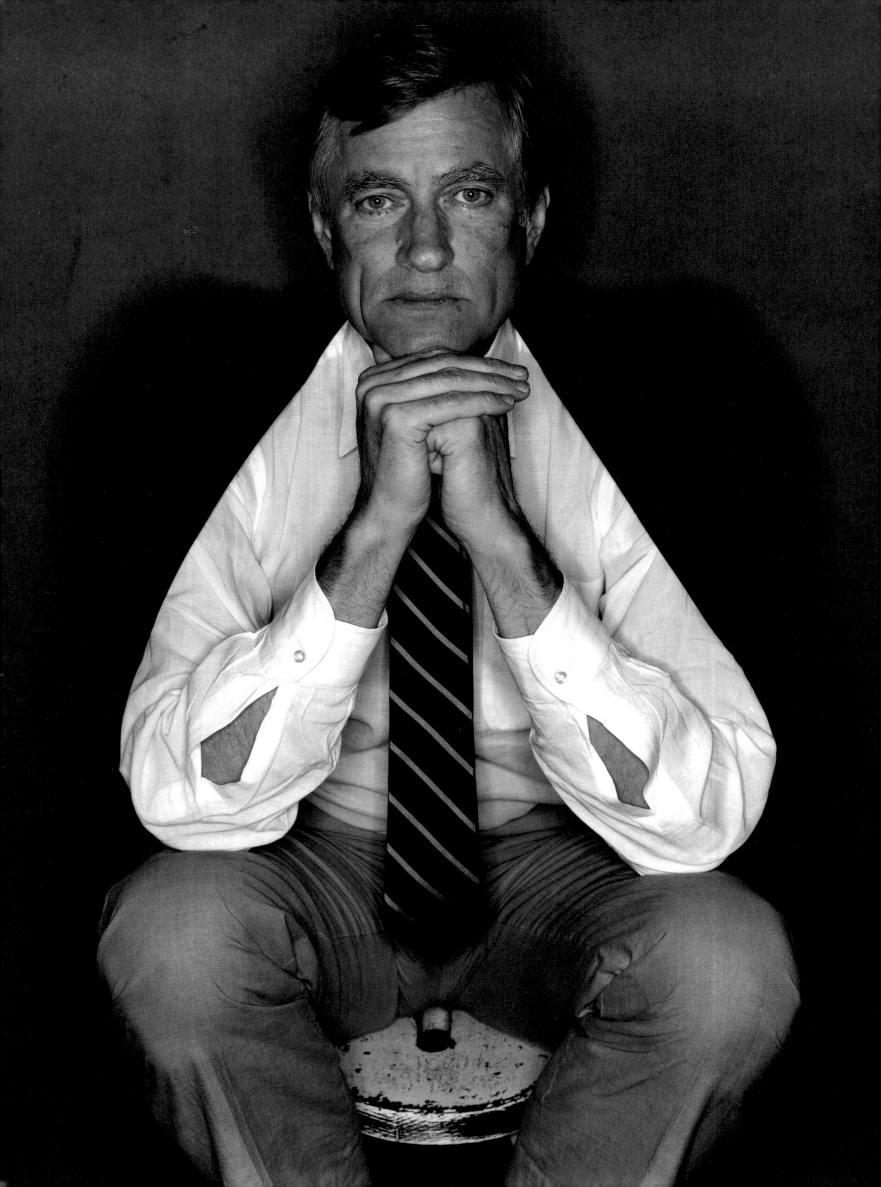

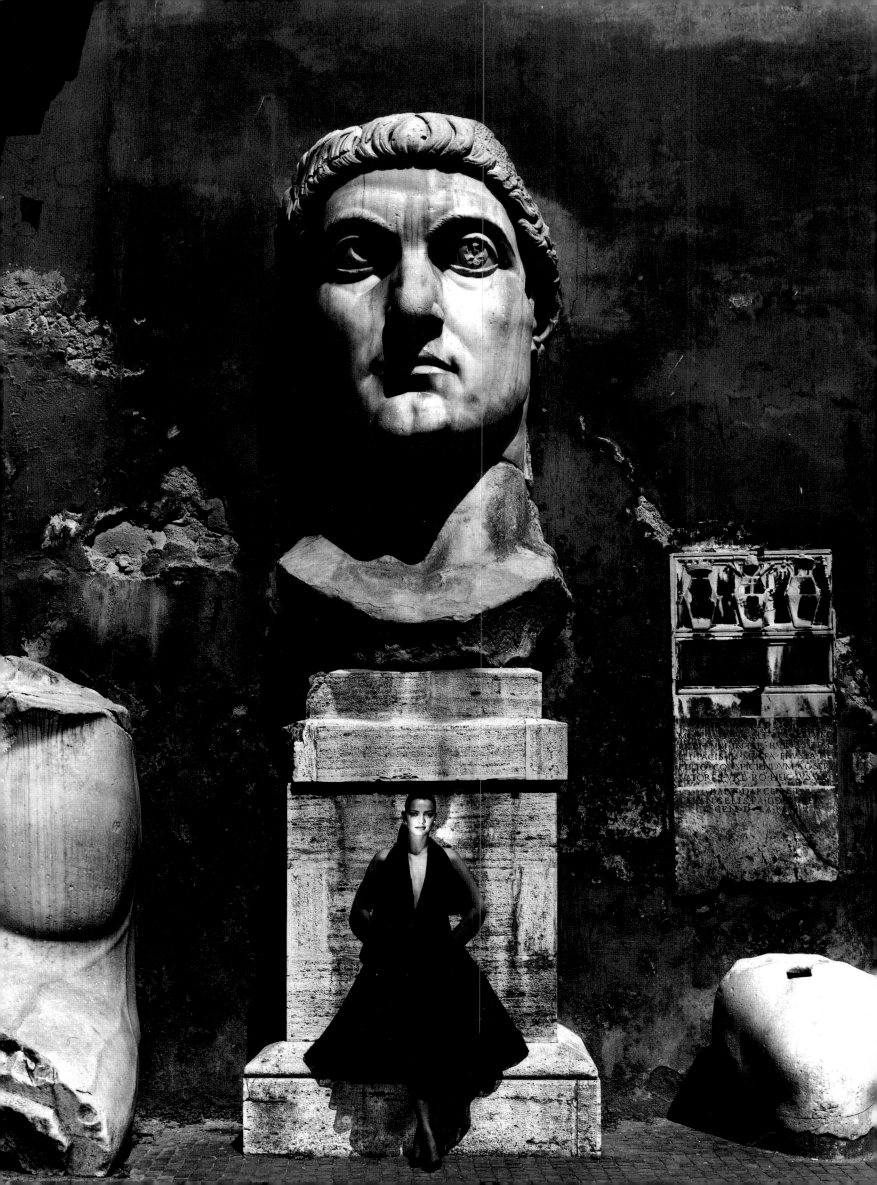

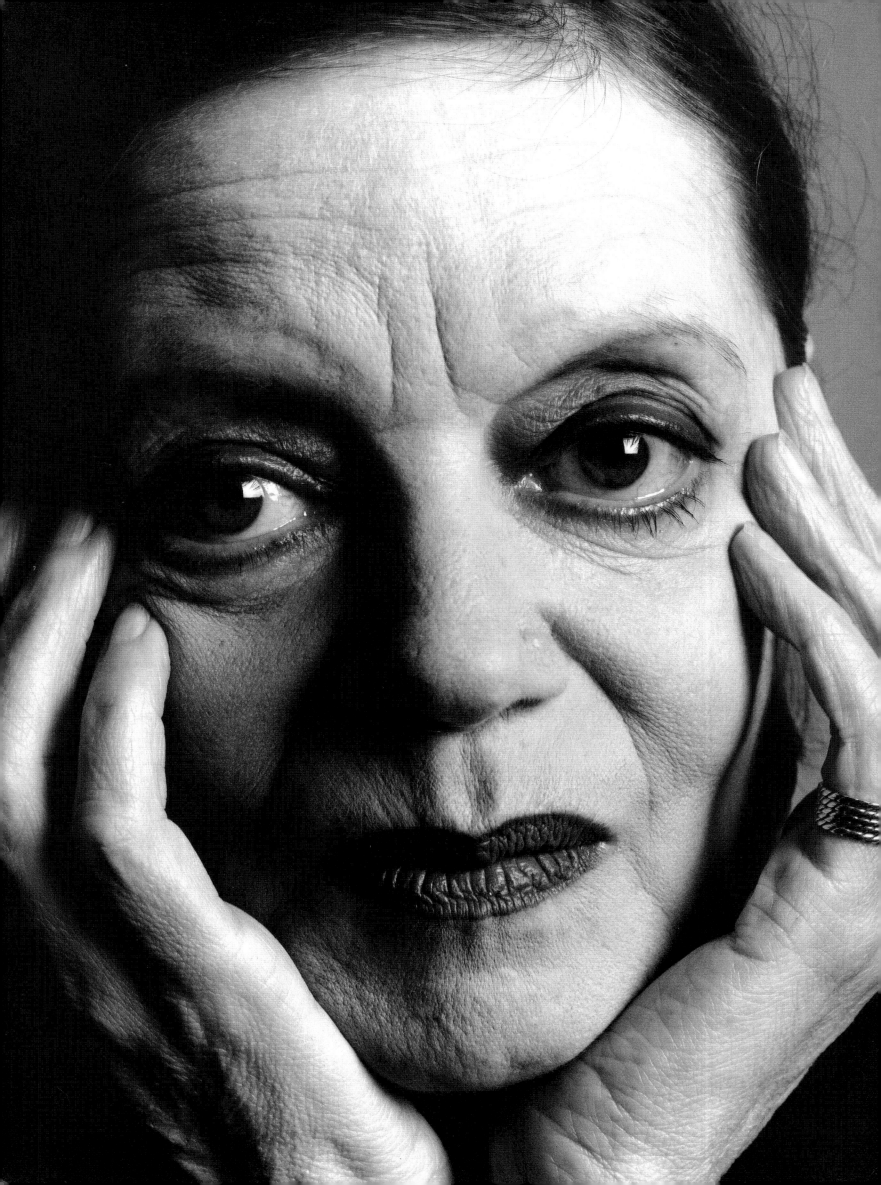

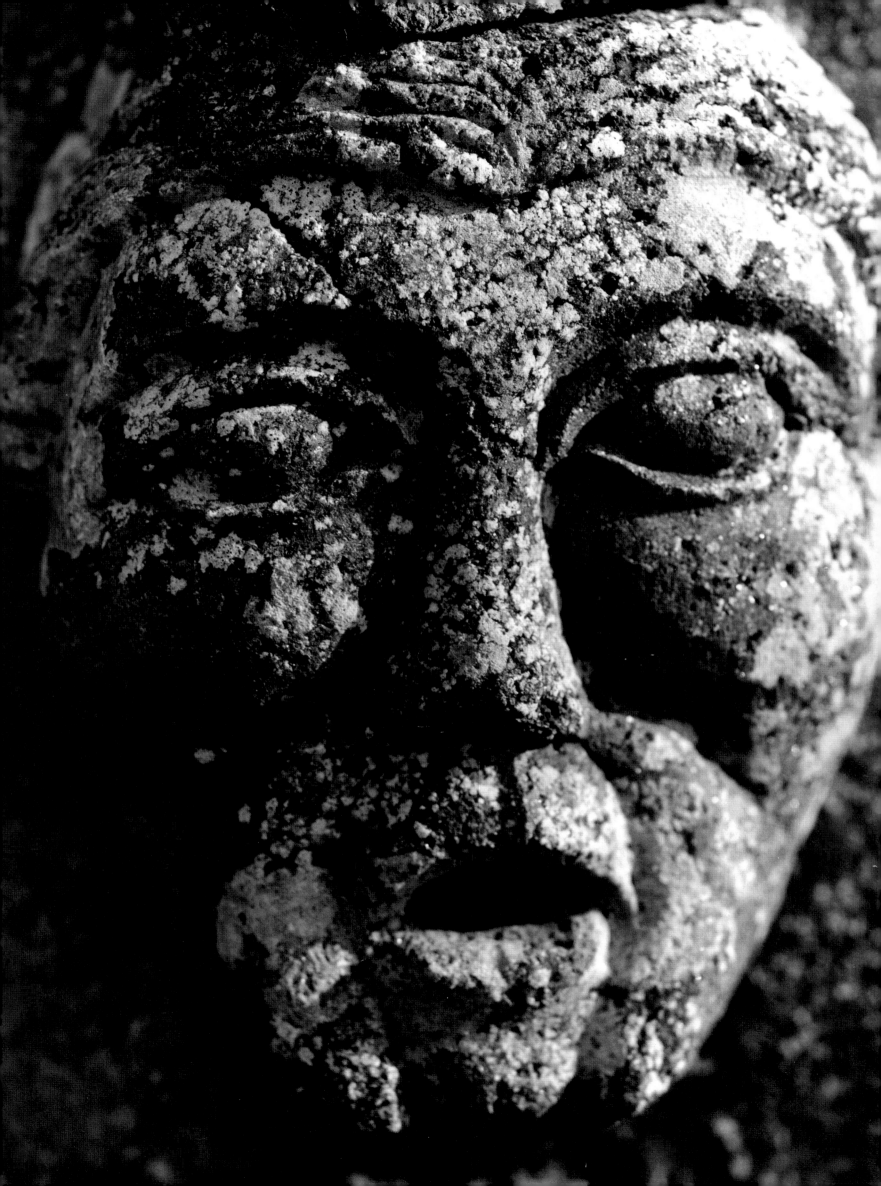

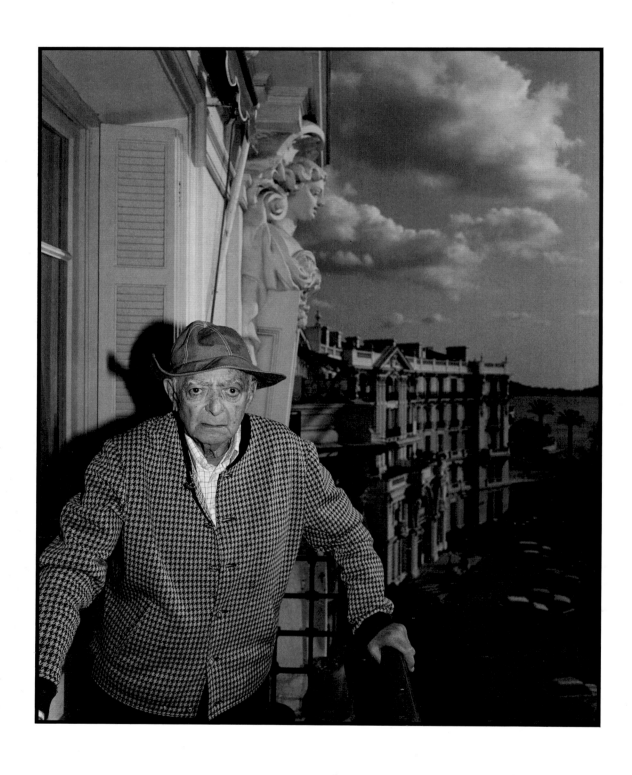

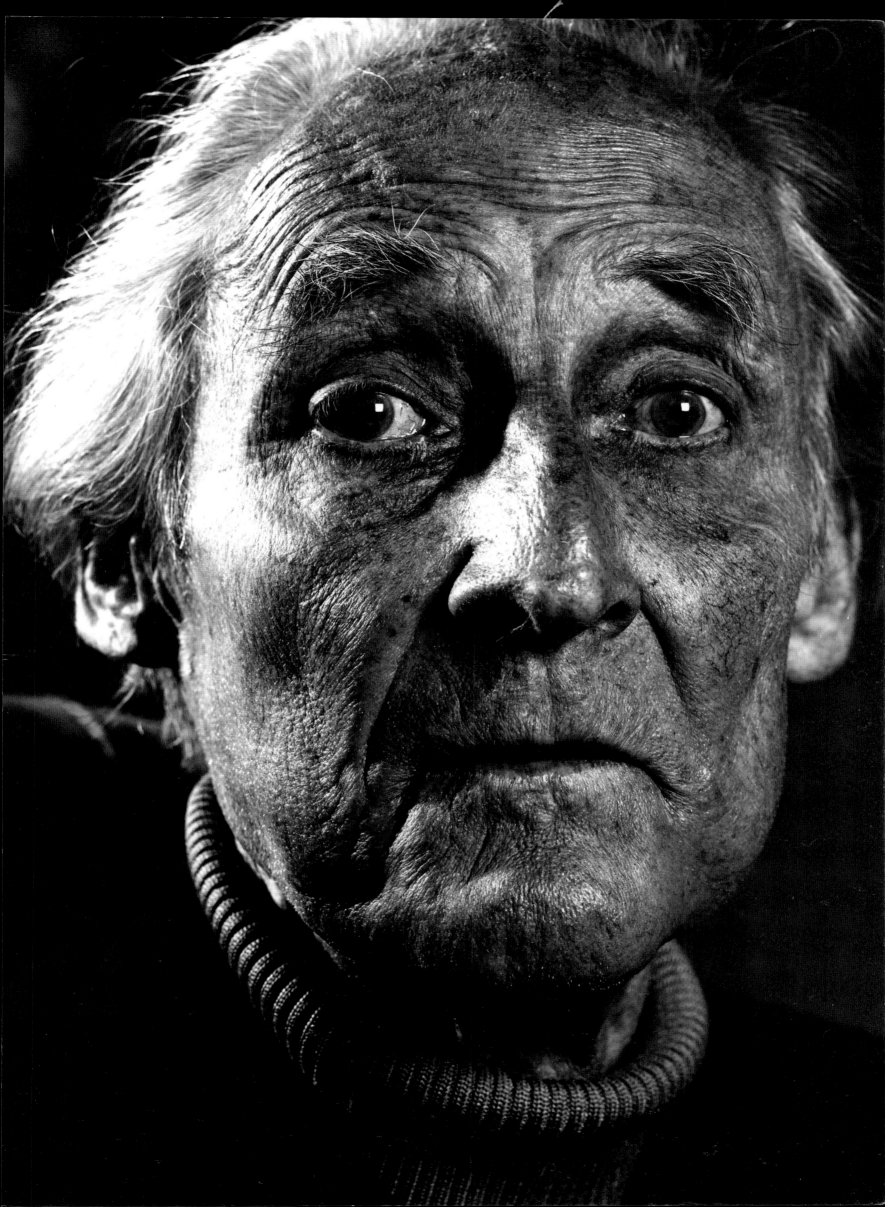

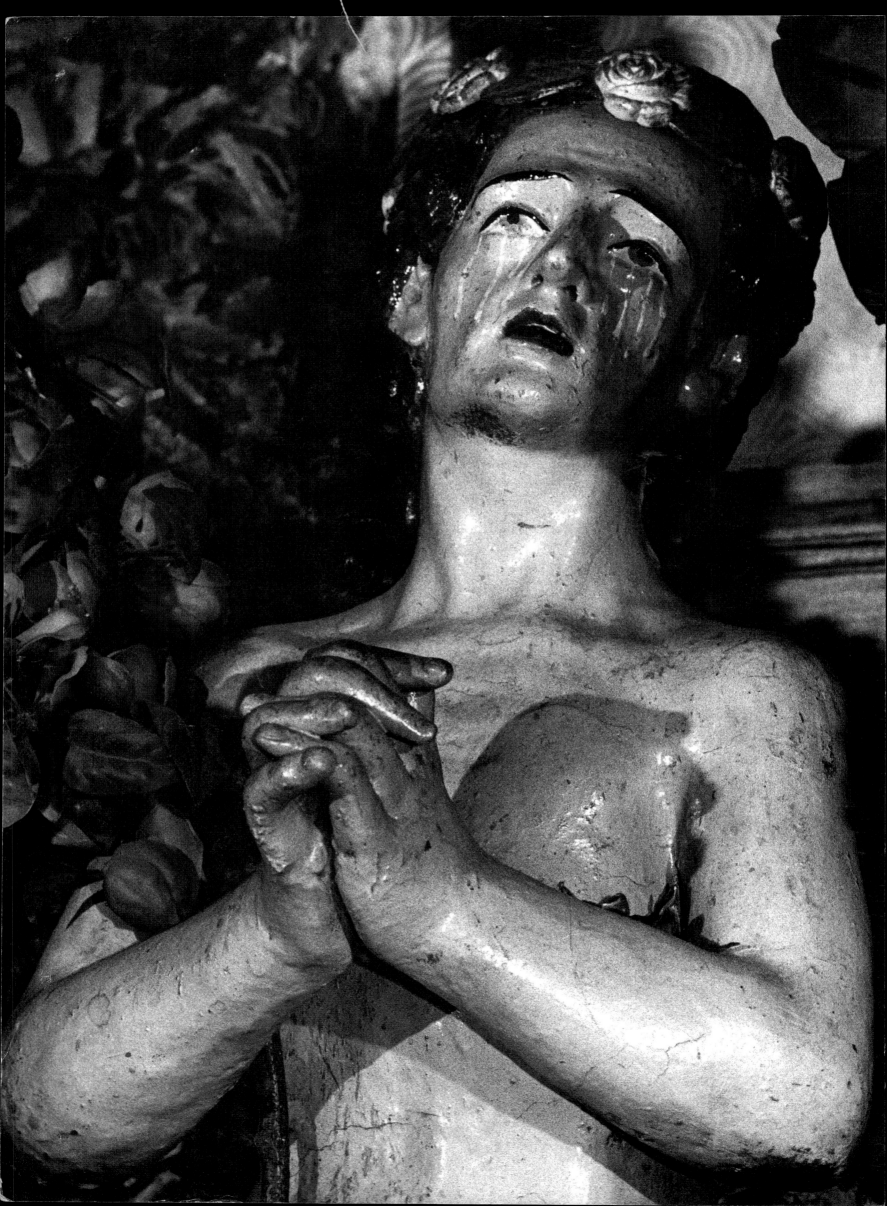

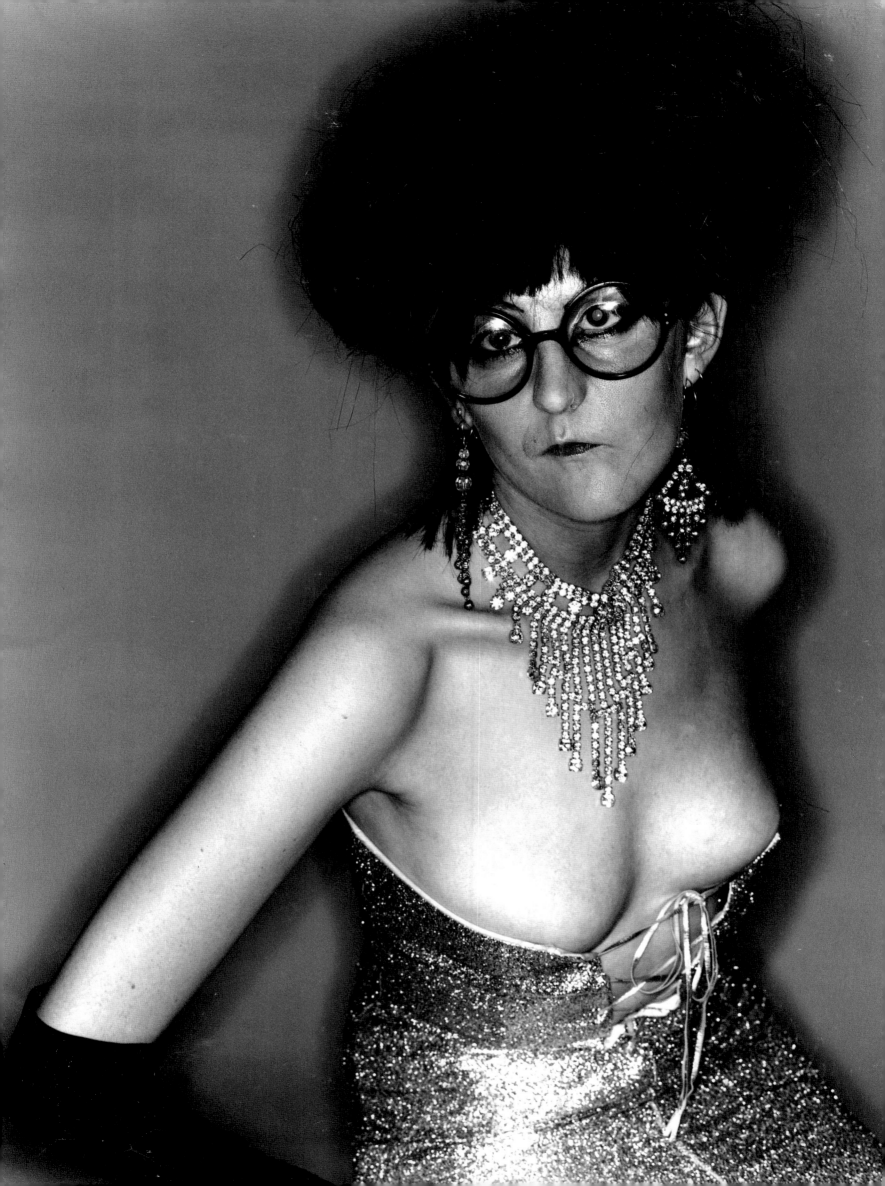

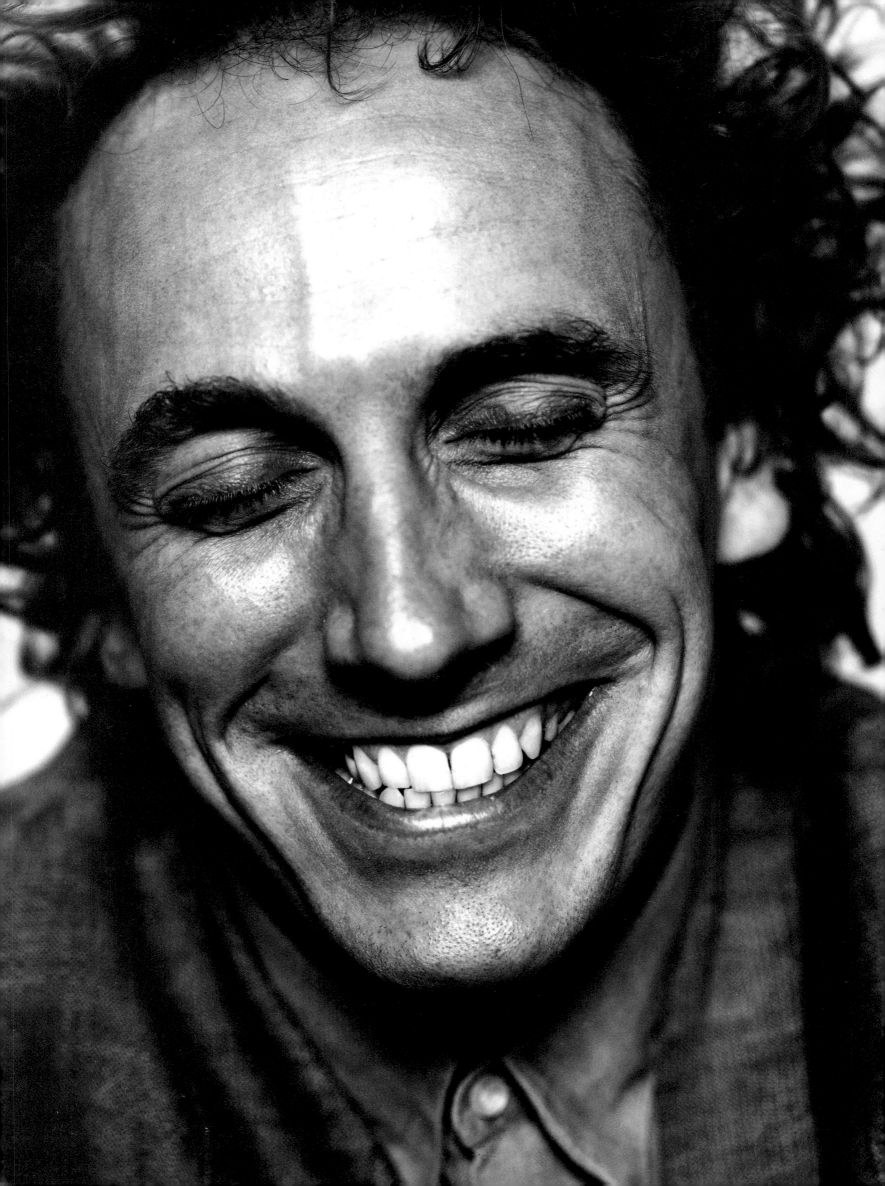

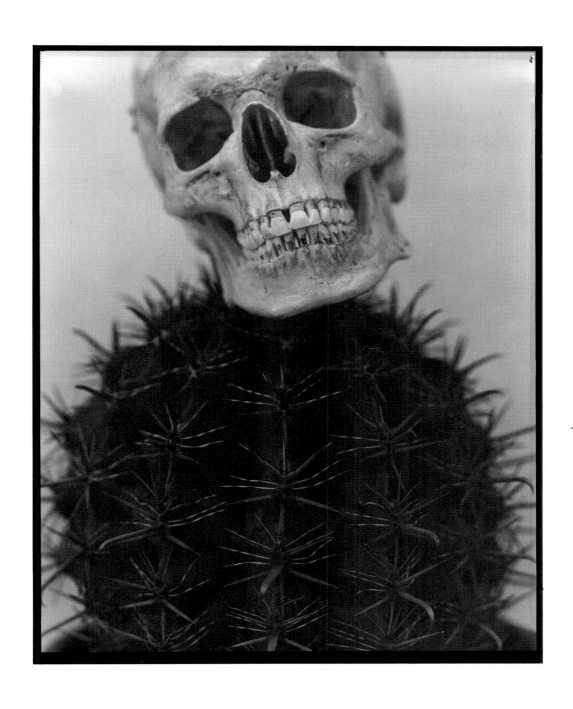

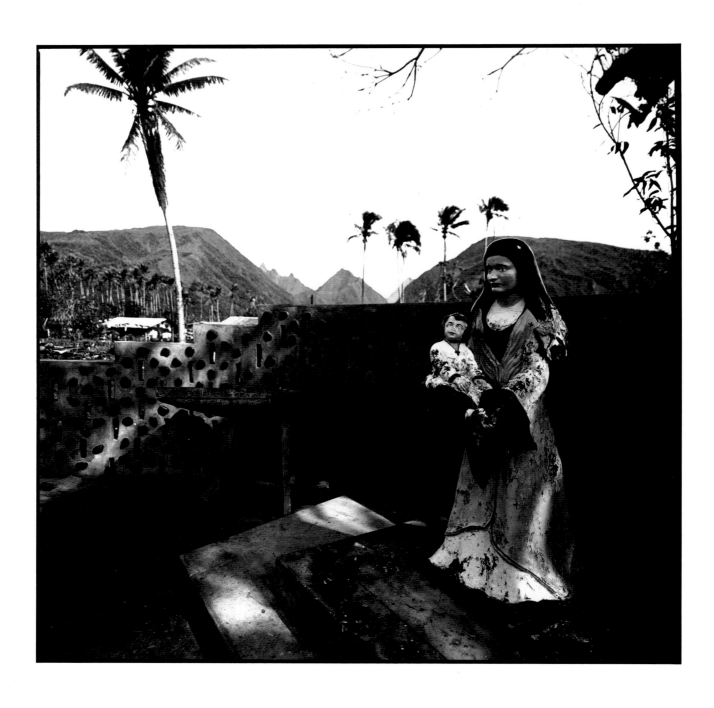

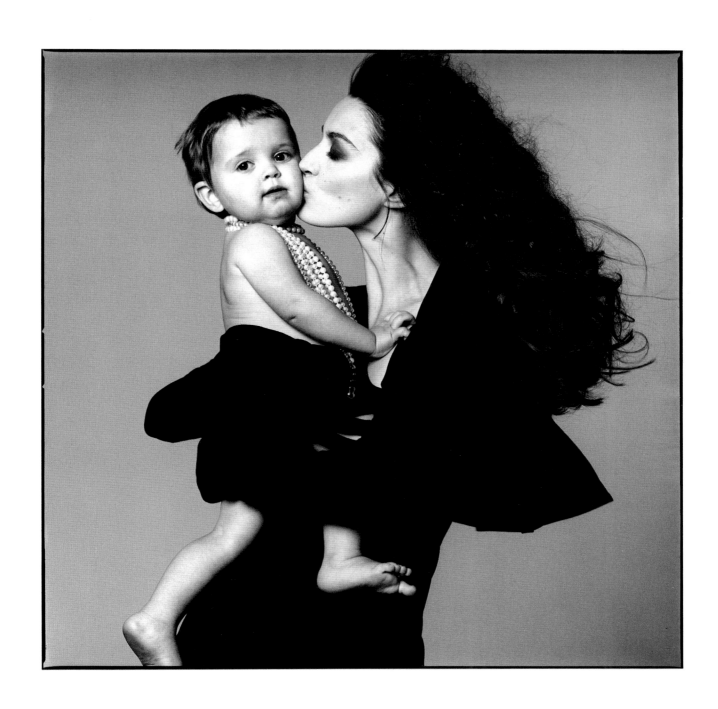

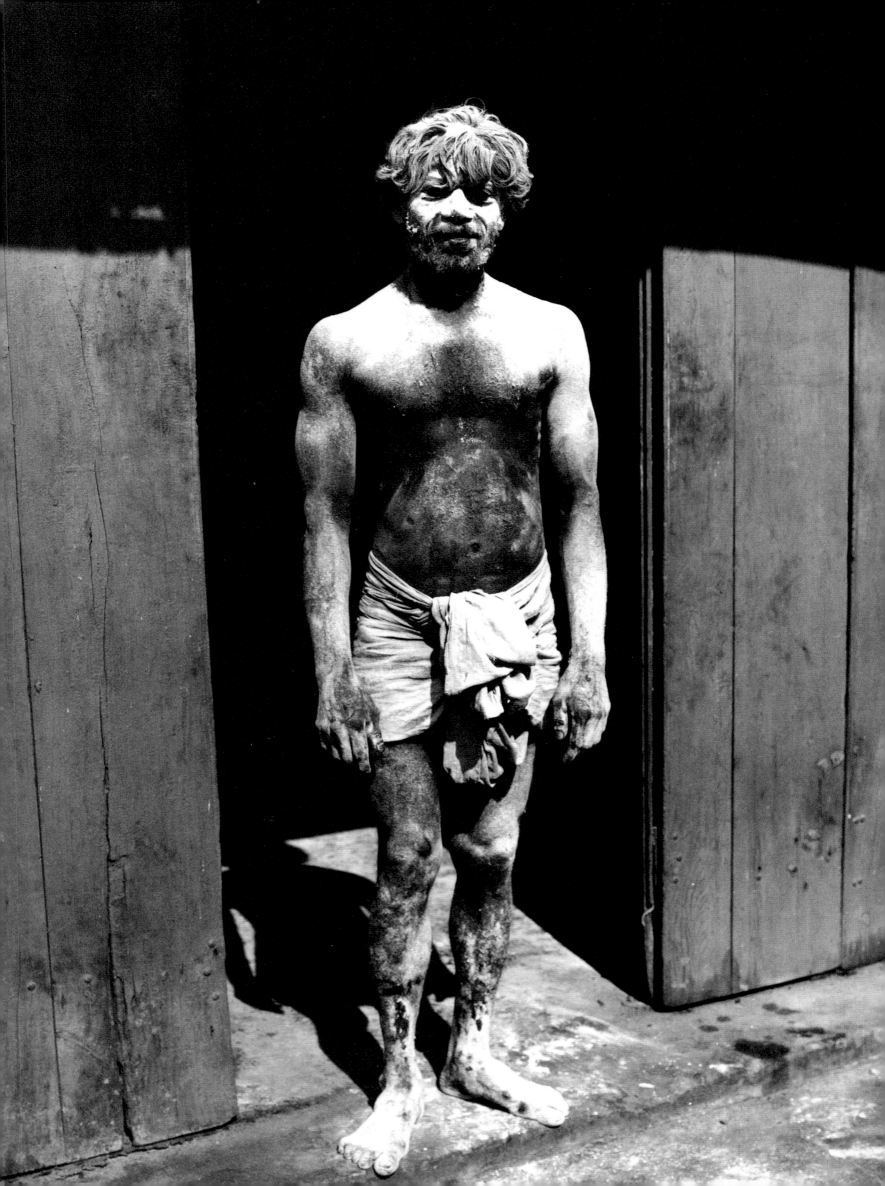

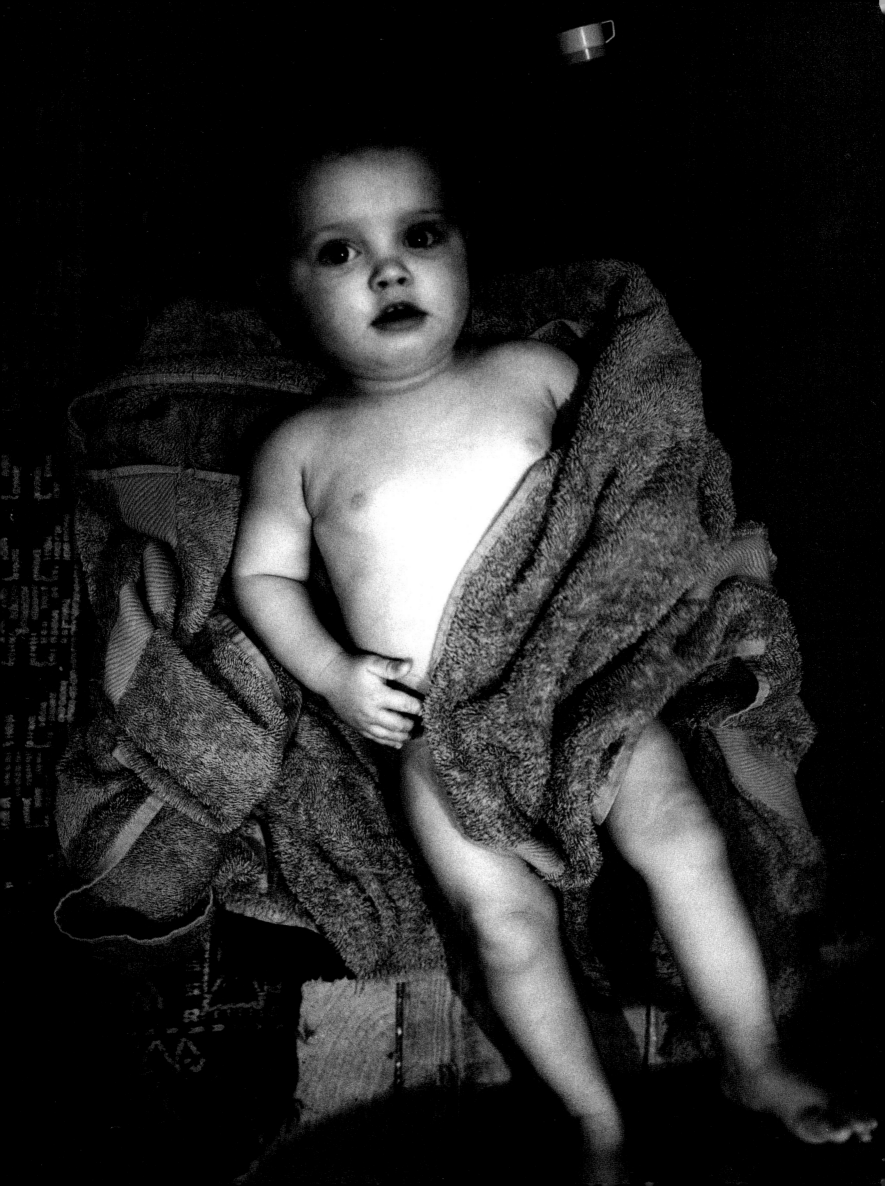

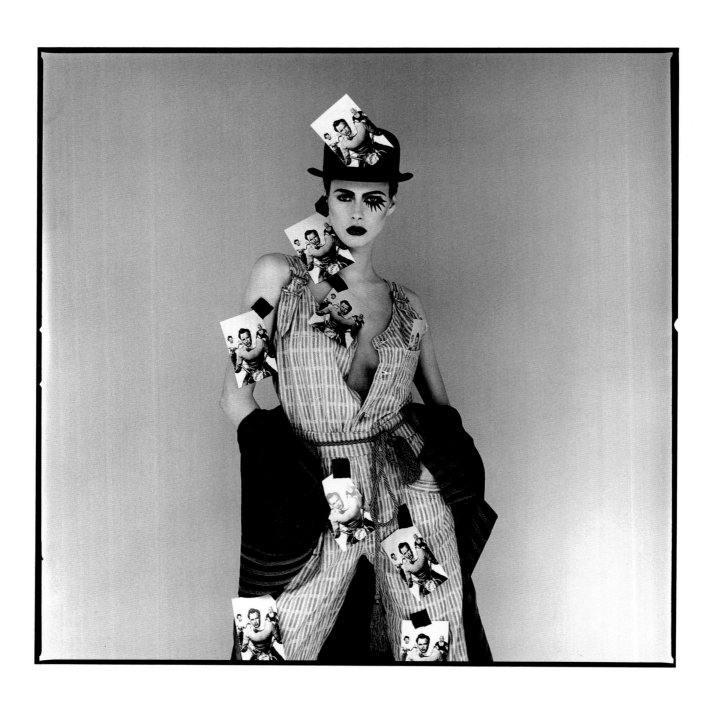

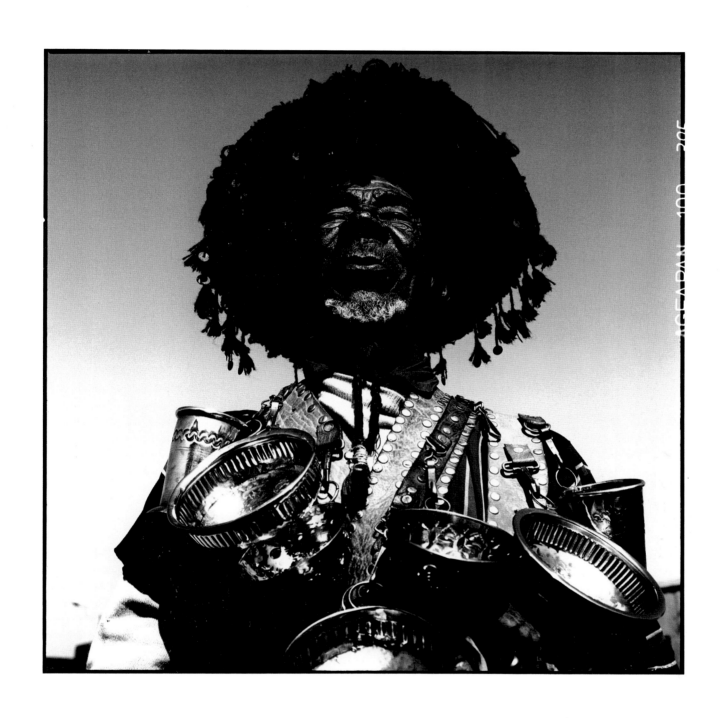

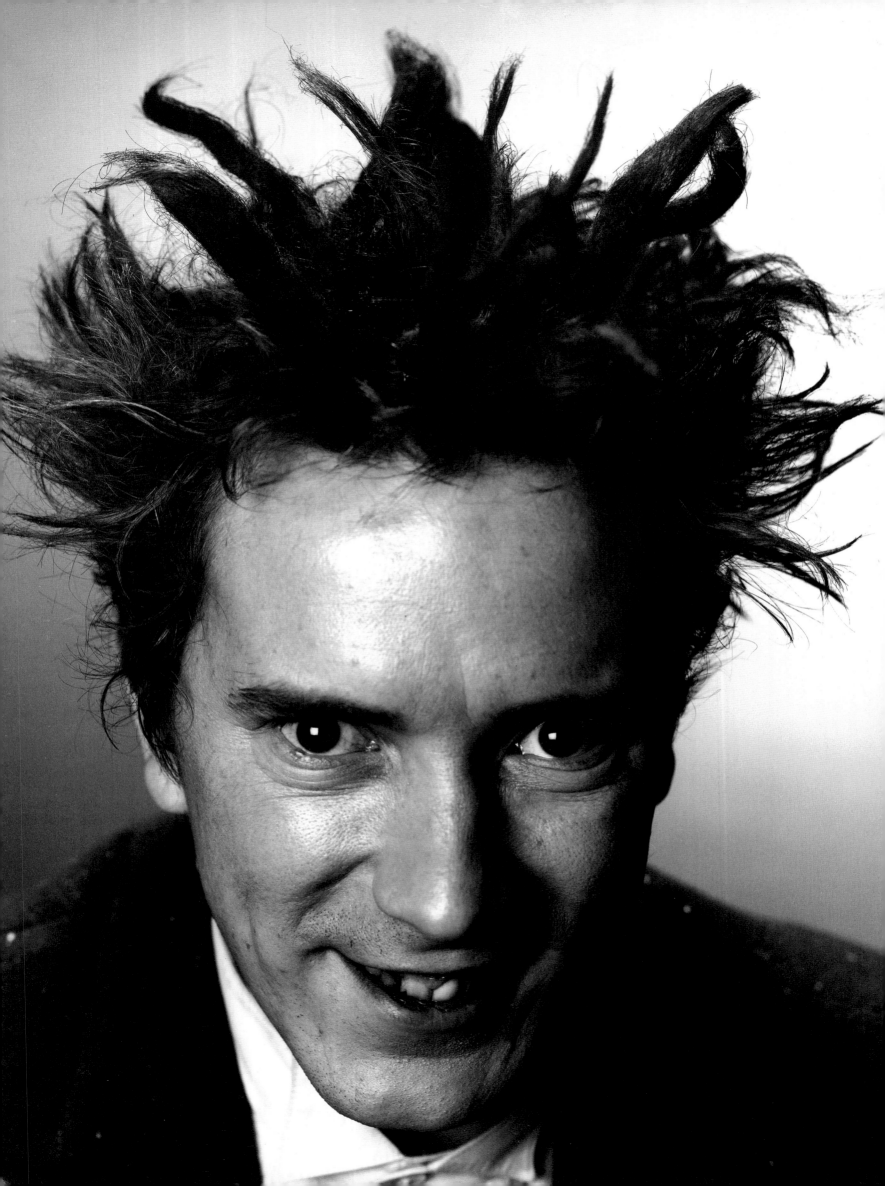

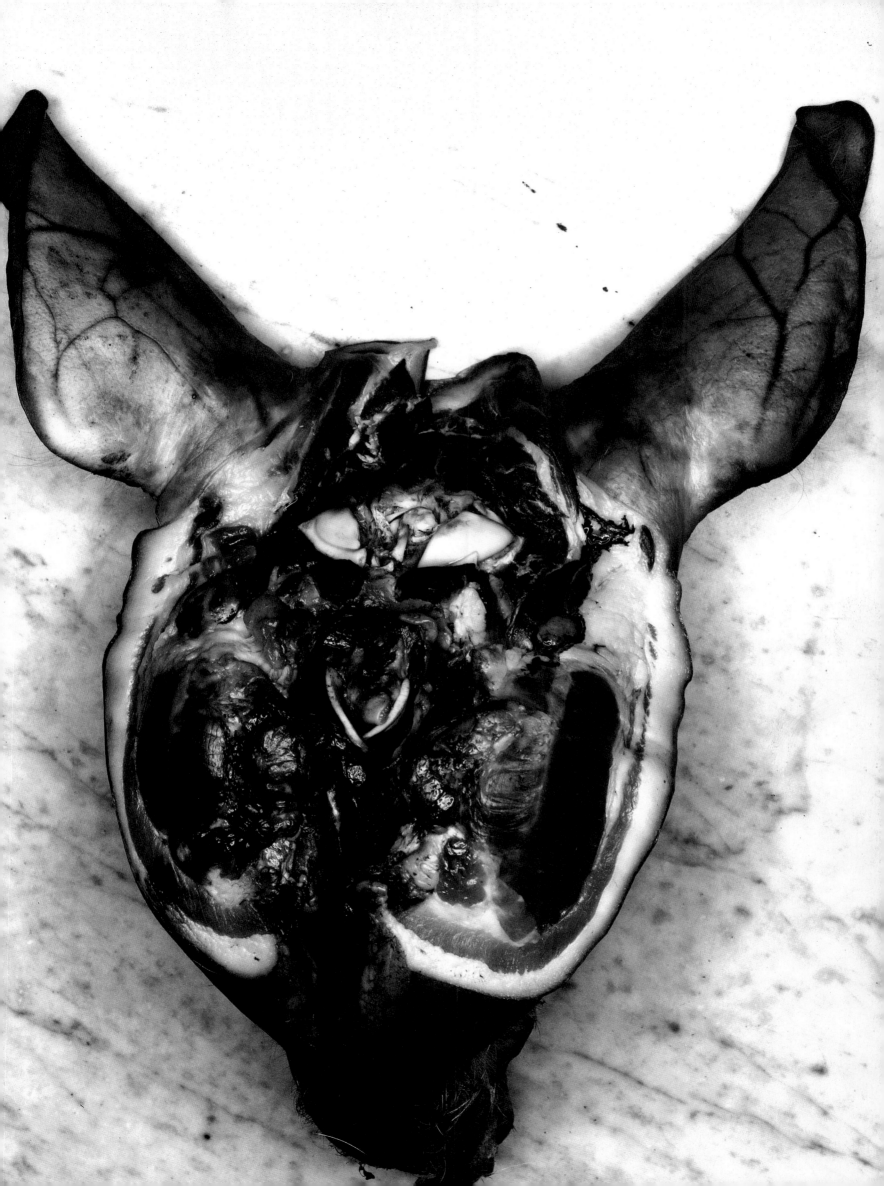

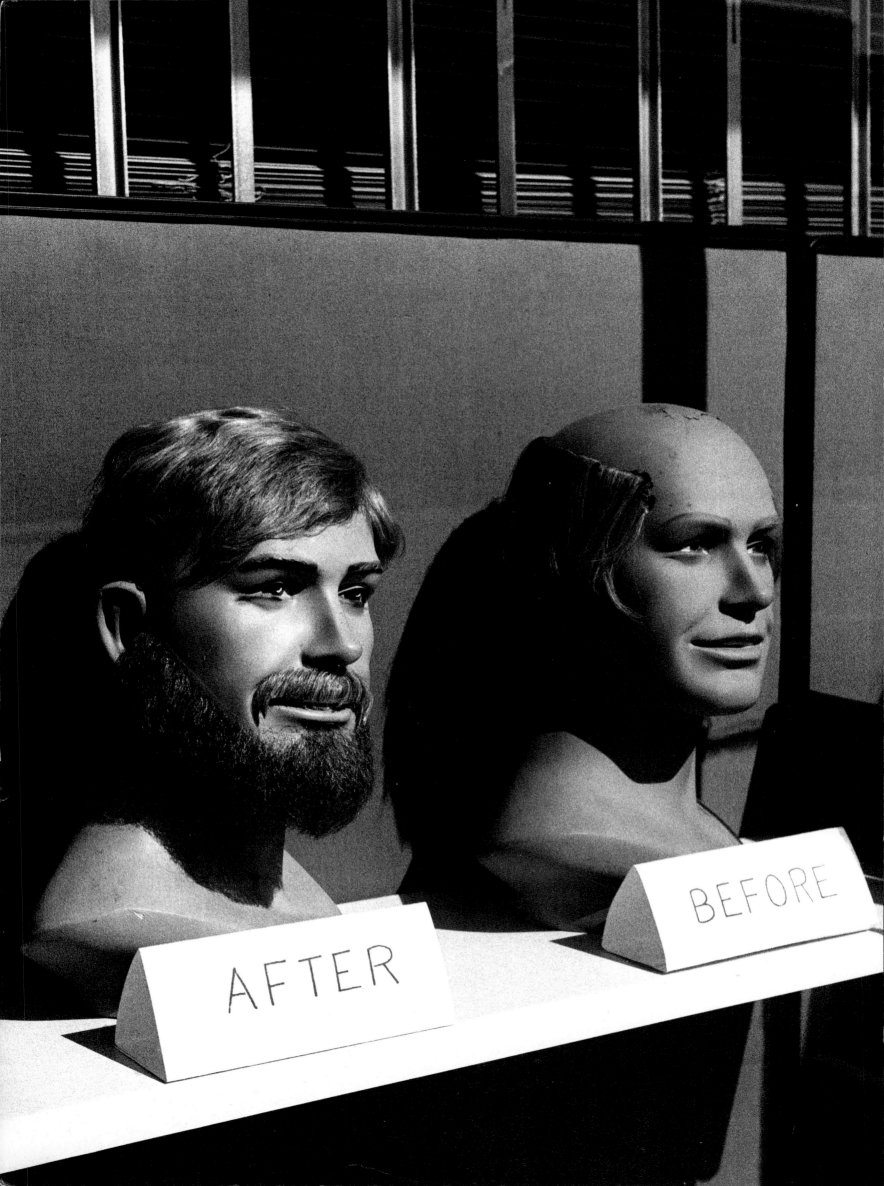

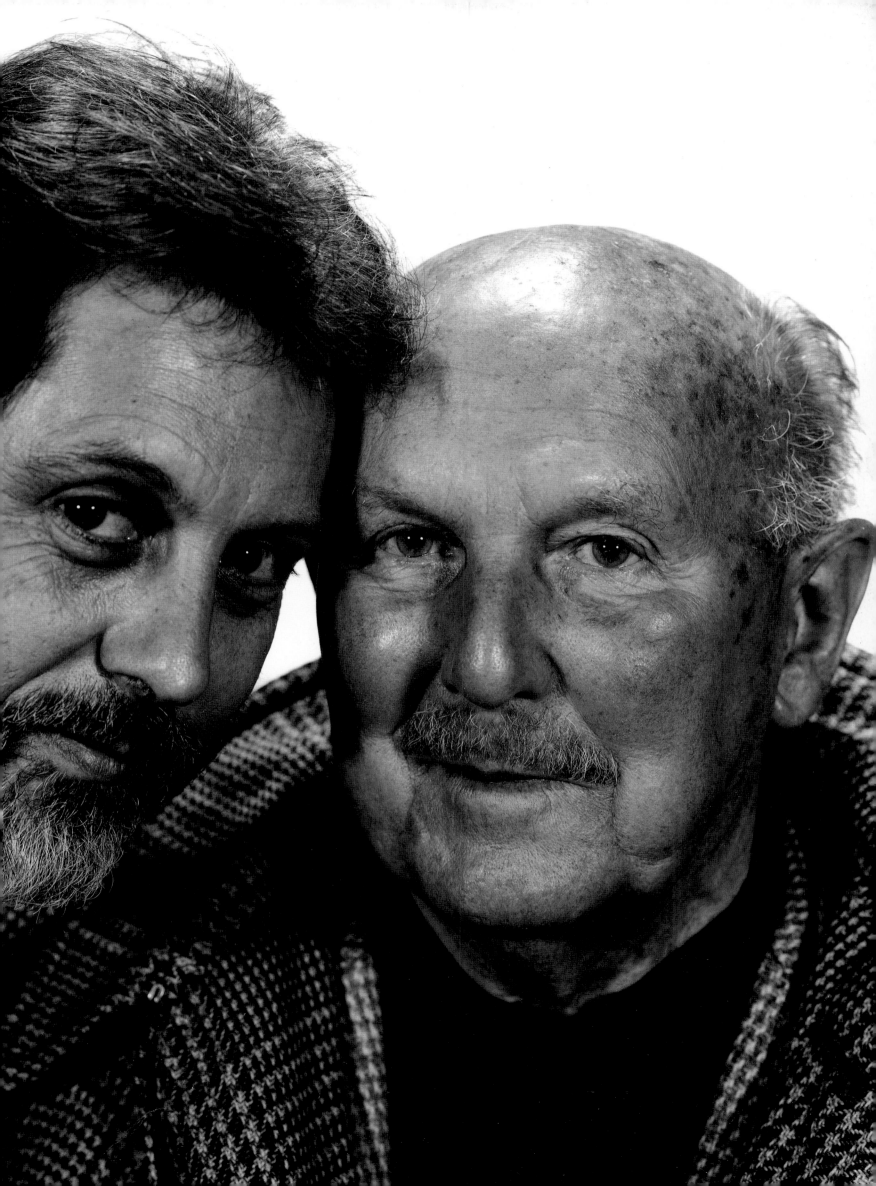

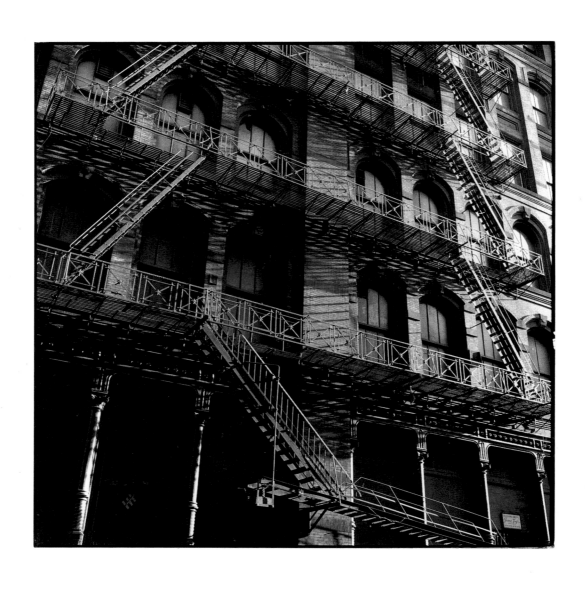

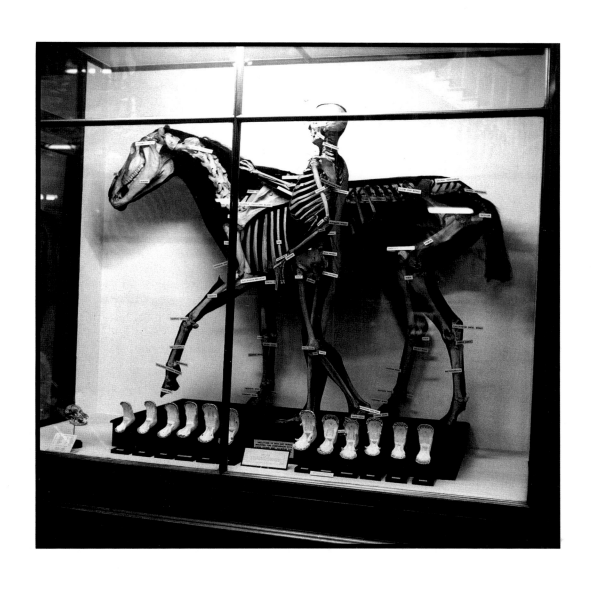

143

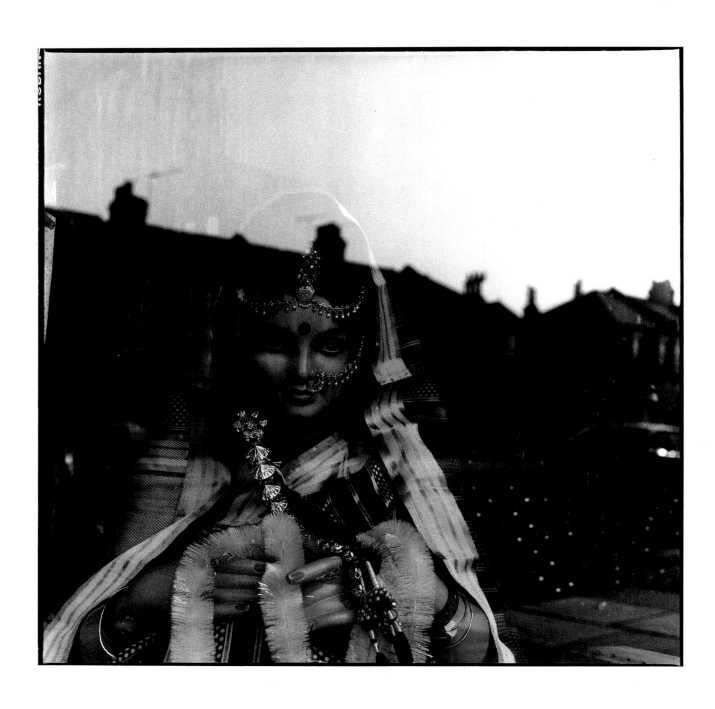

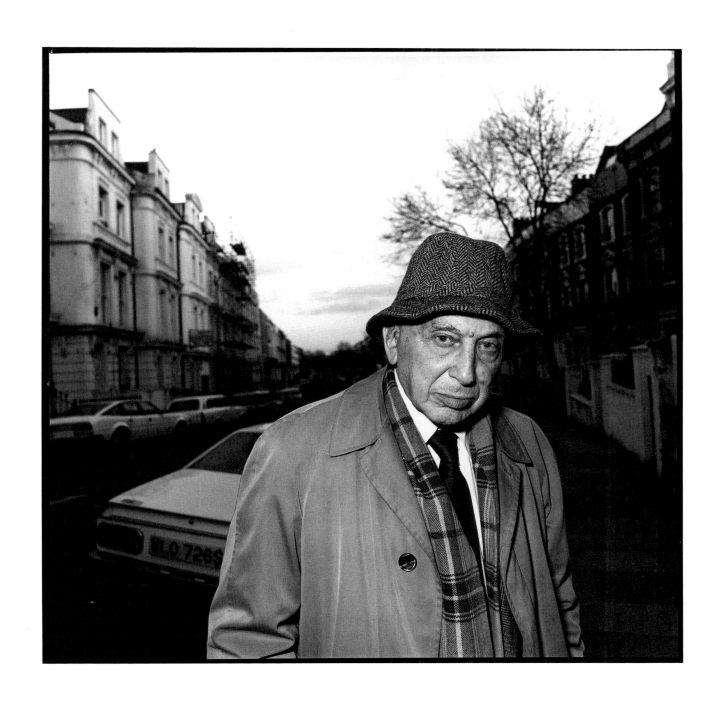

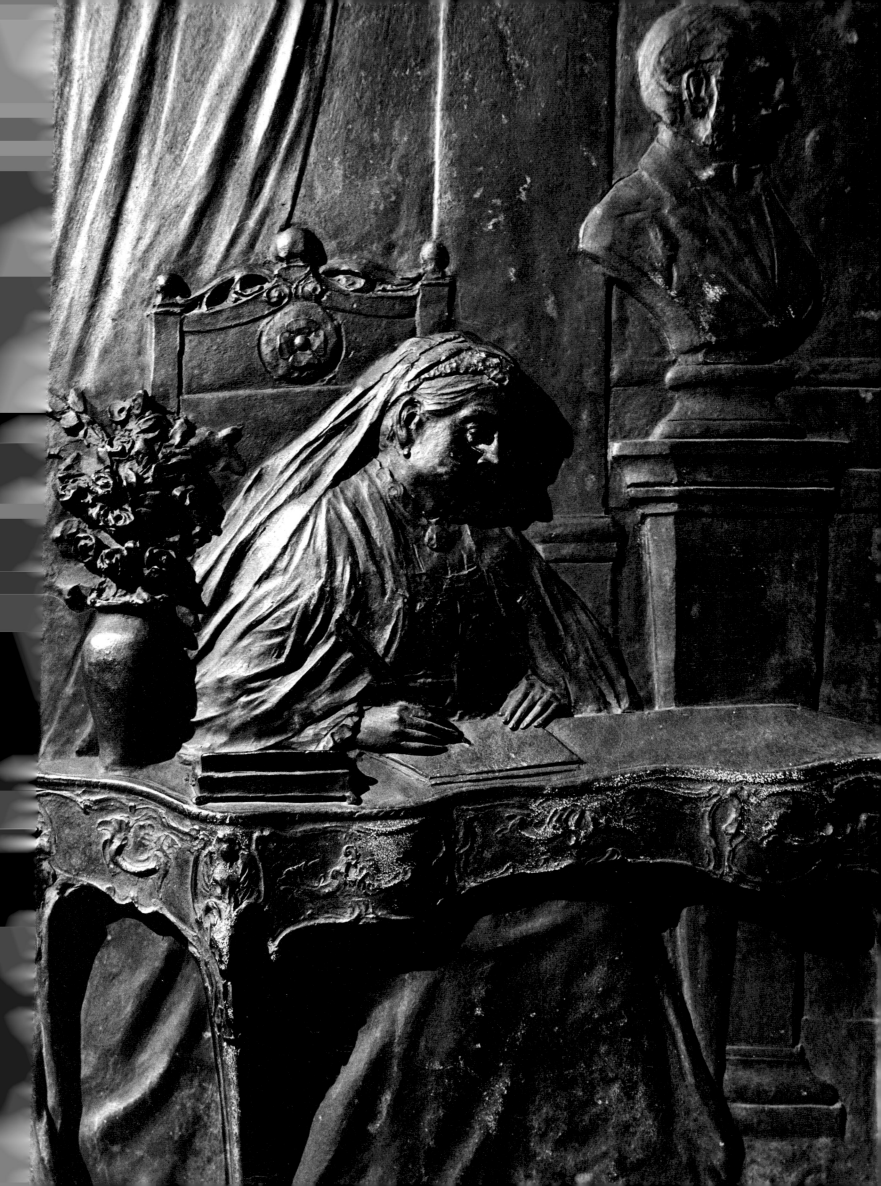

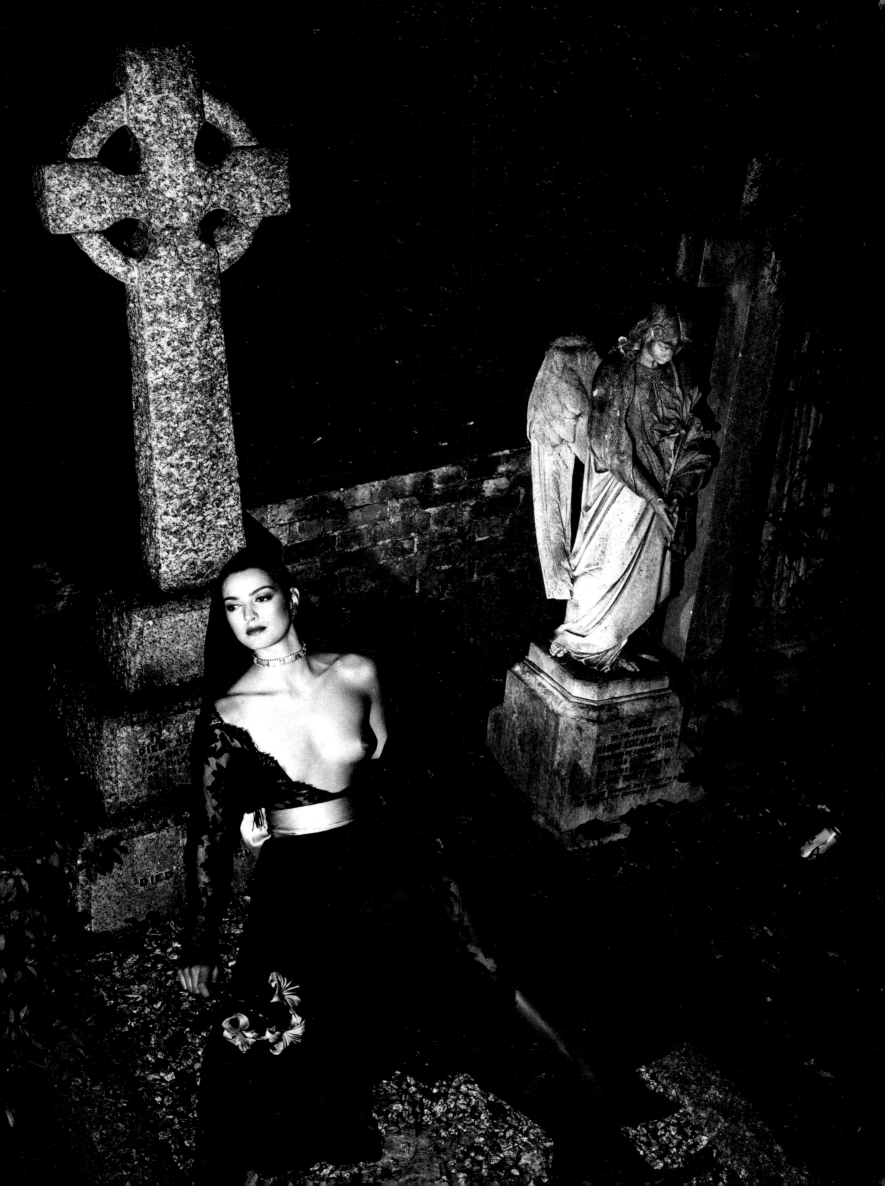

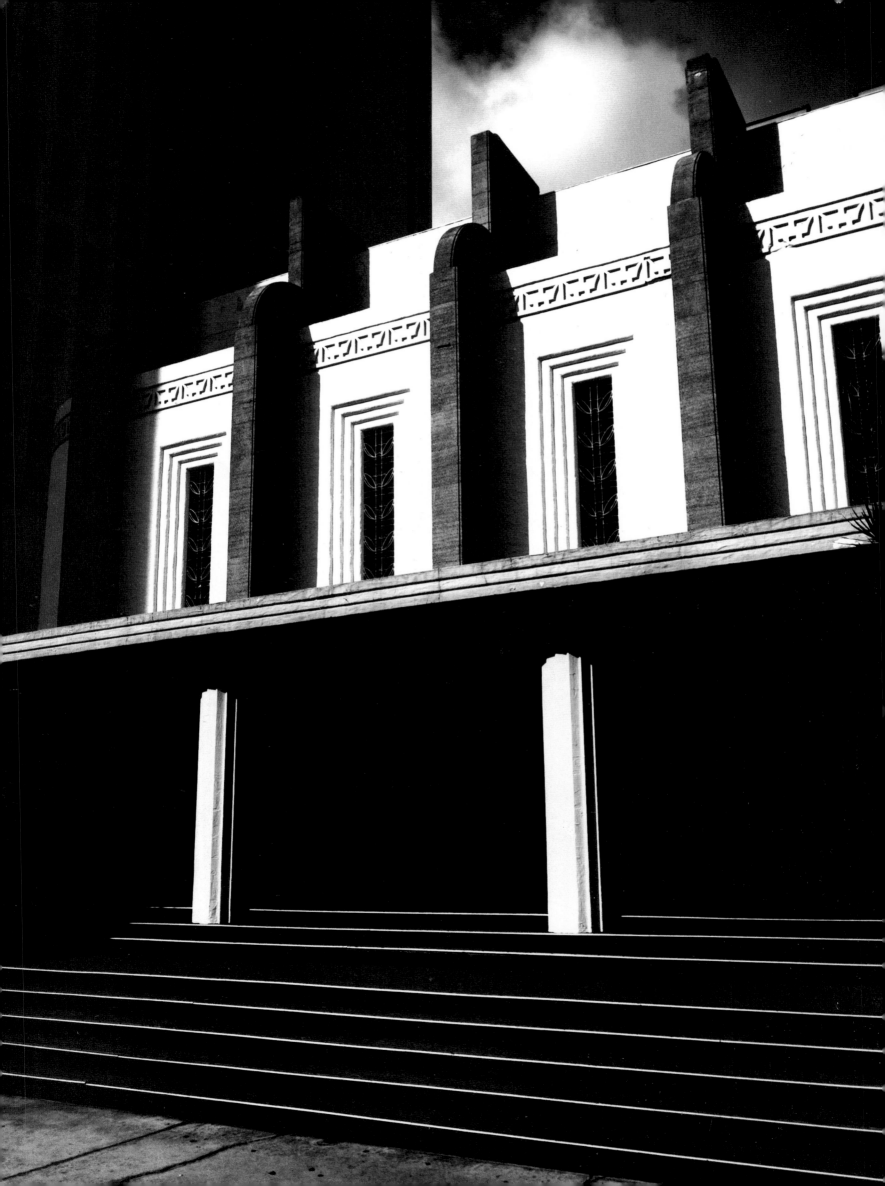

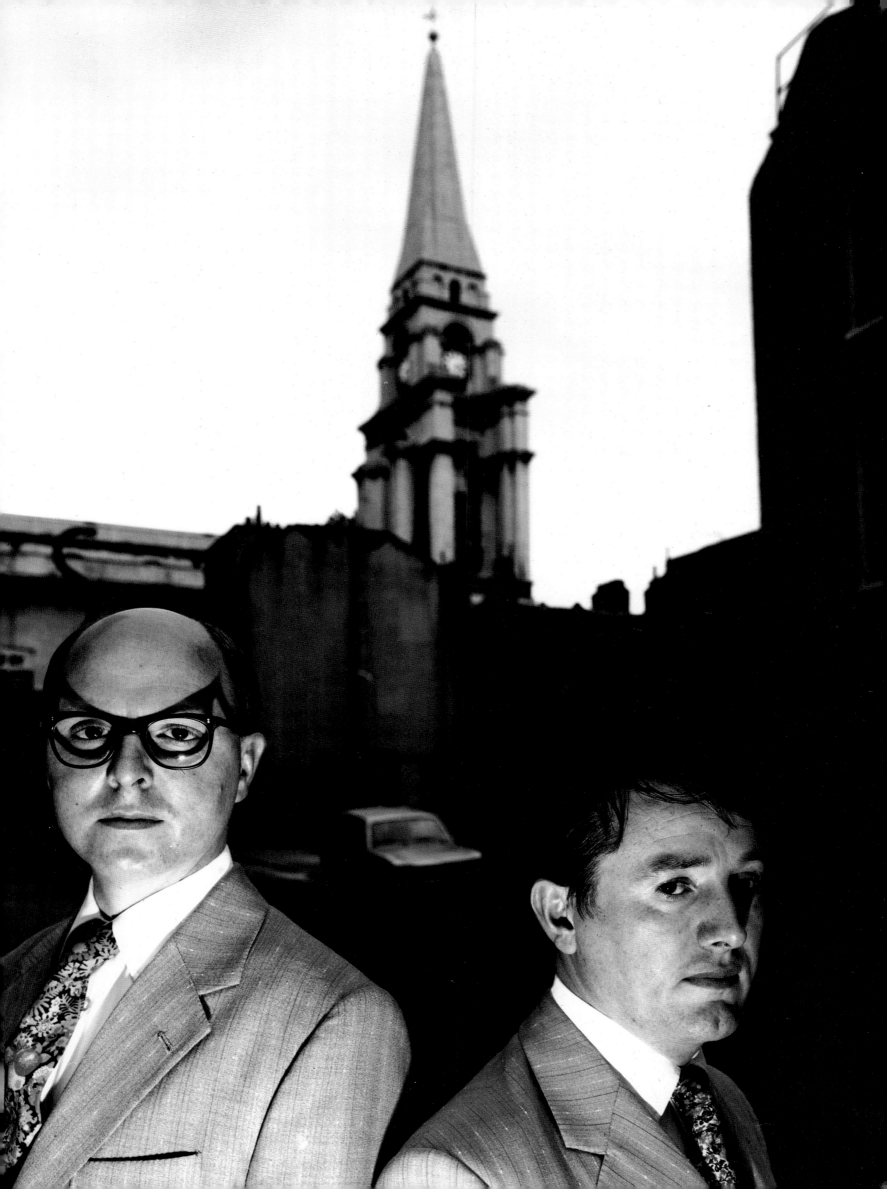

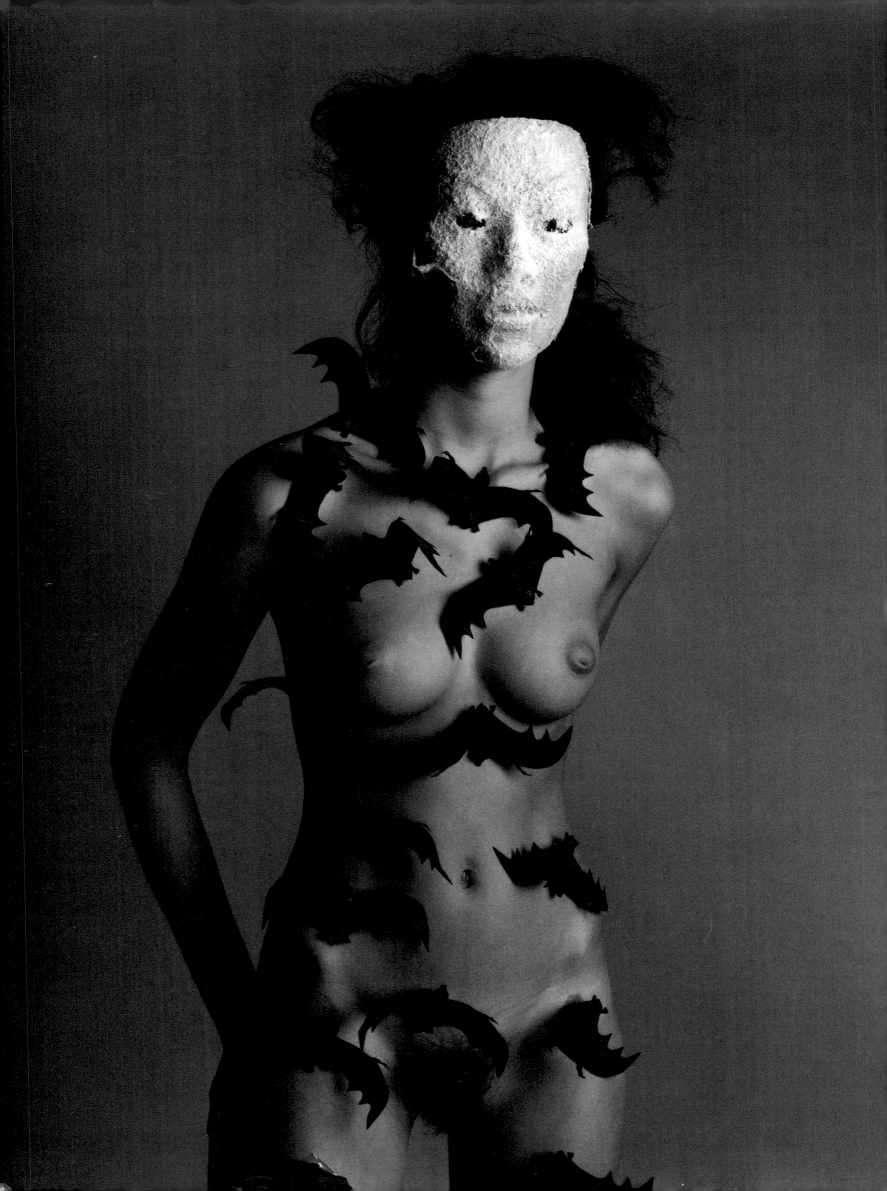

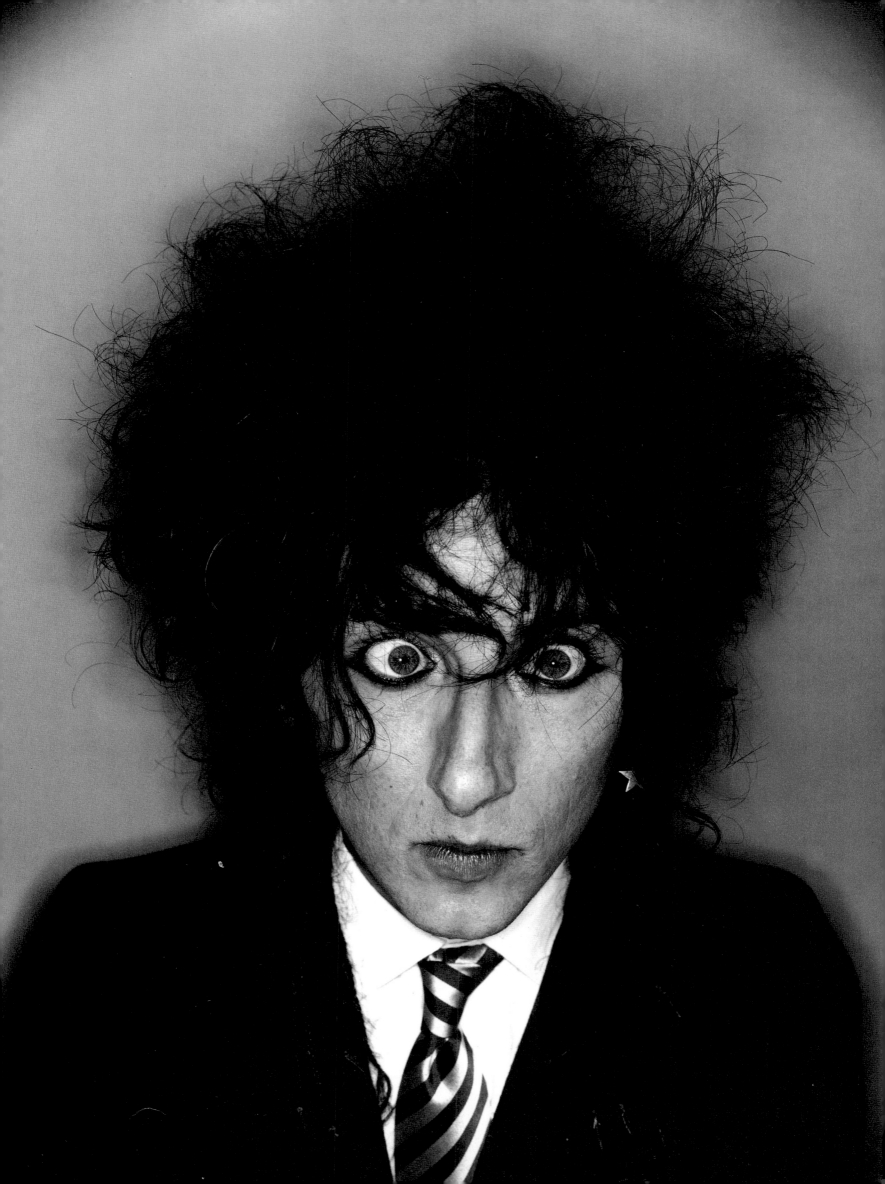

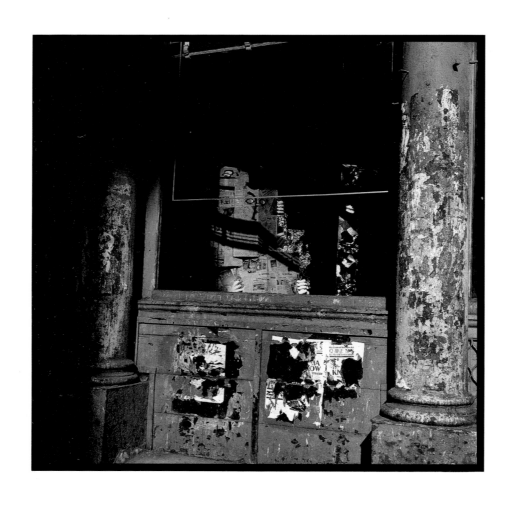

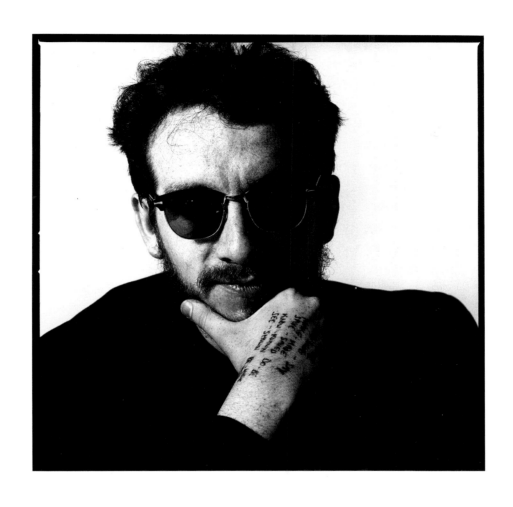

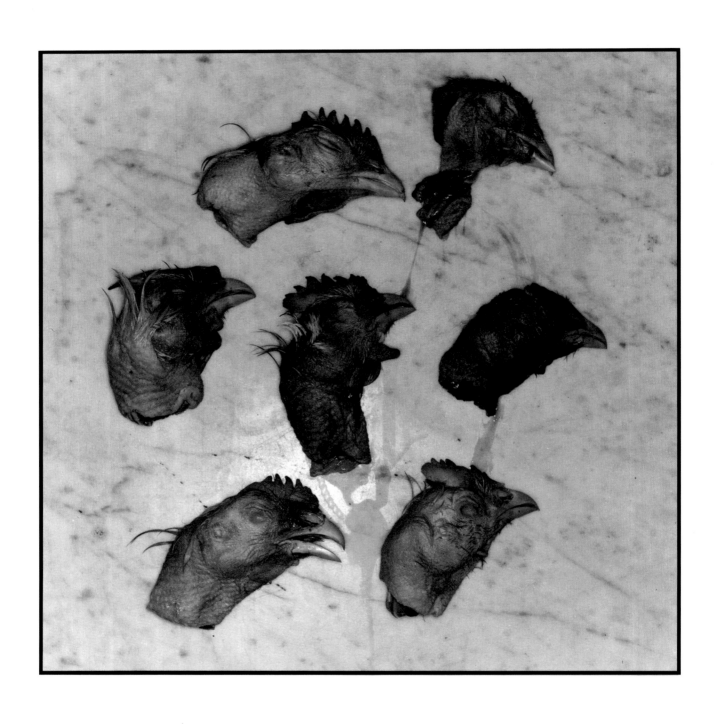

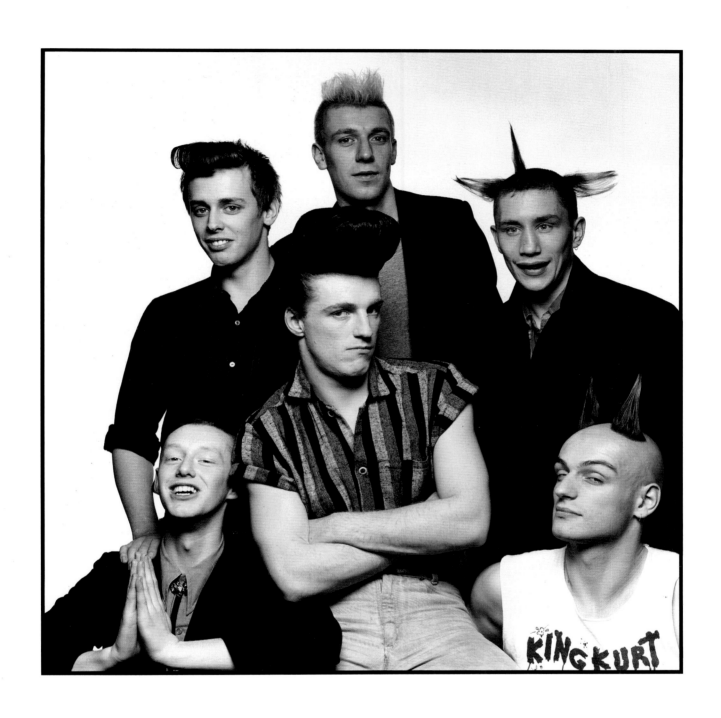

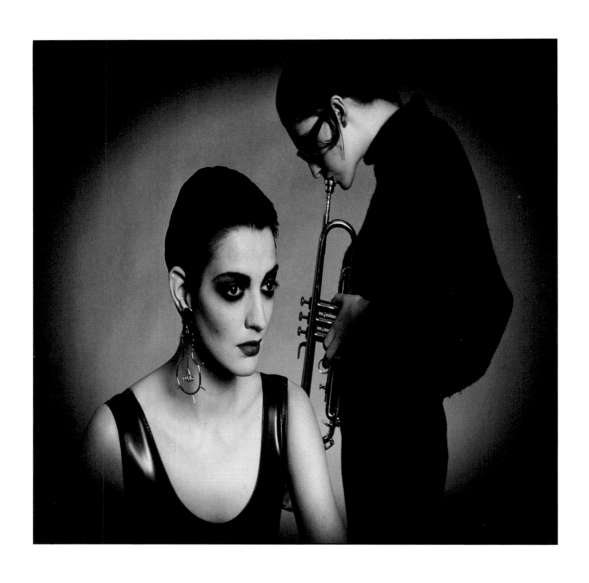

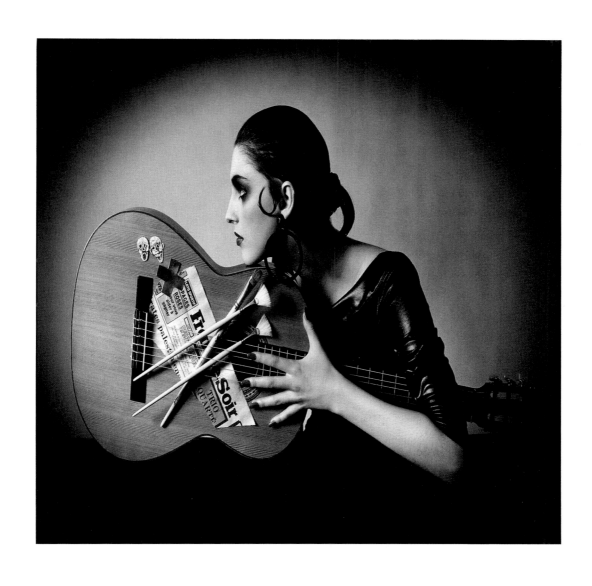

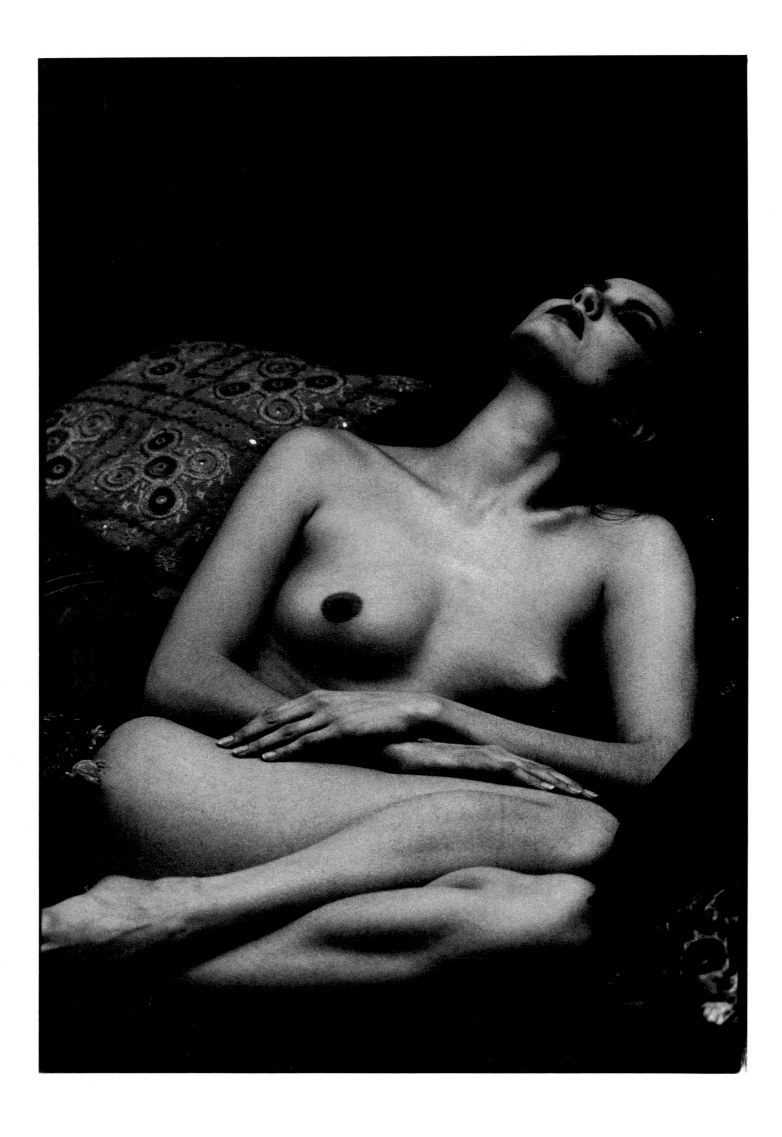

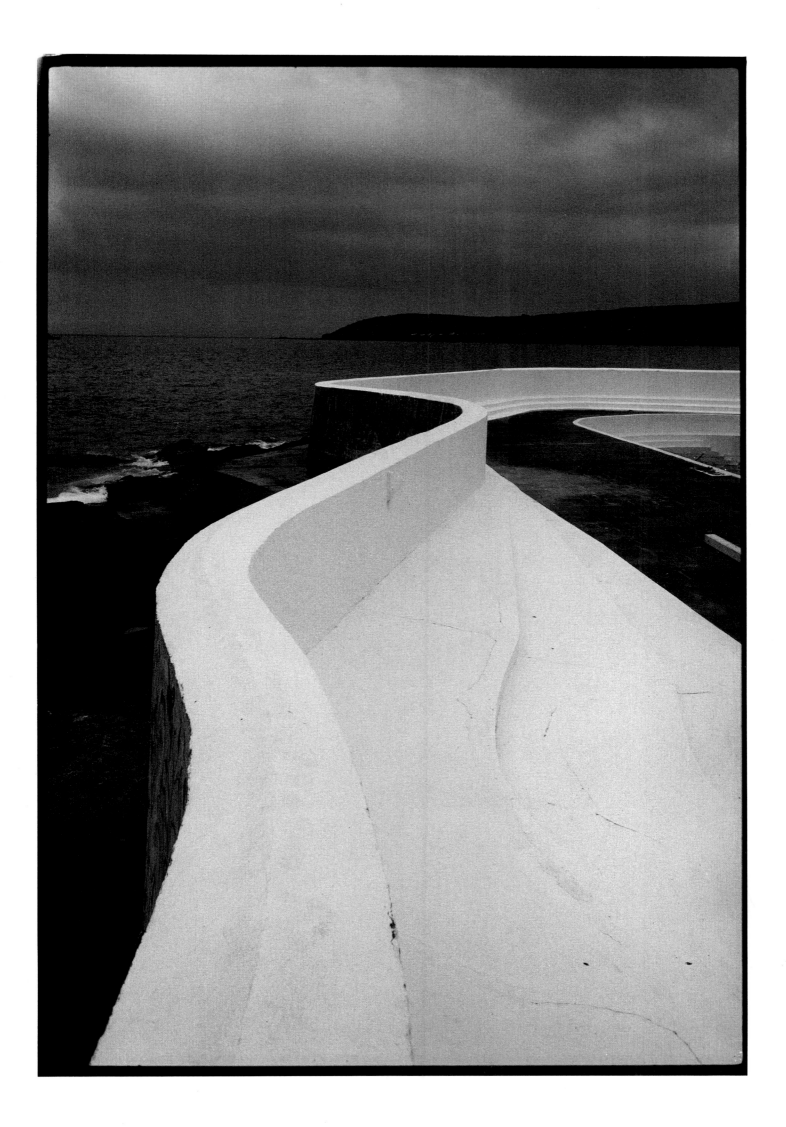

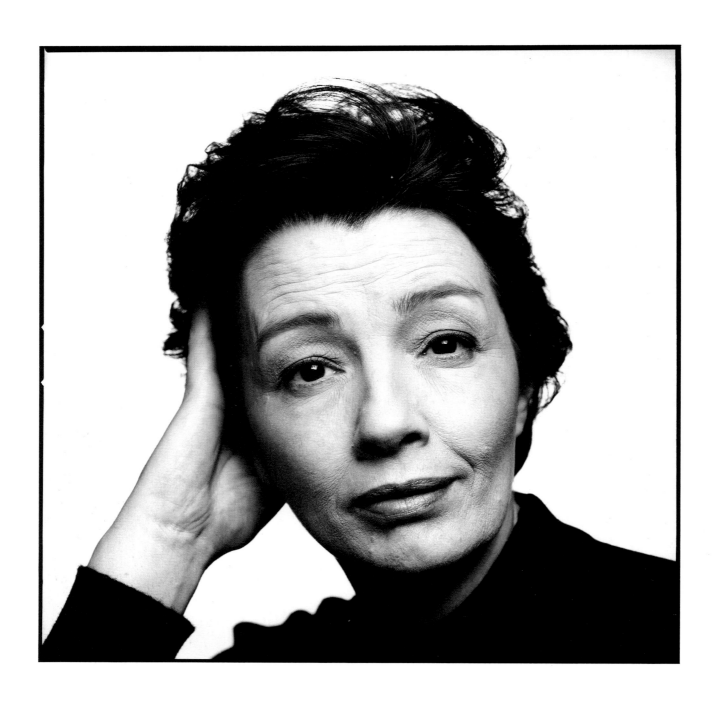

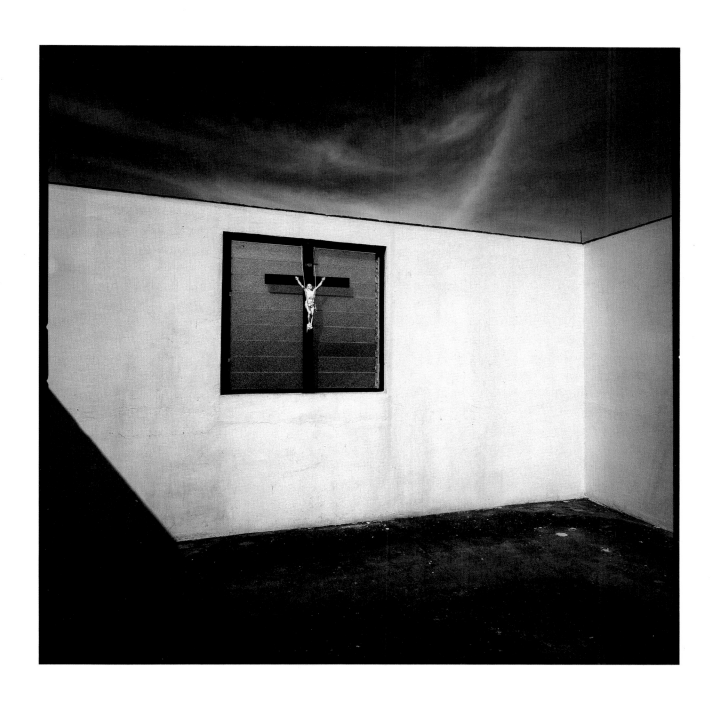

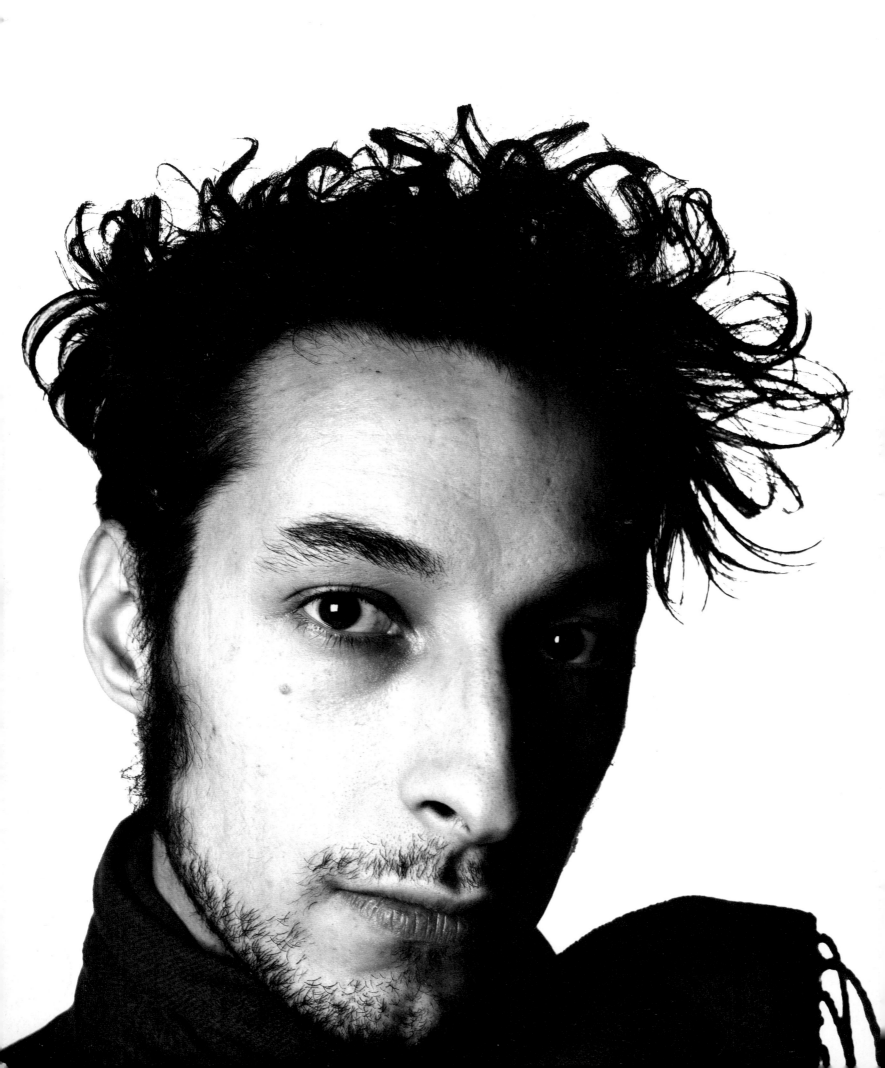

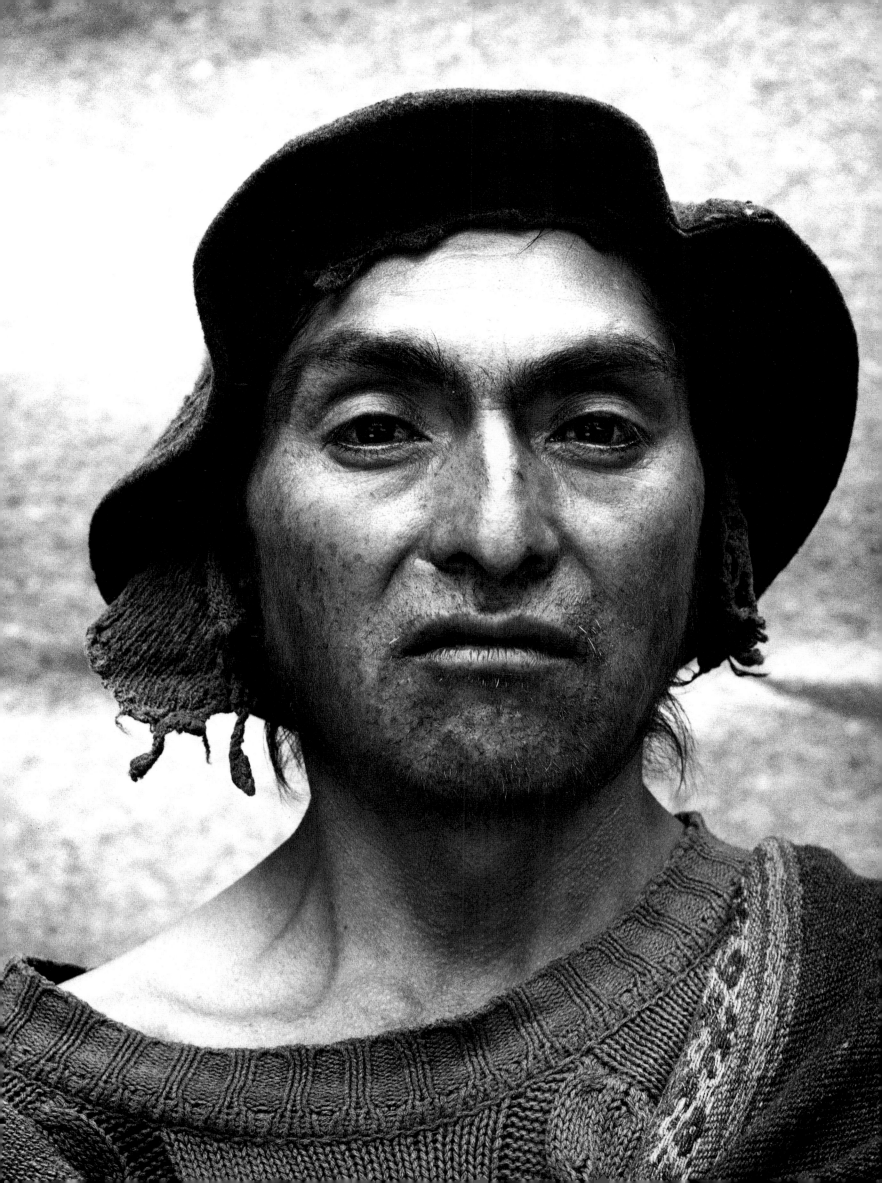

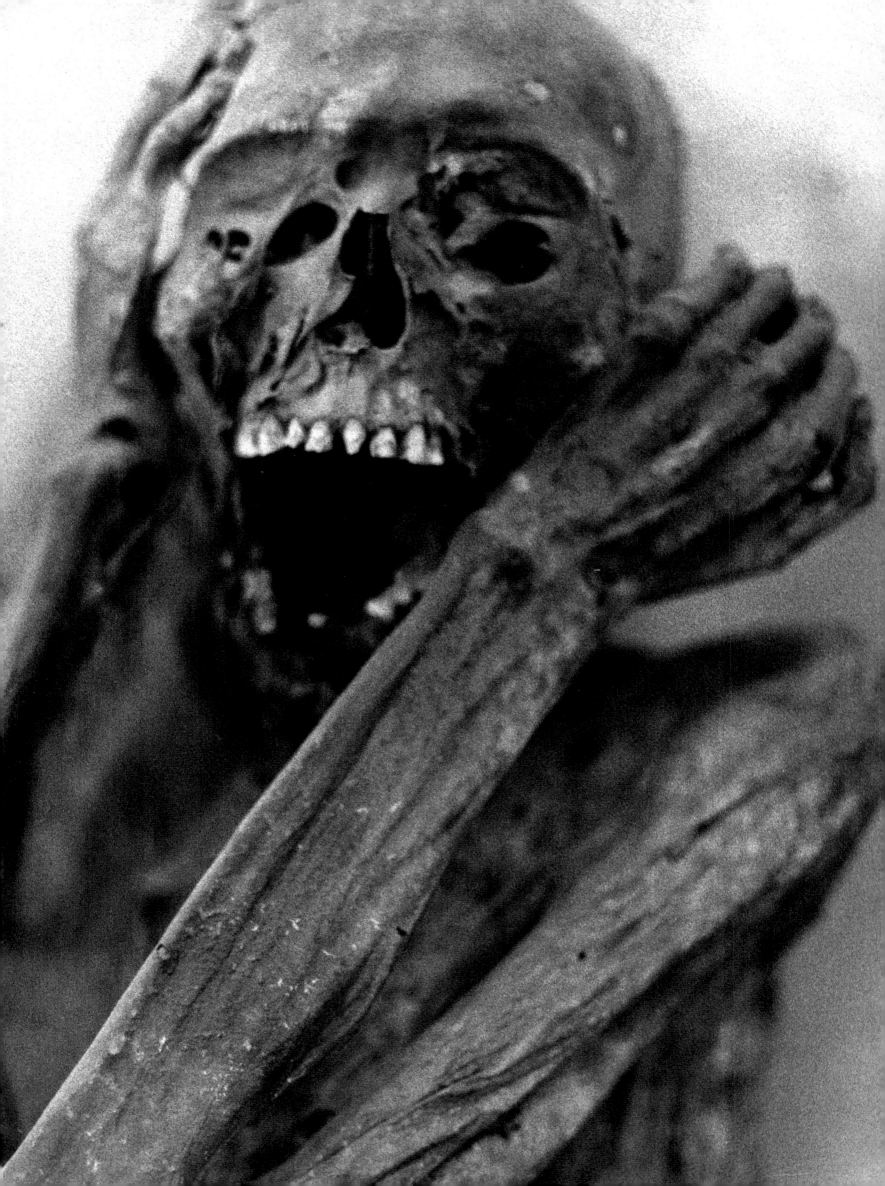

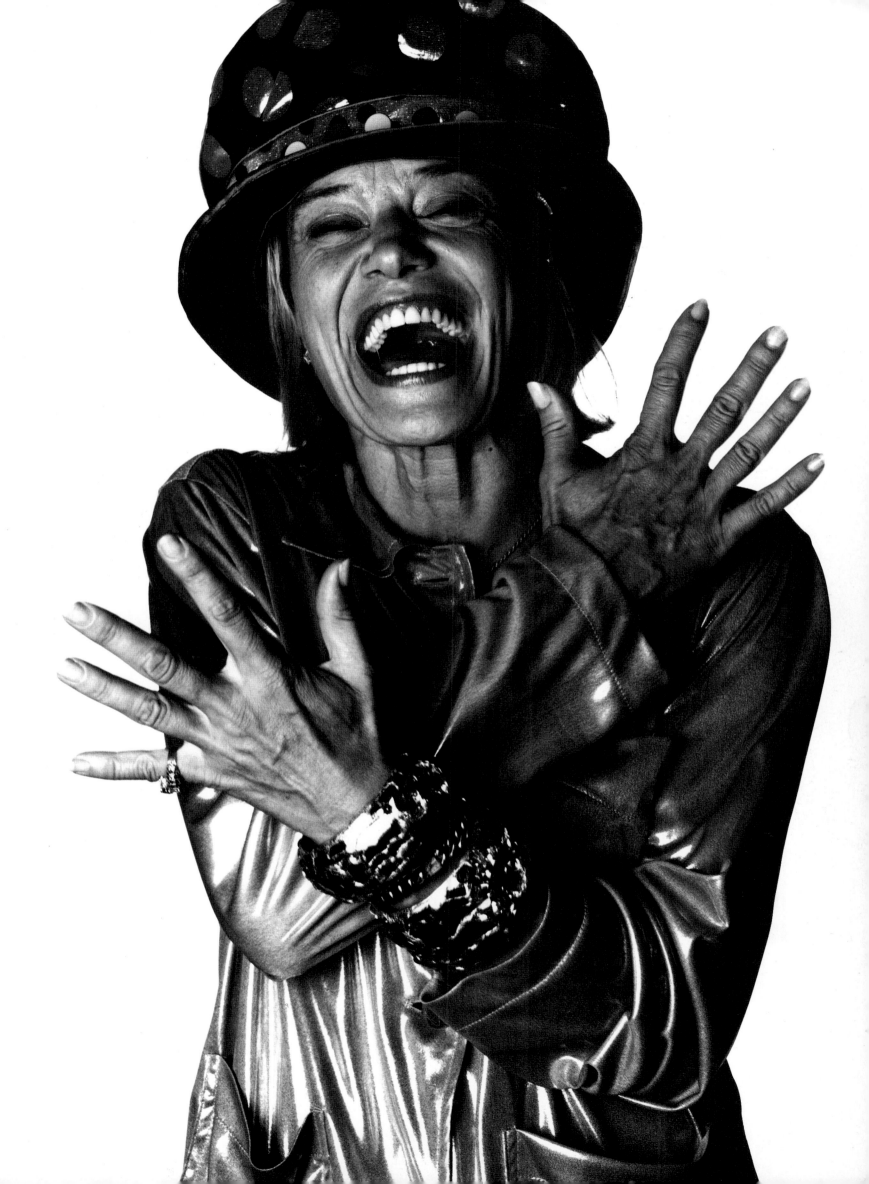

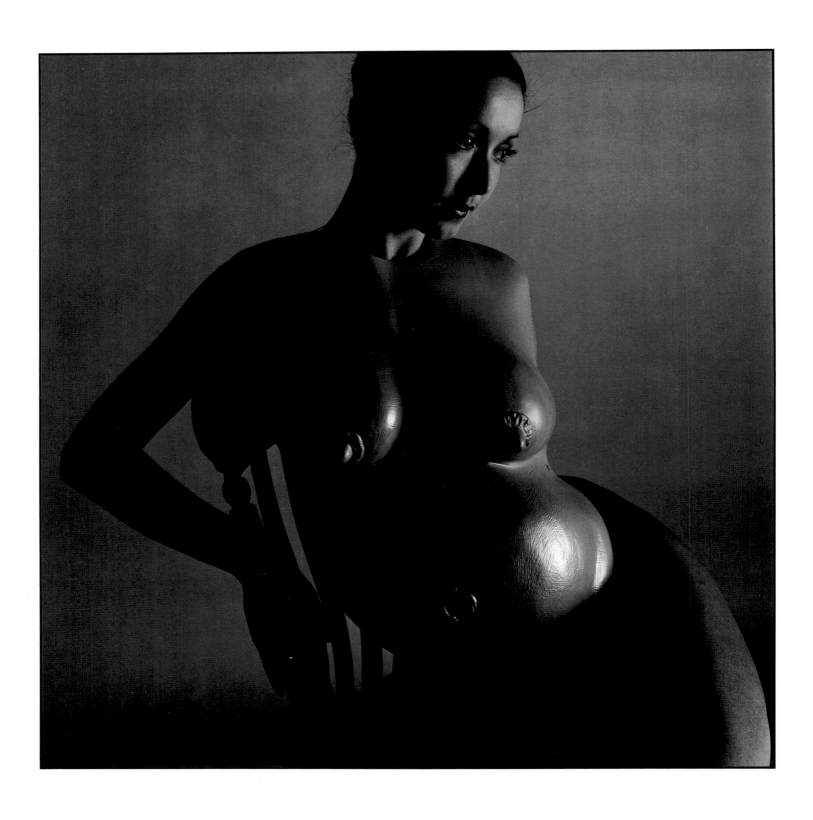

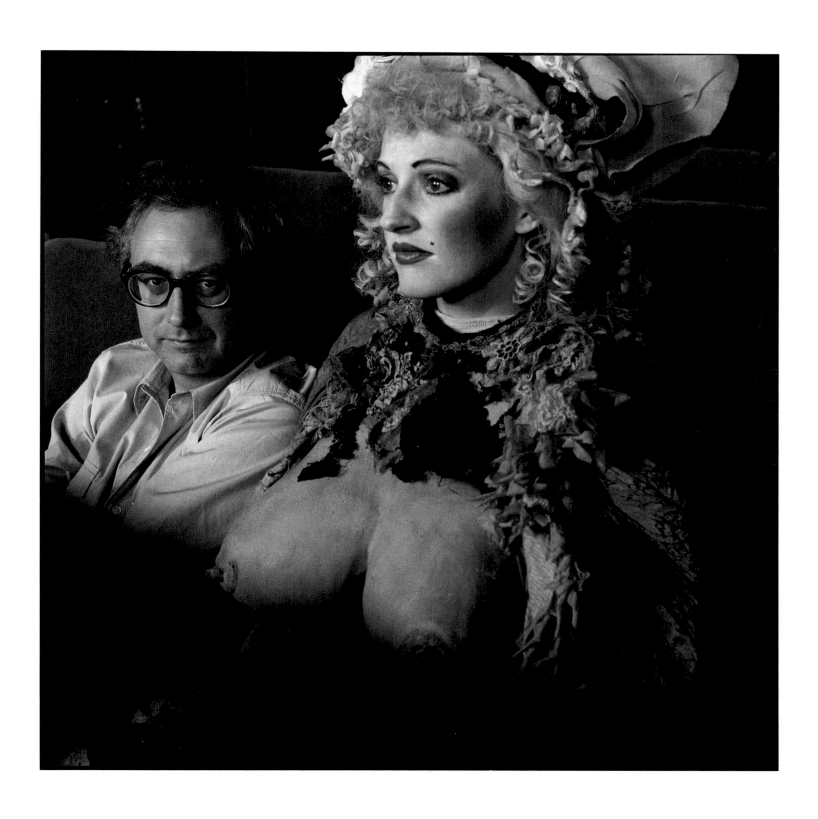

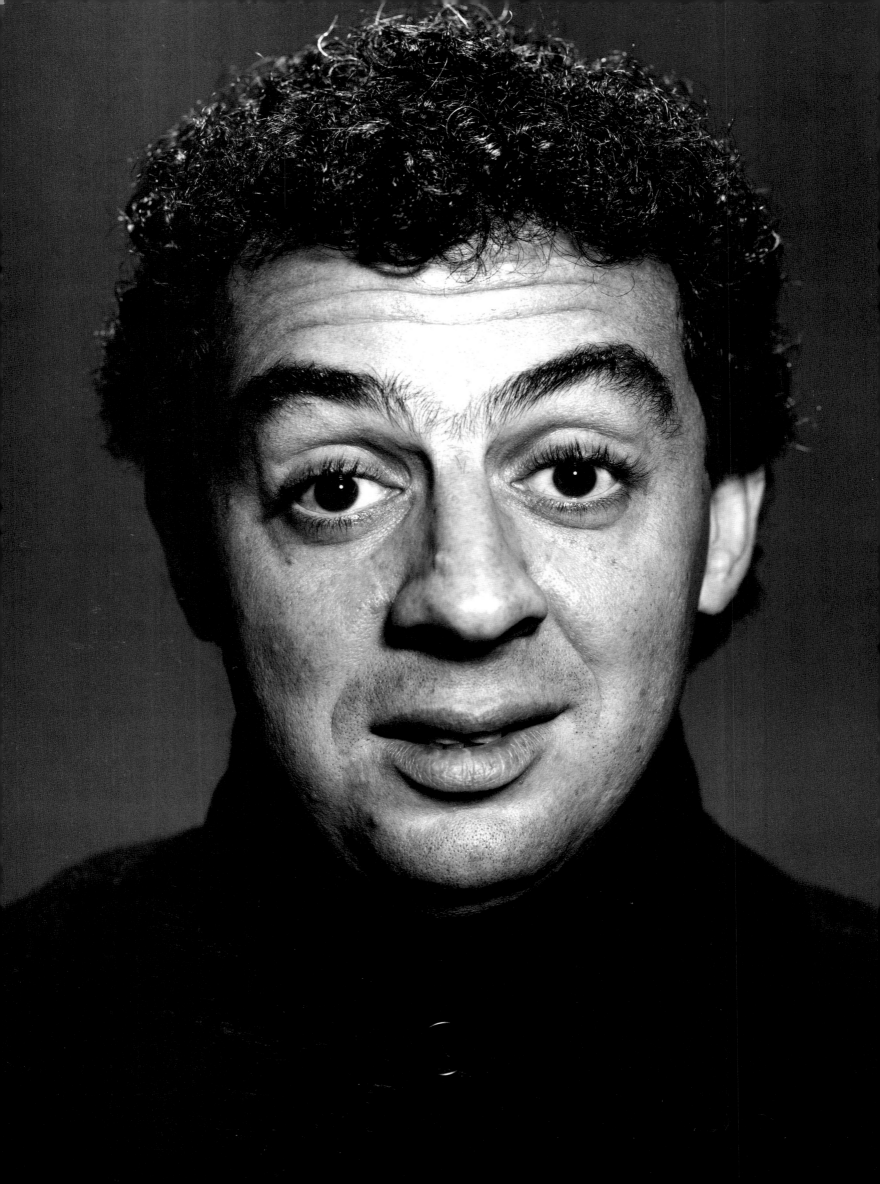

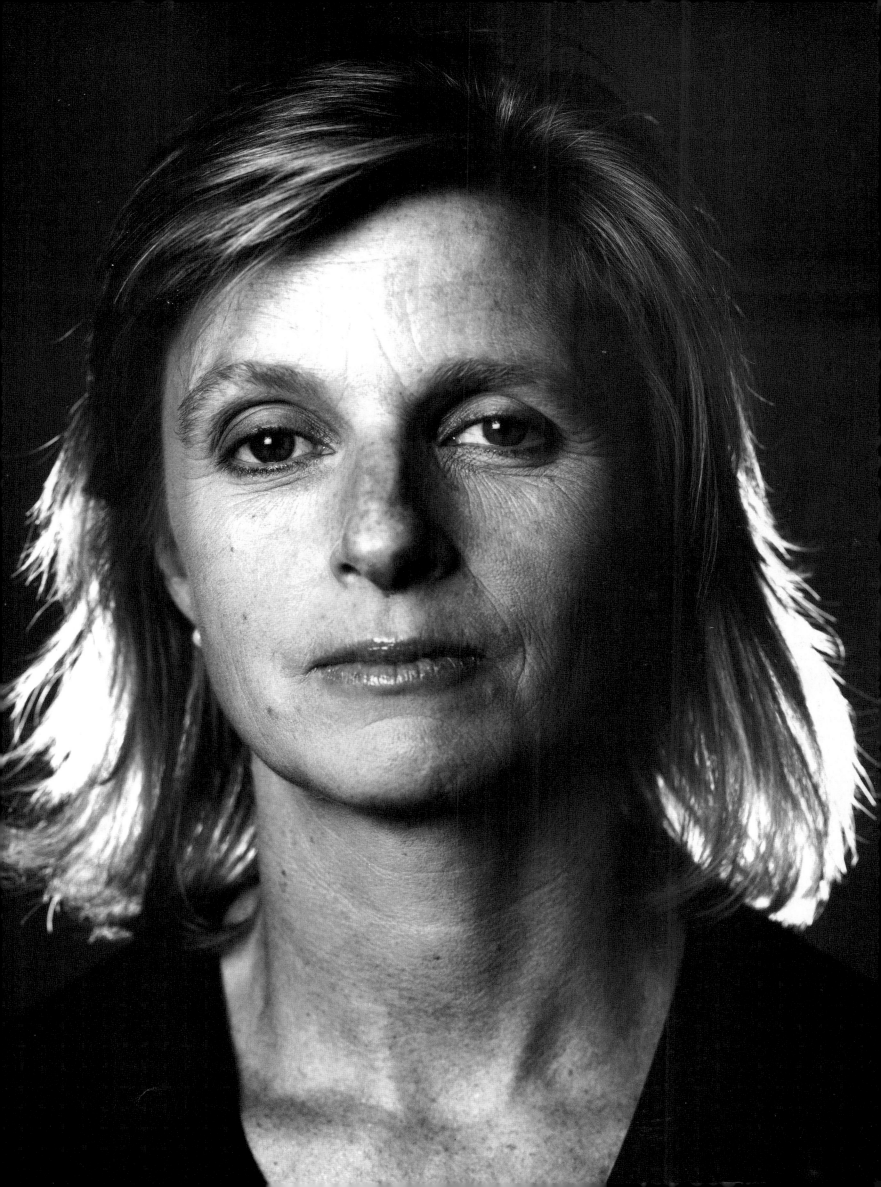

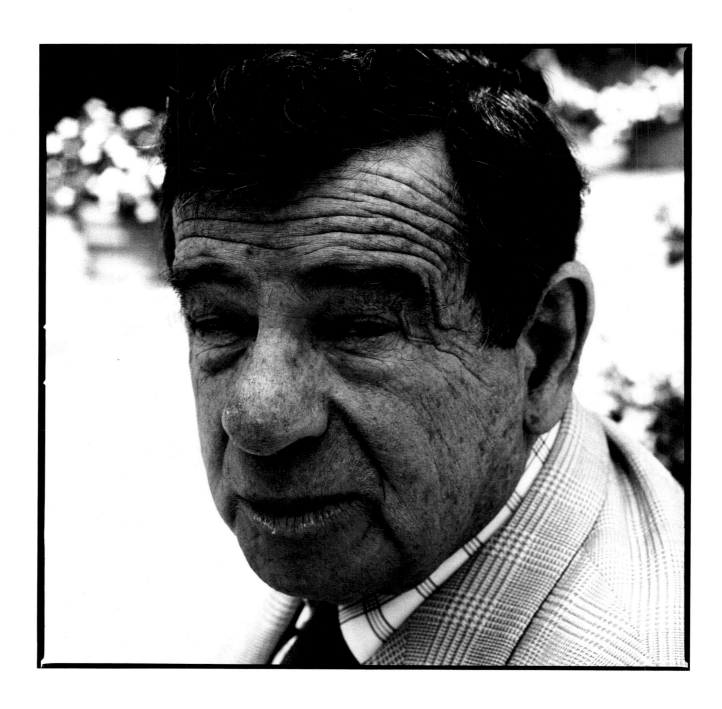

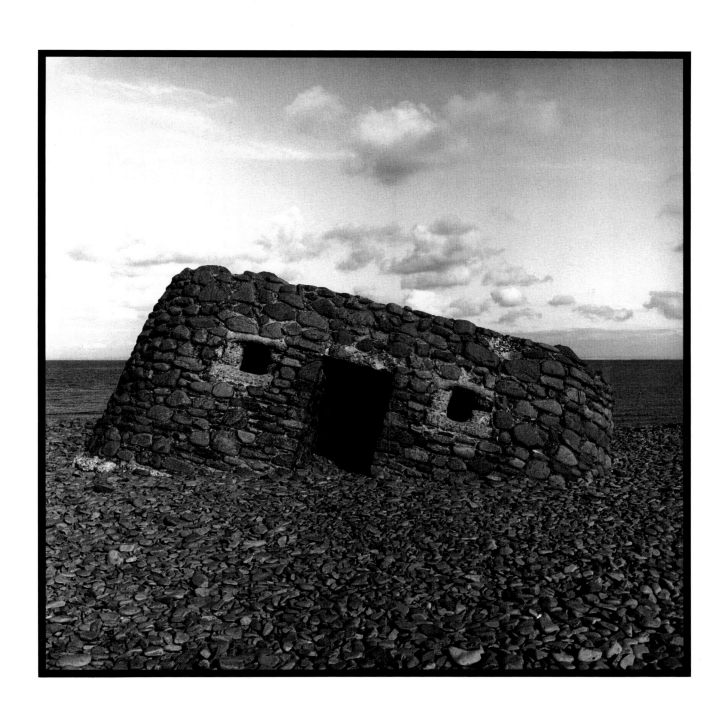

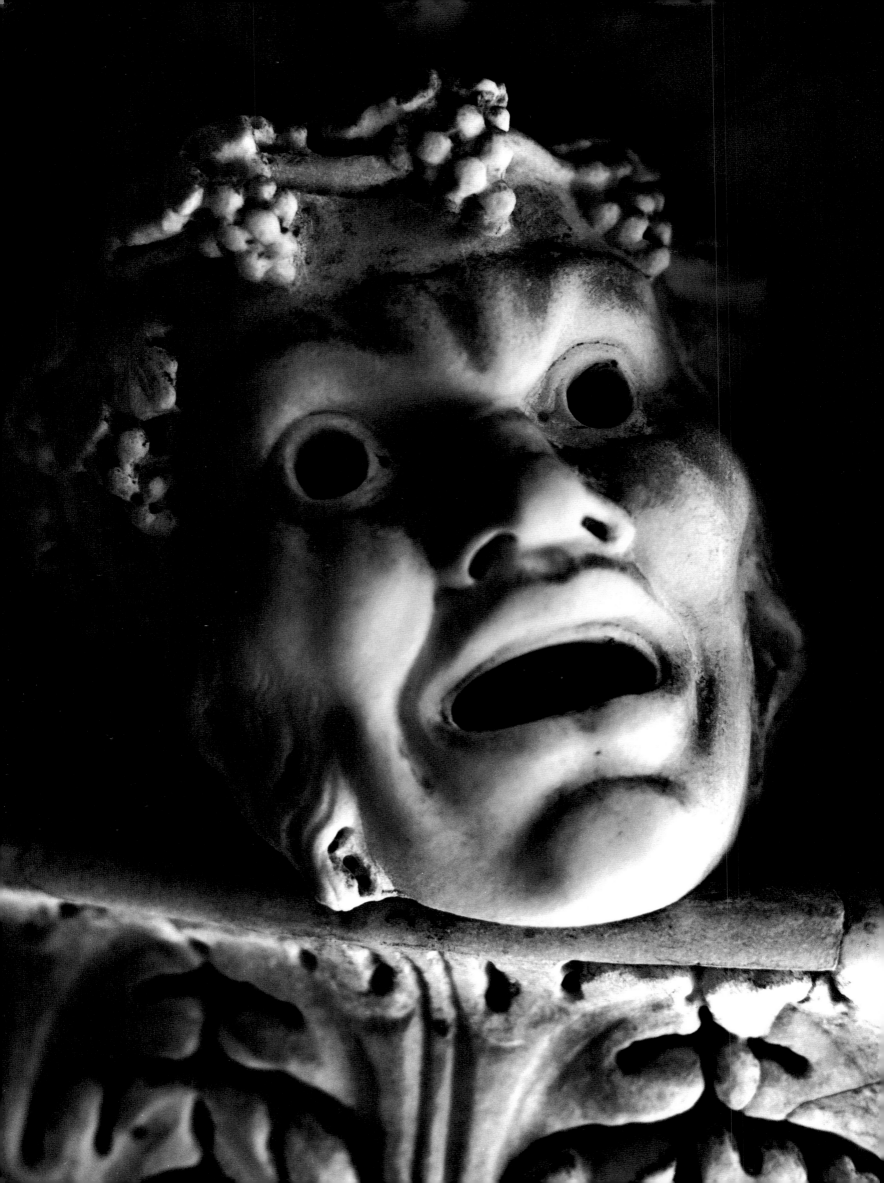

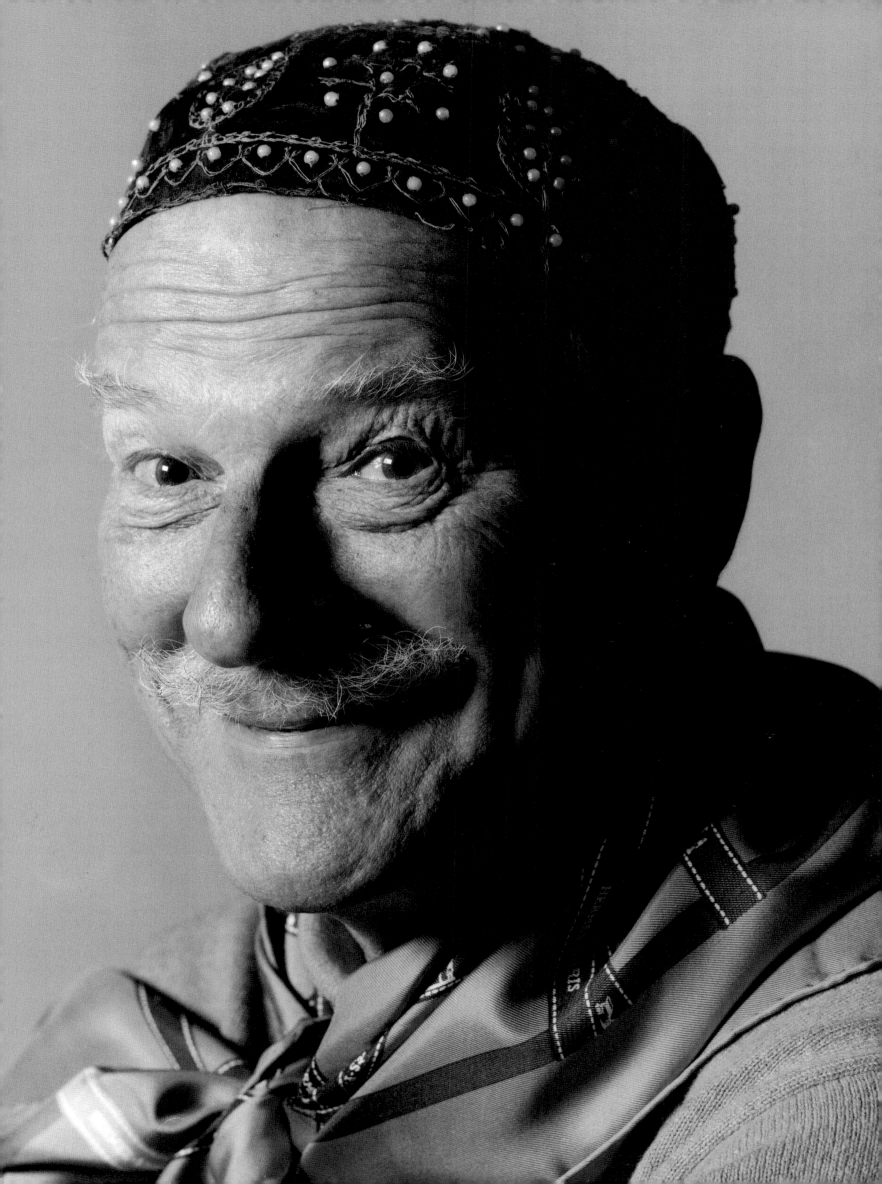

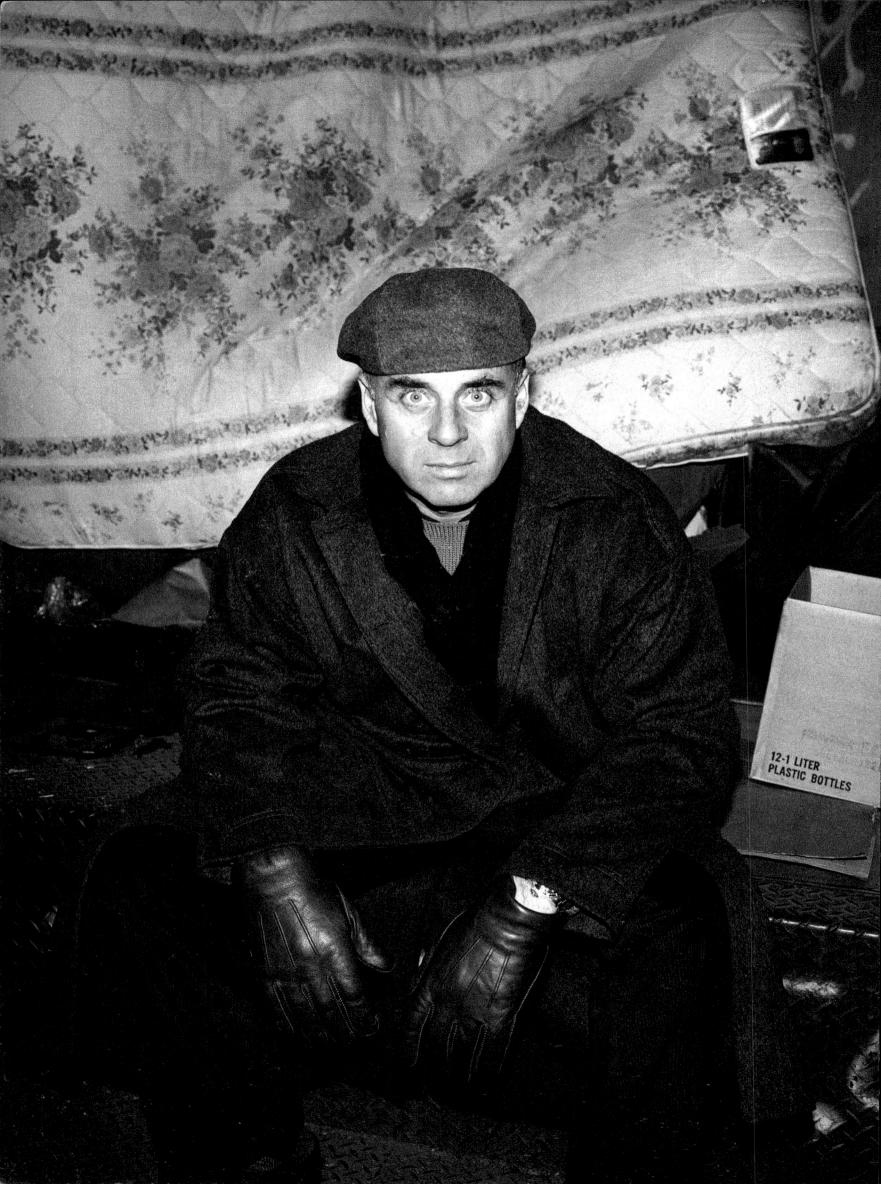

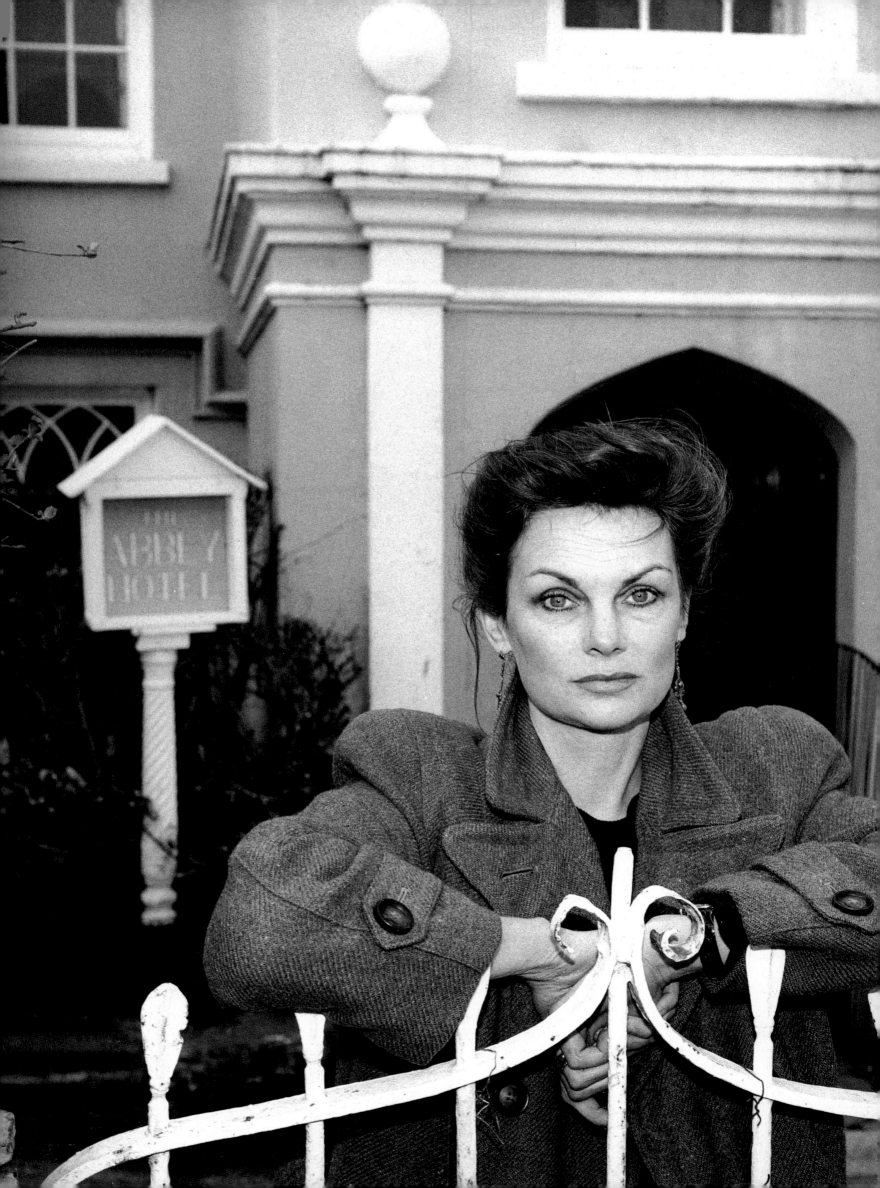

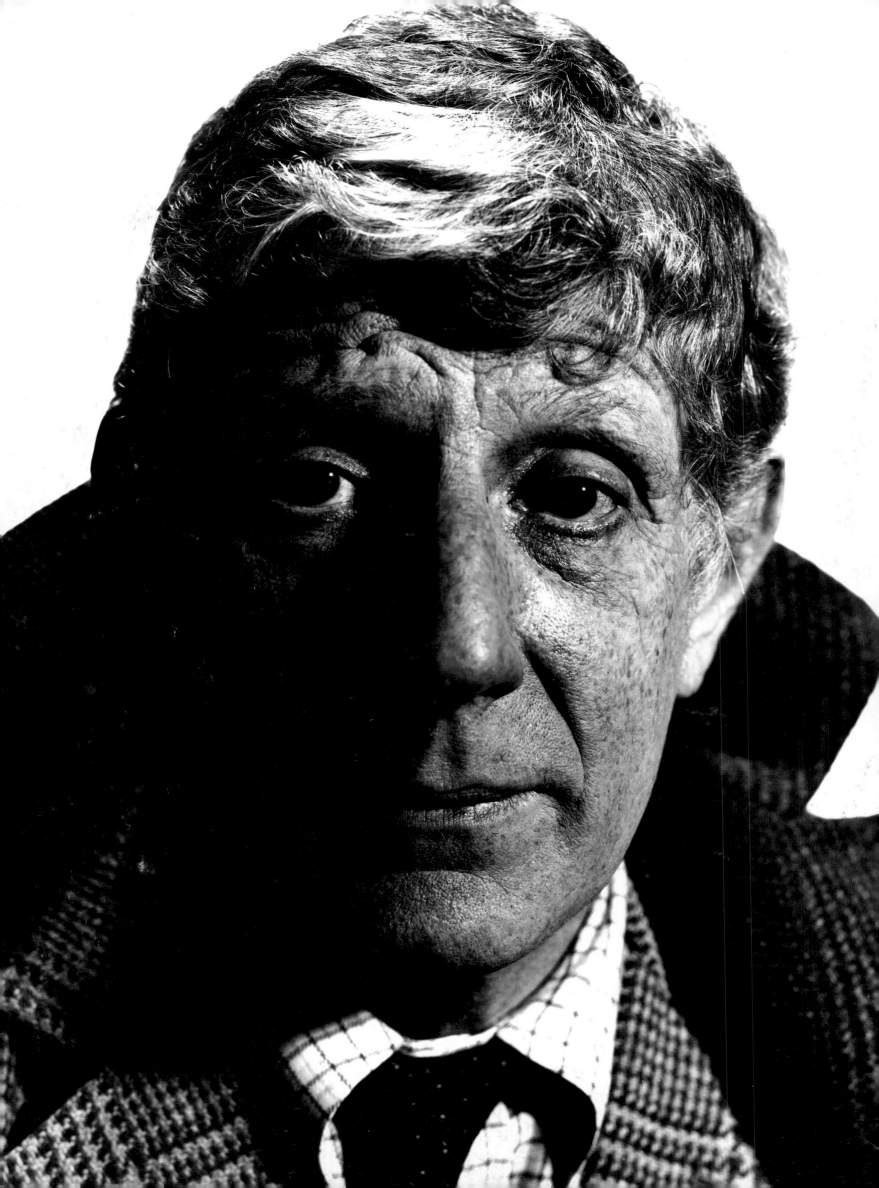

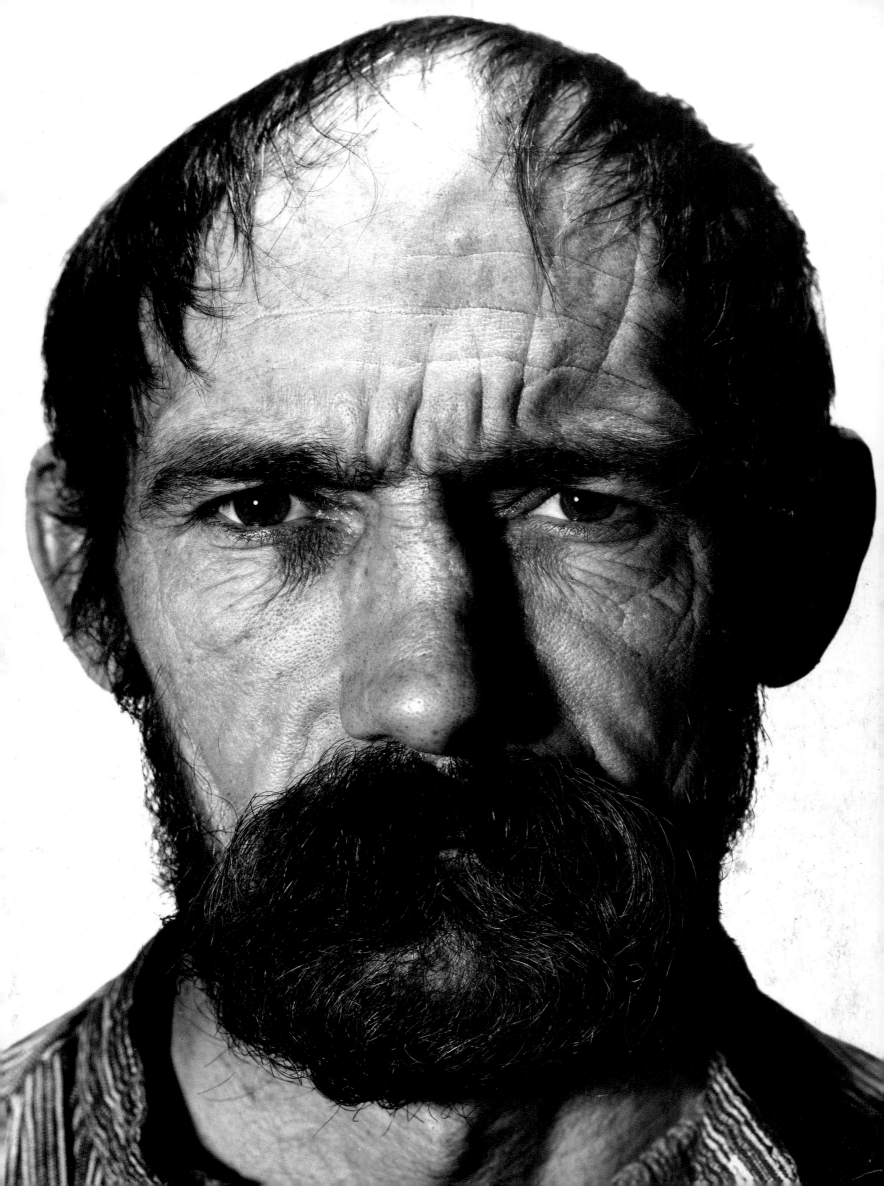

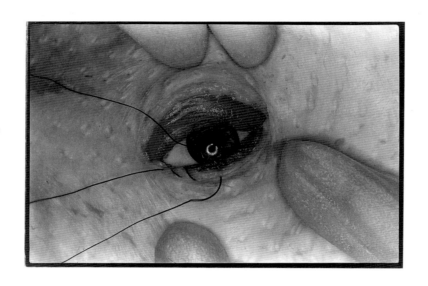

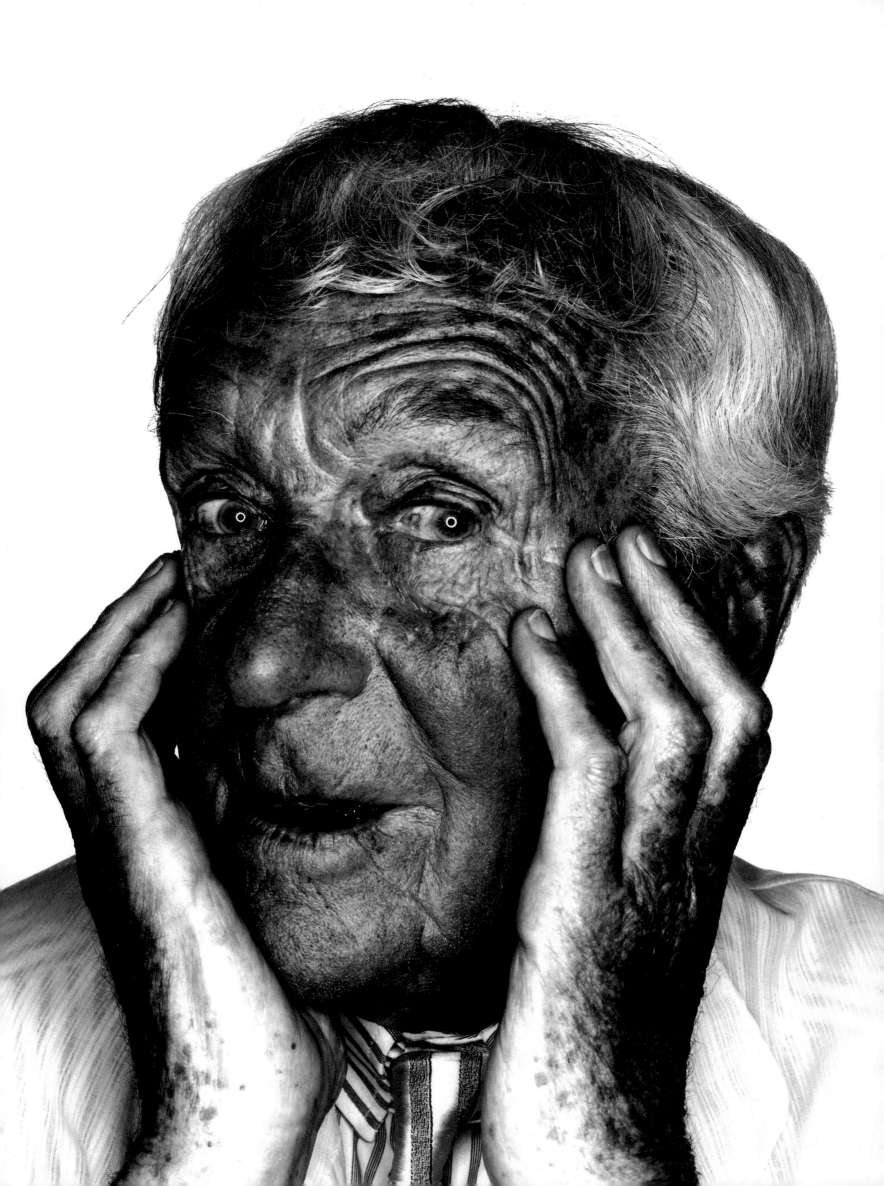

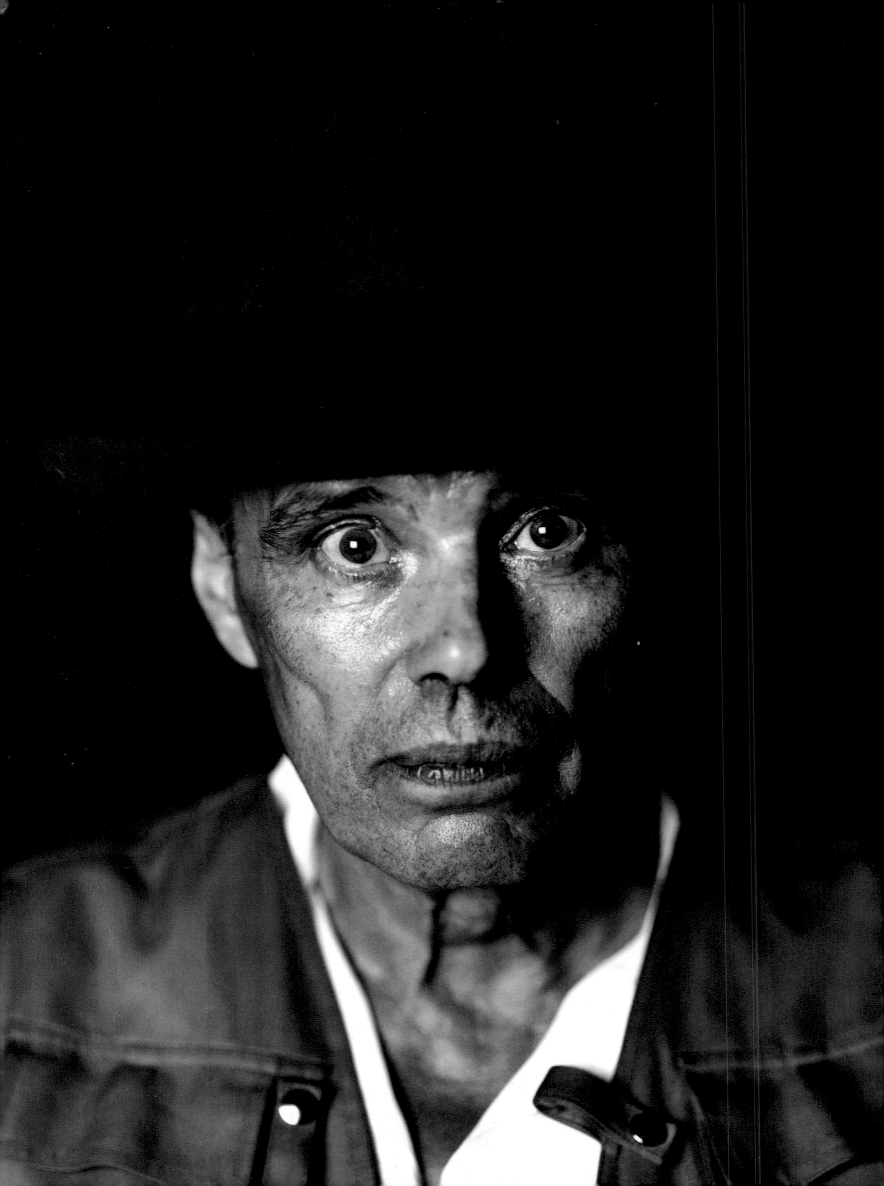

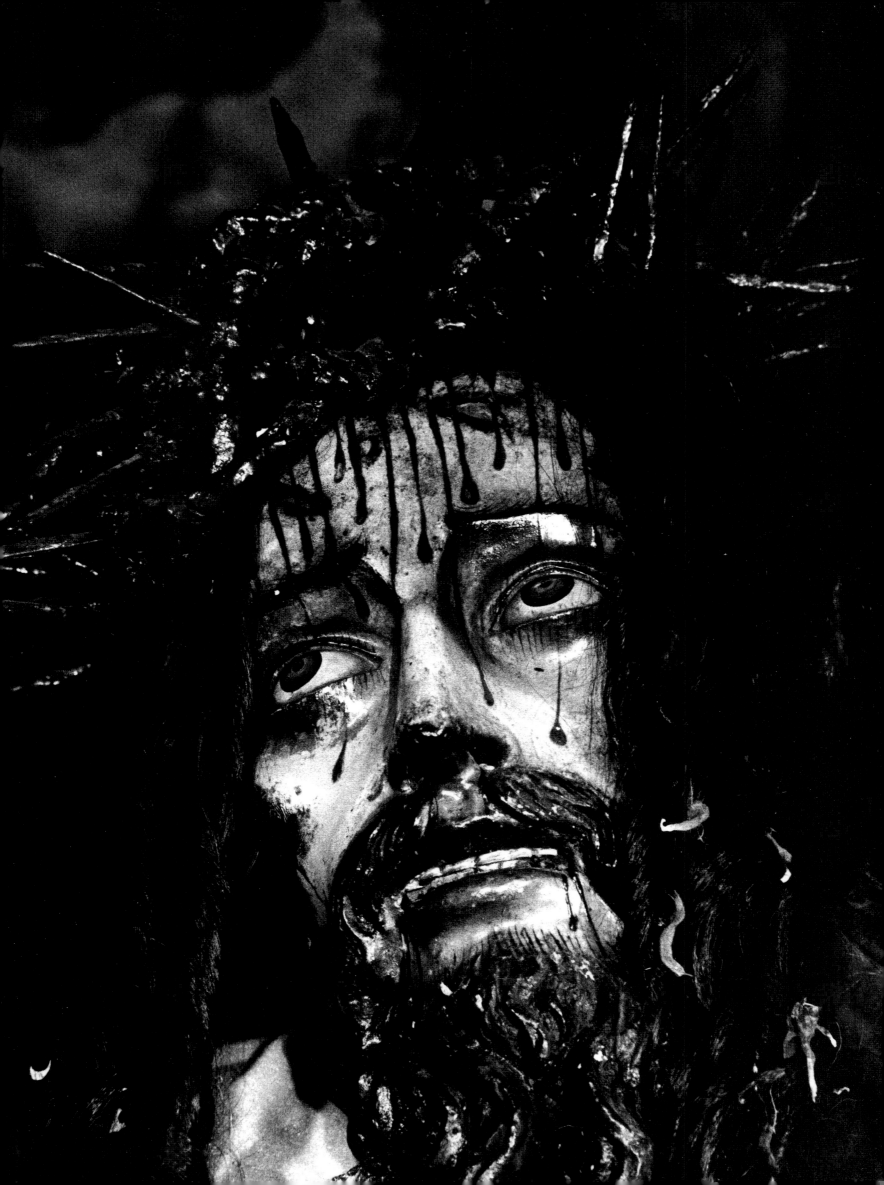

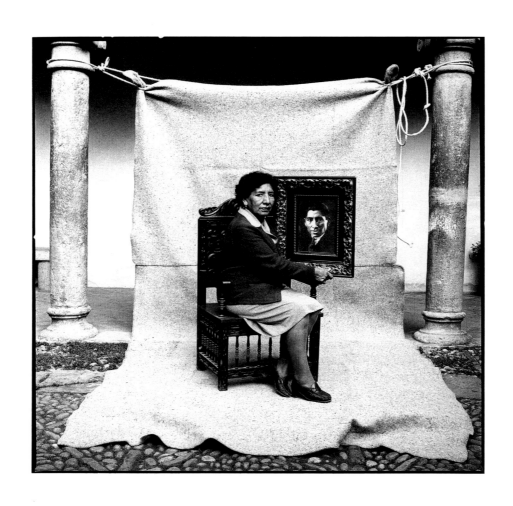

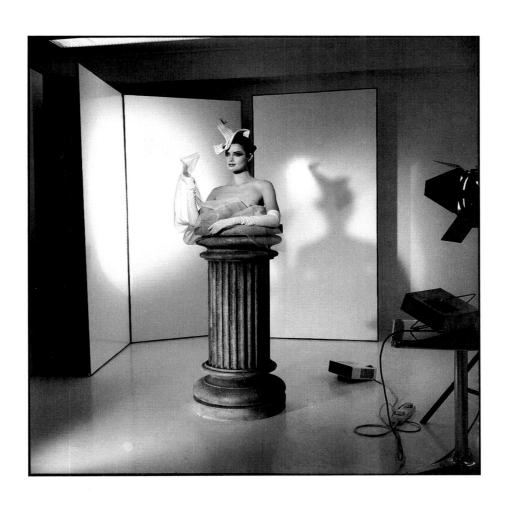

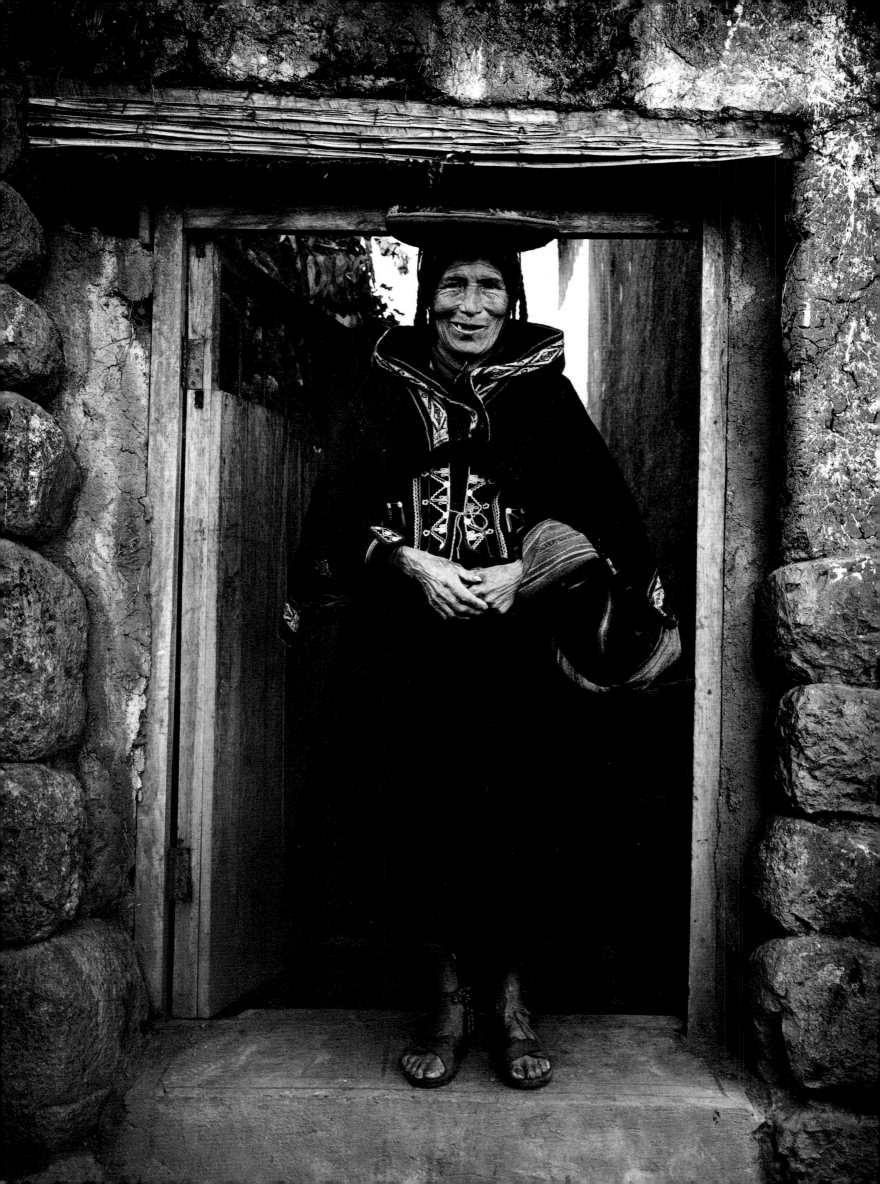

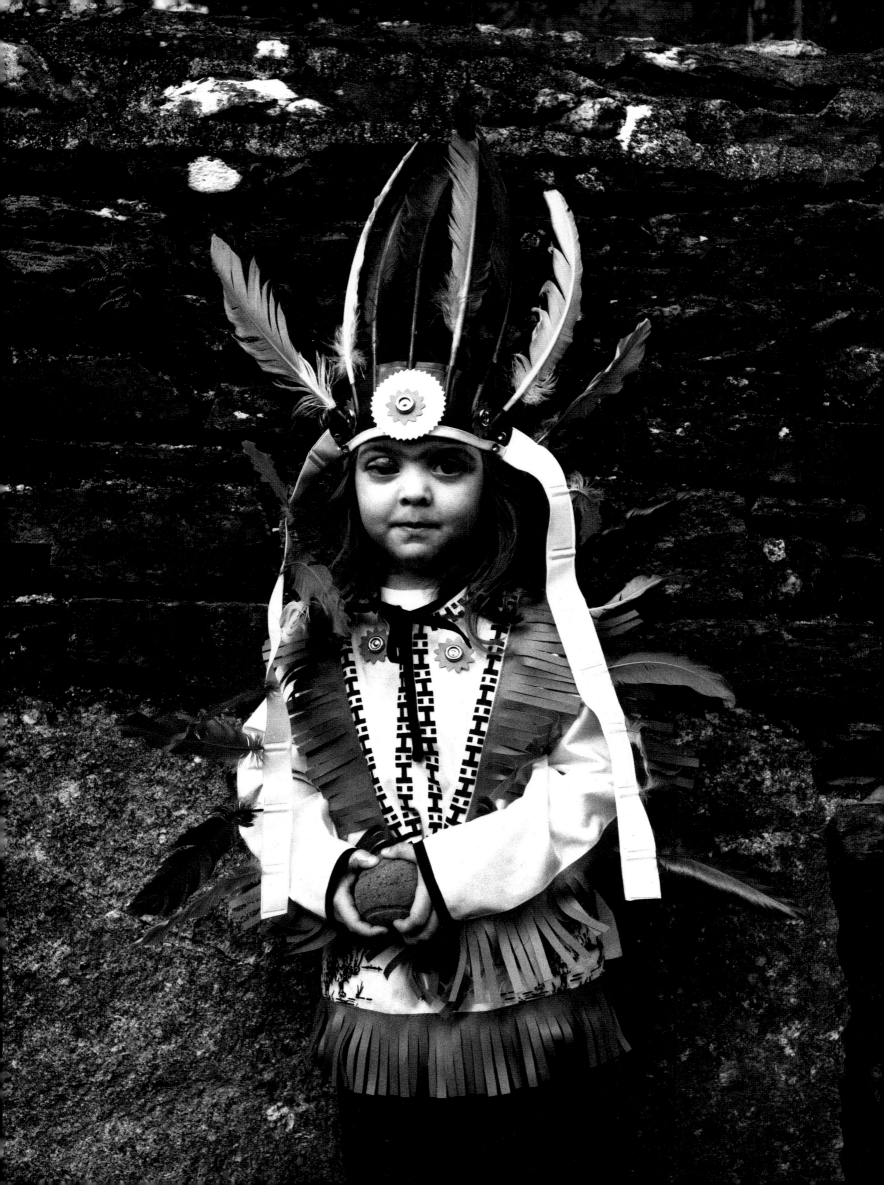

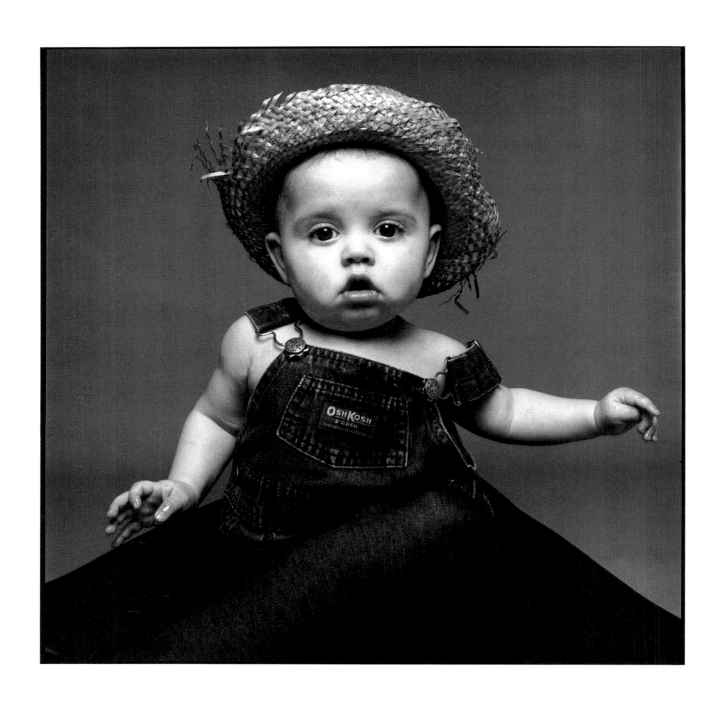

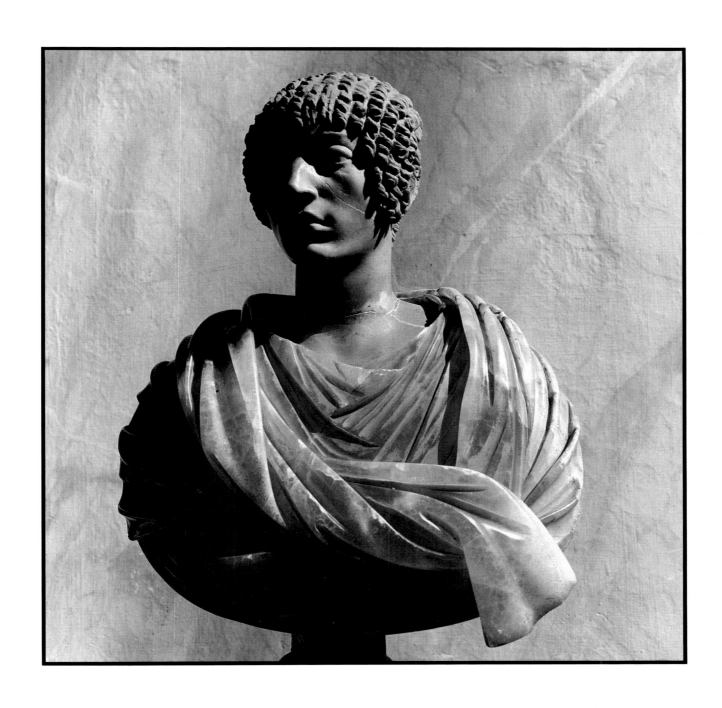

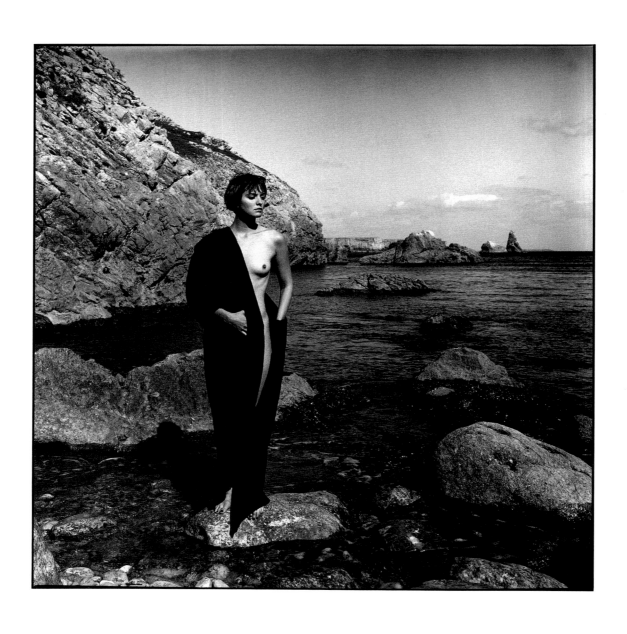

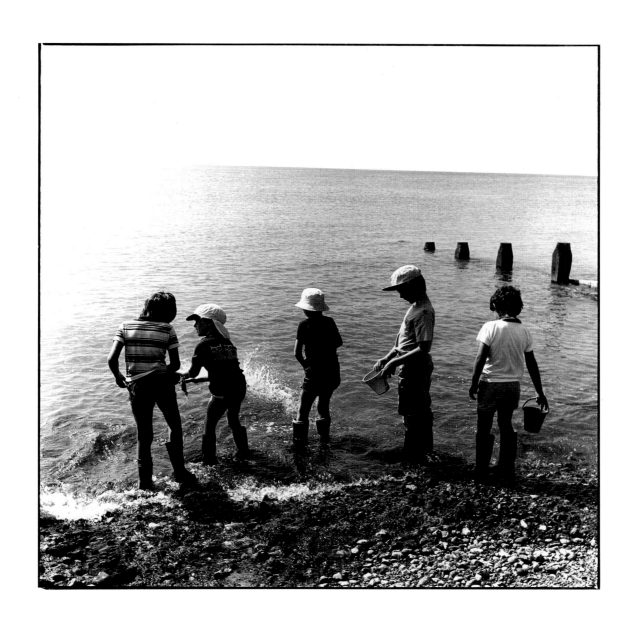

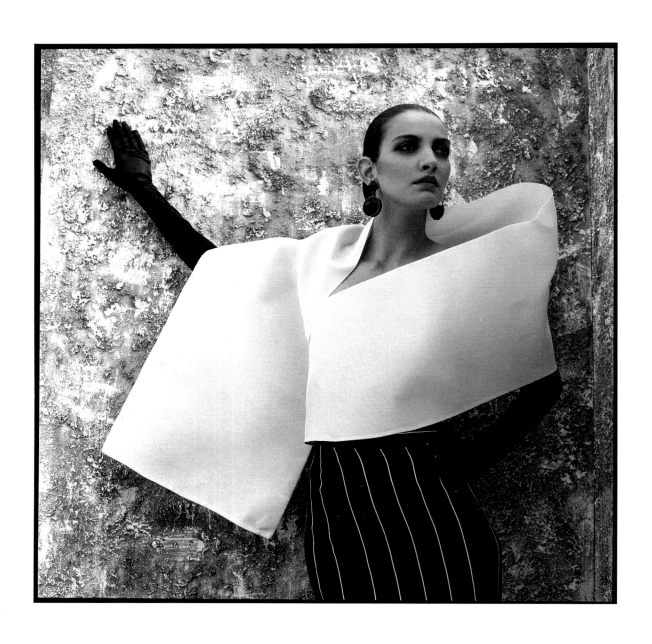

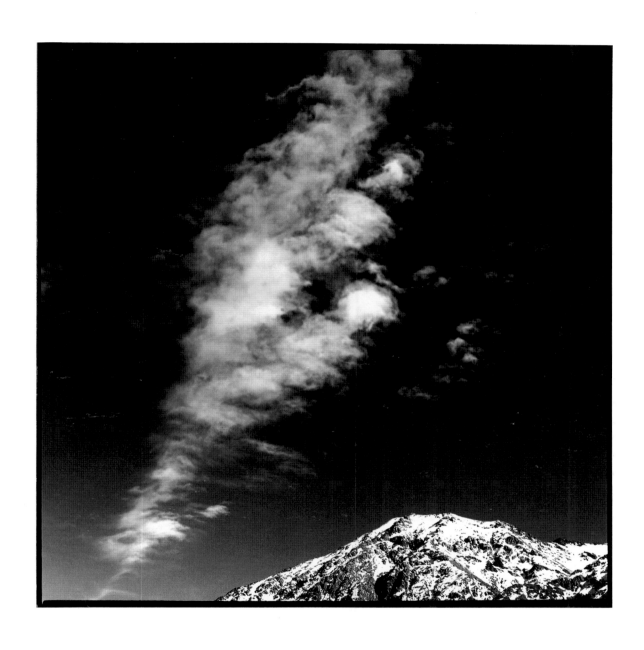

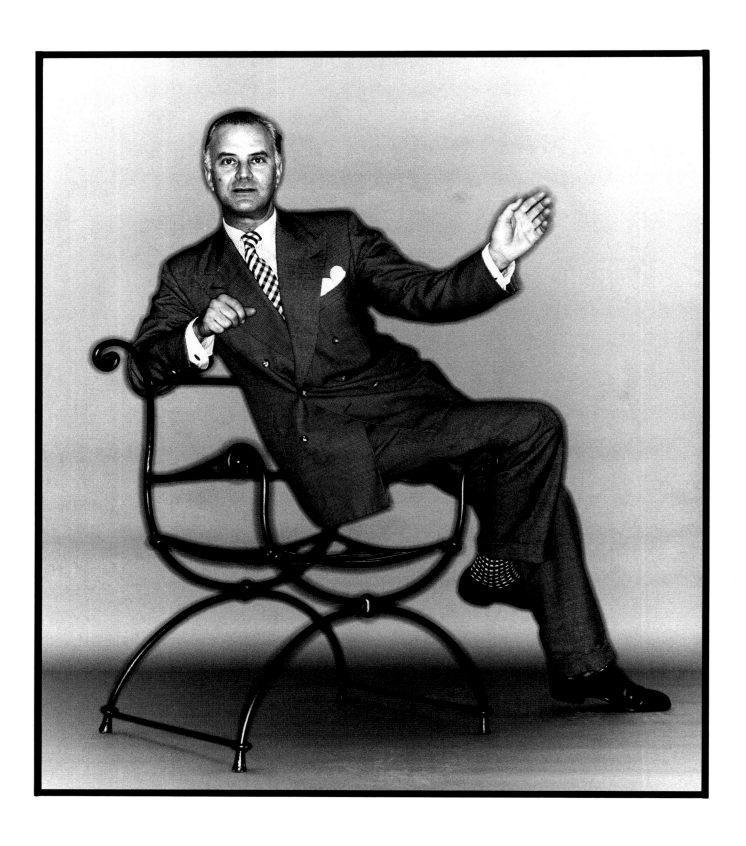

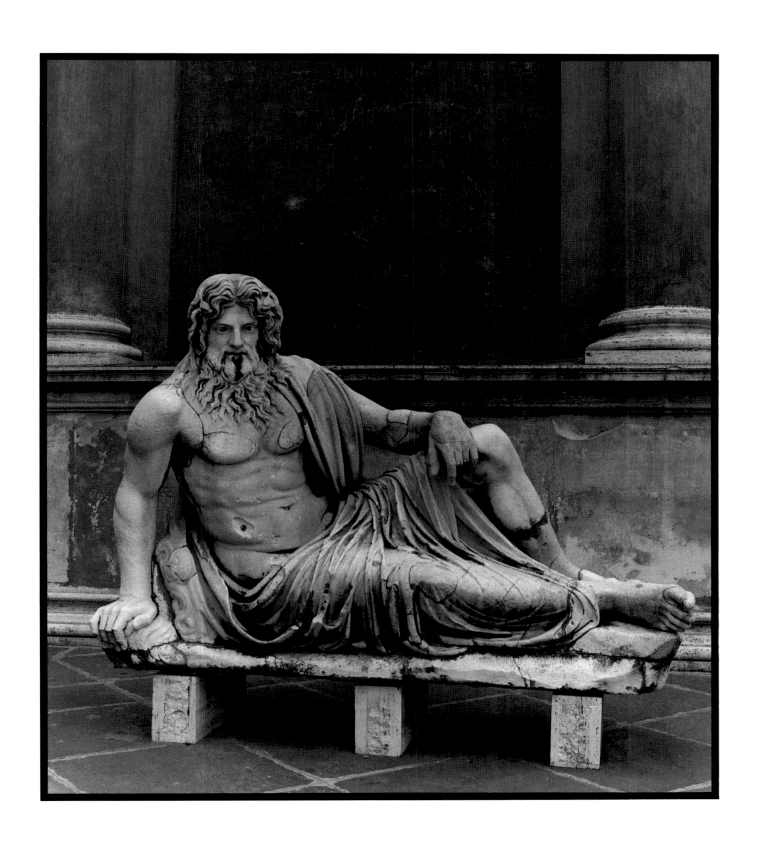

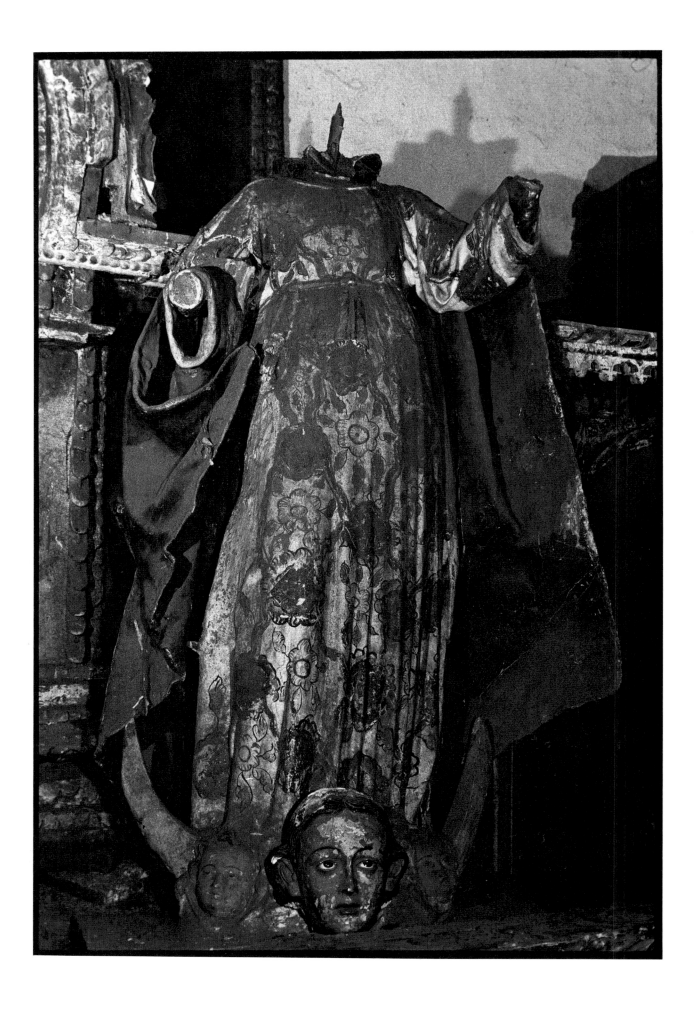

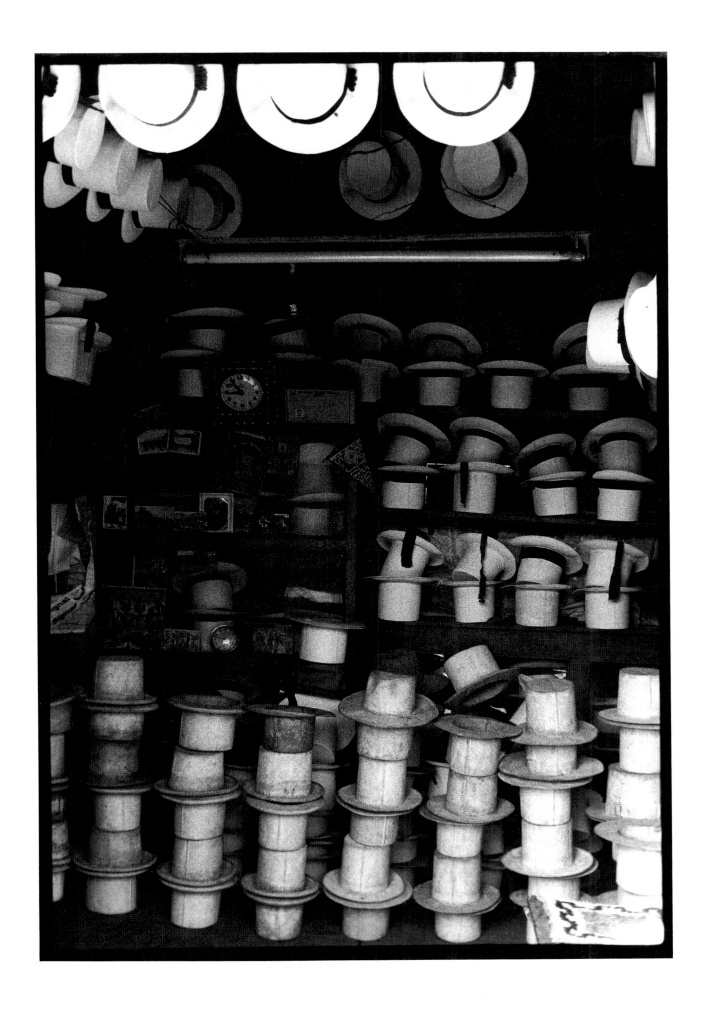

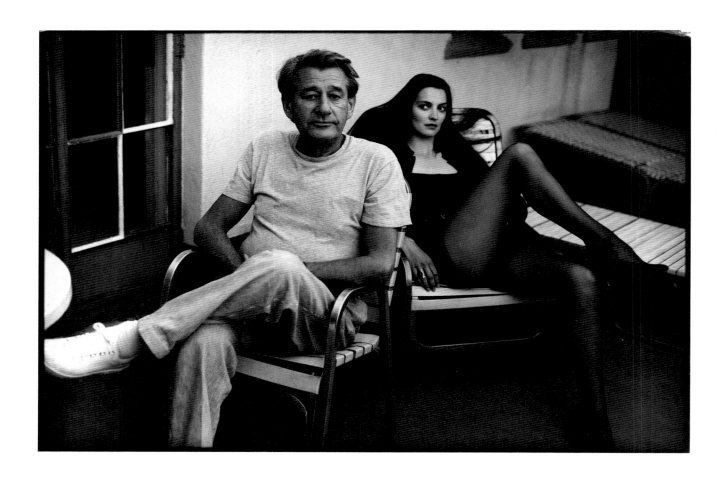

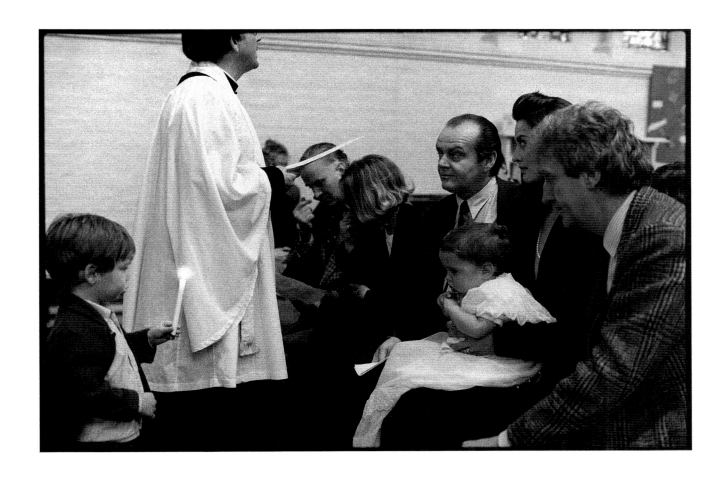

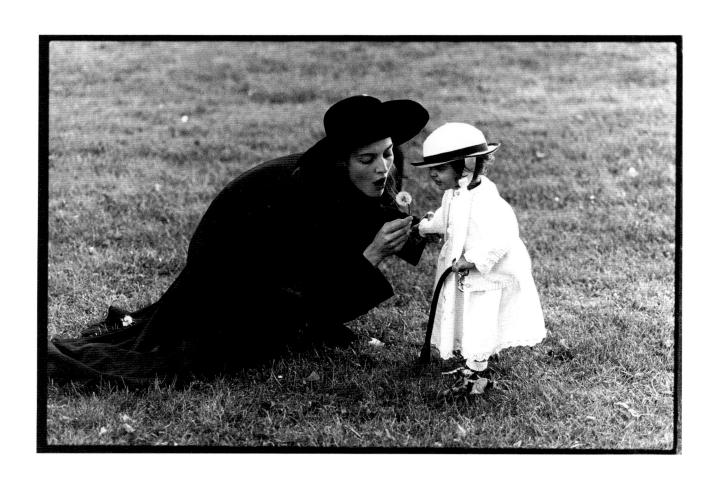

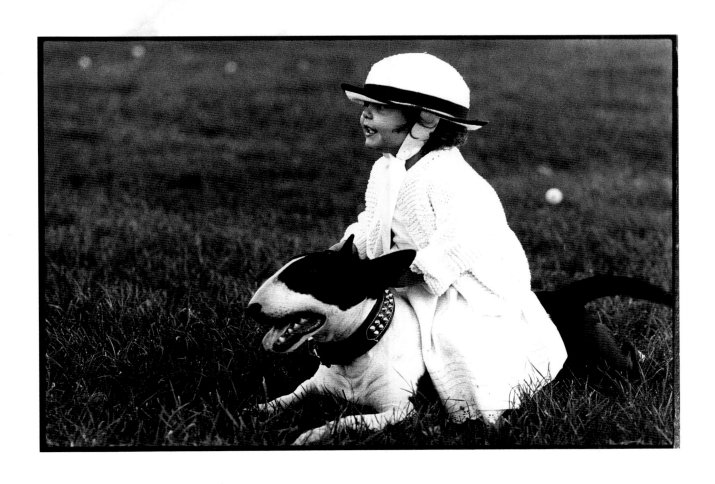

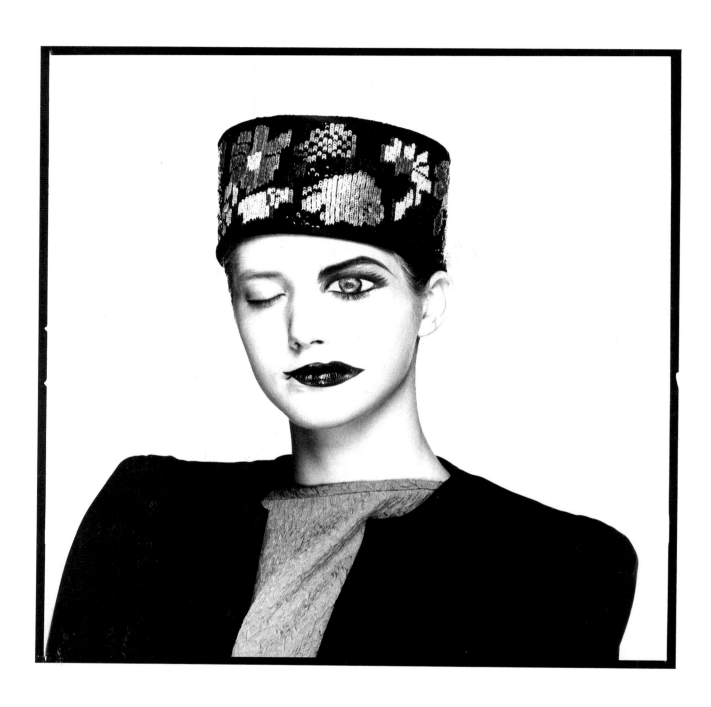

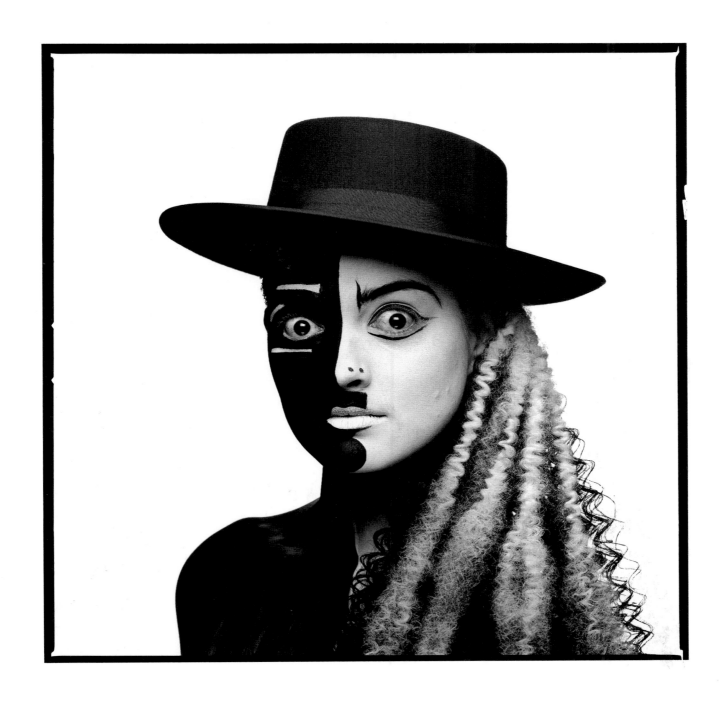

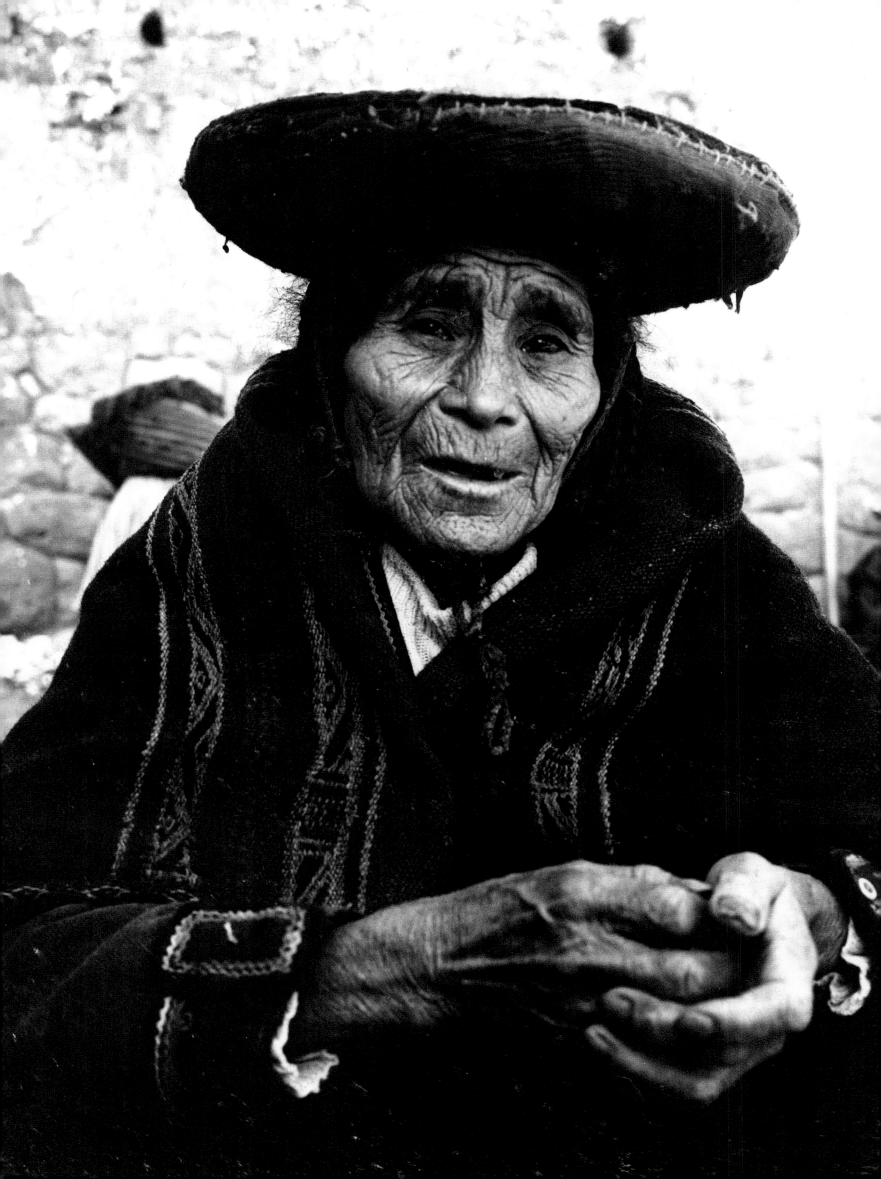

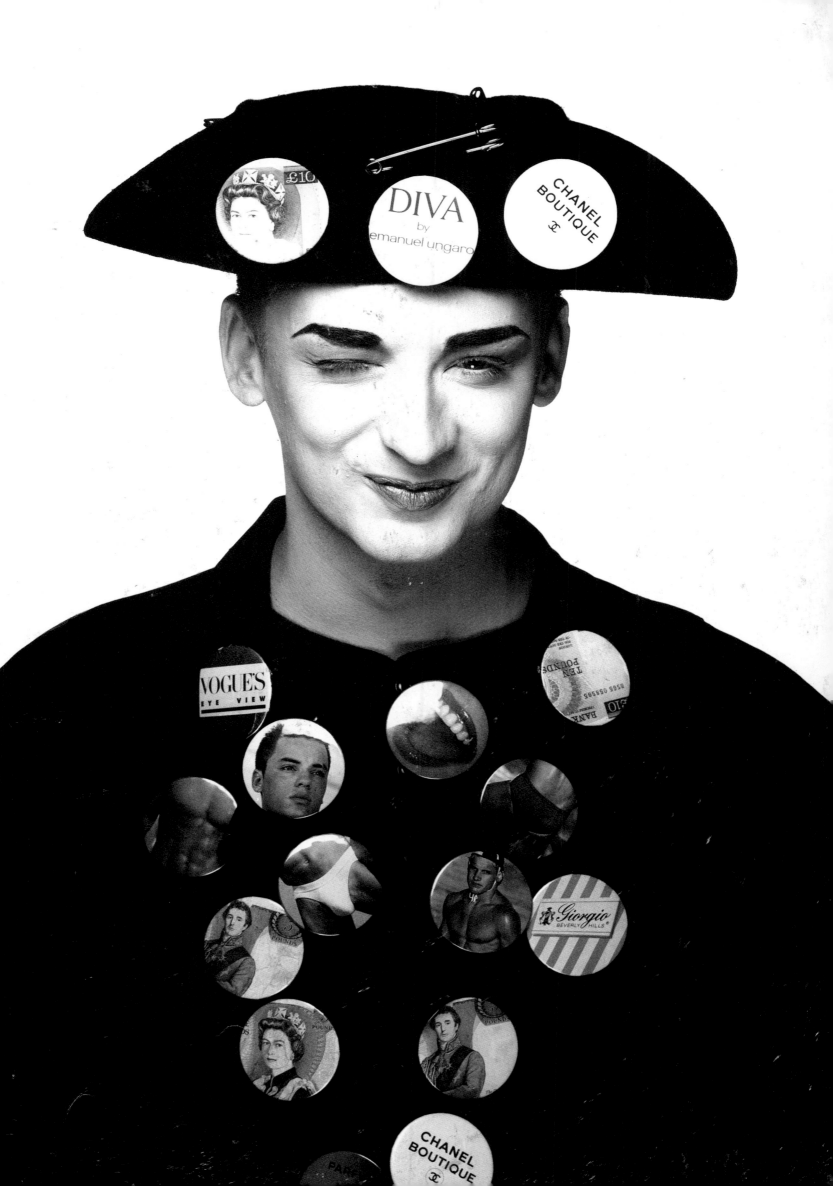

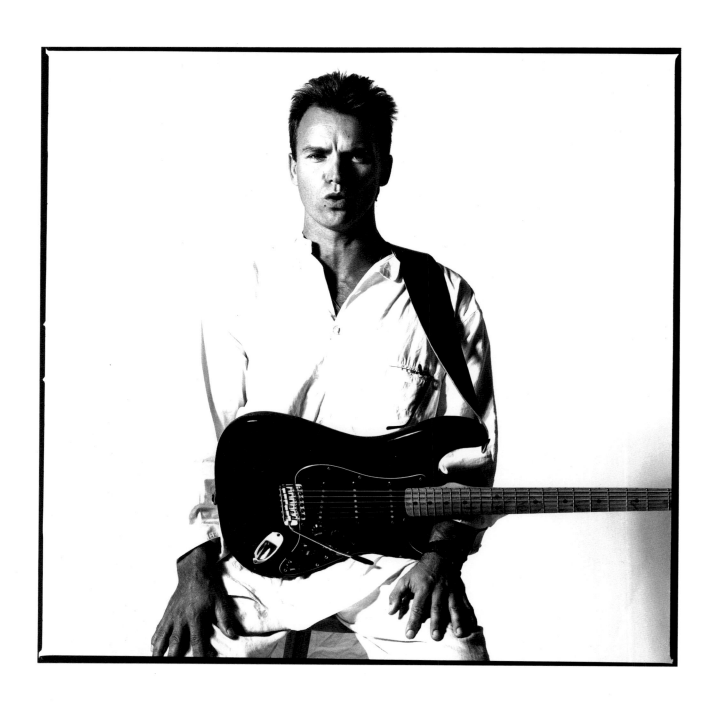

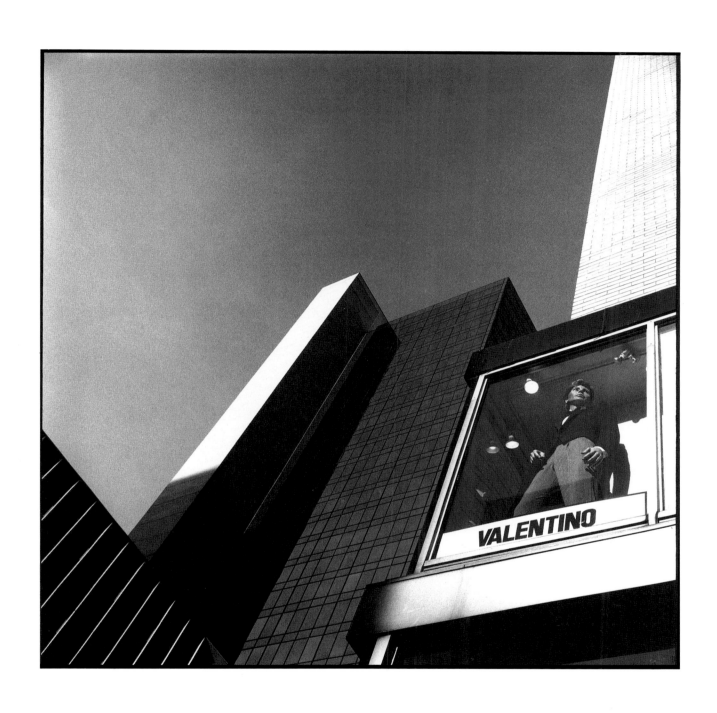

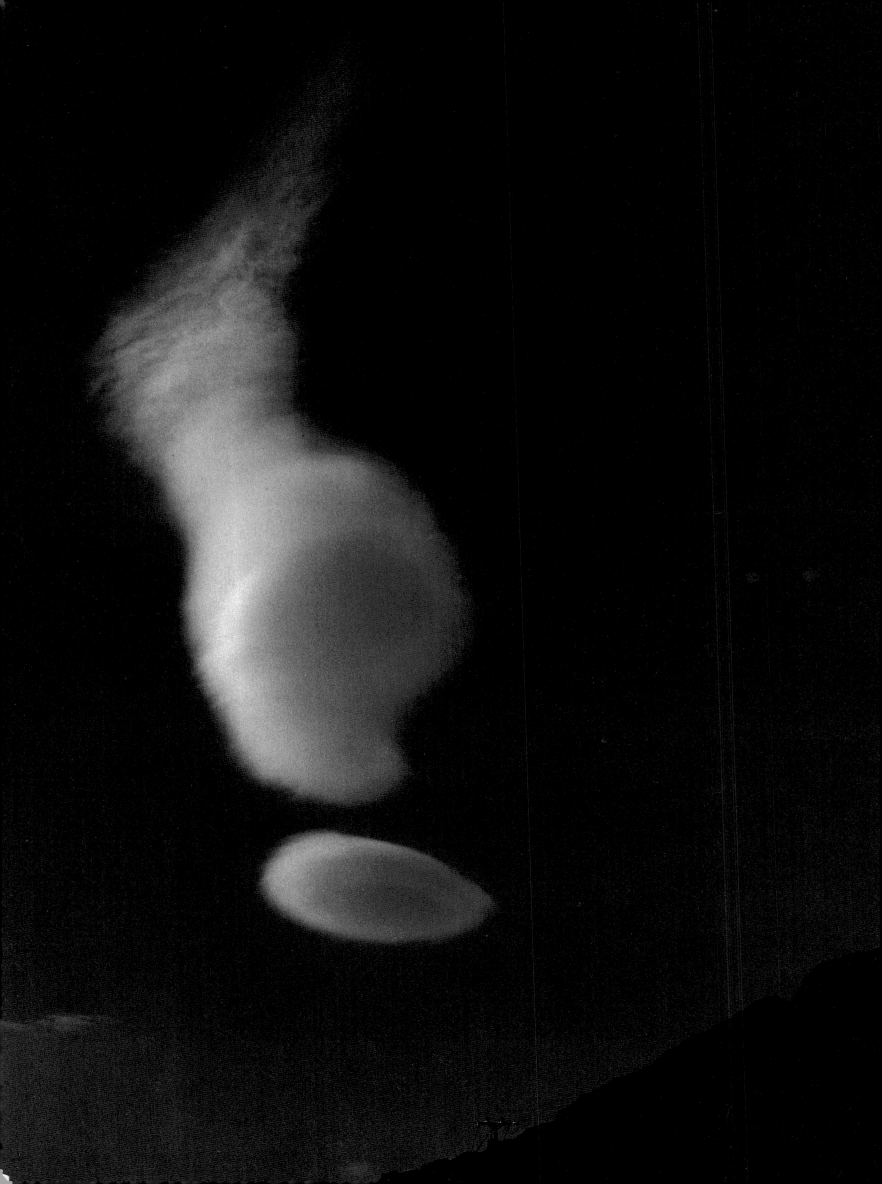

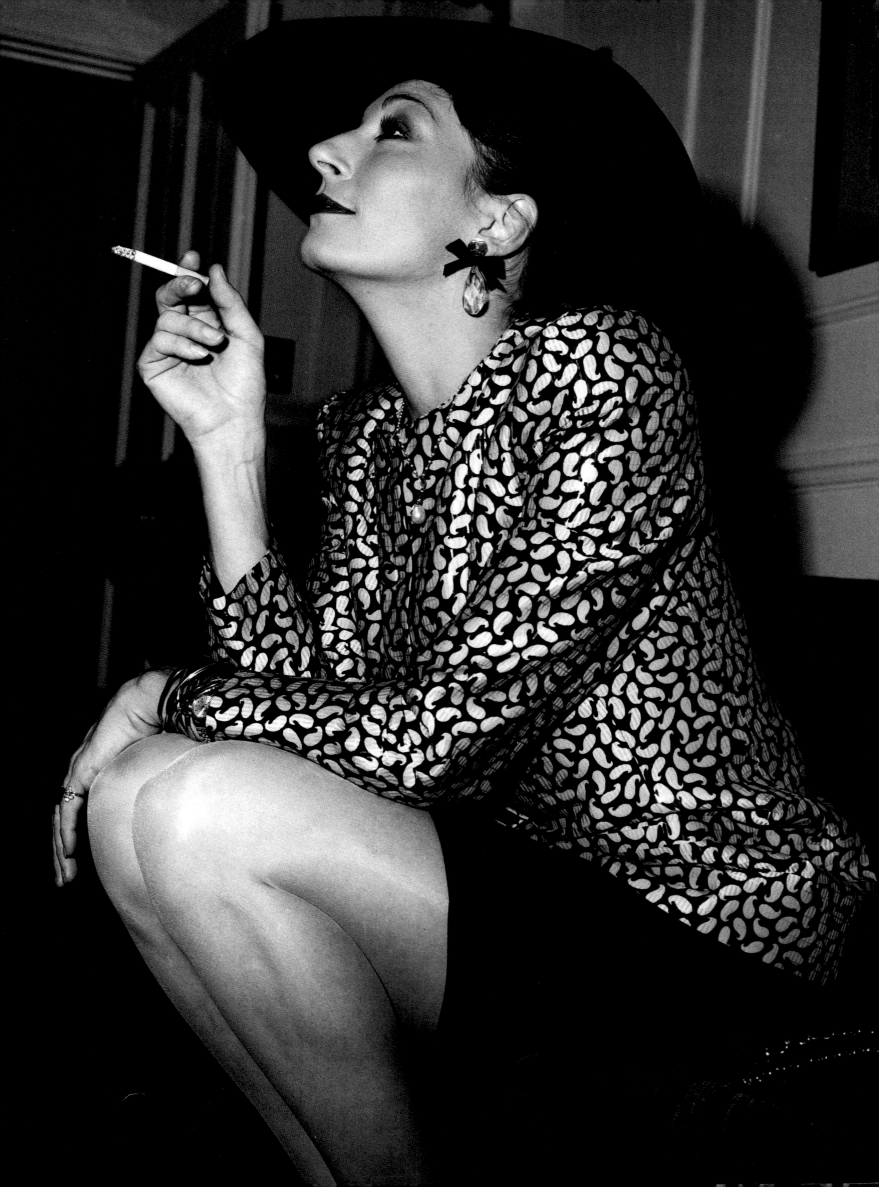

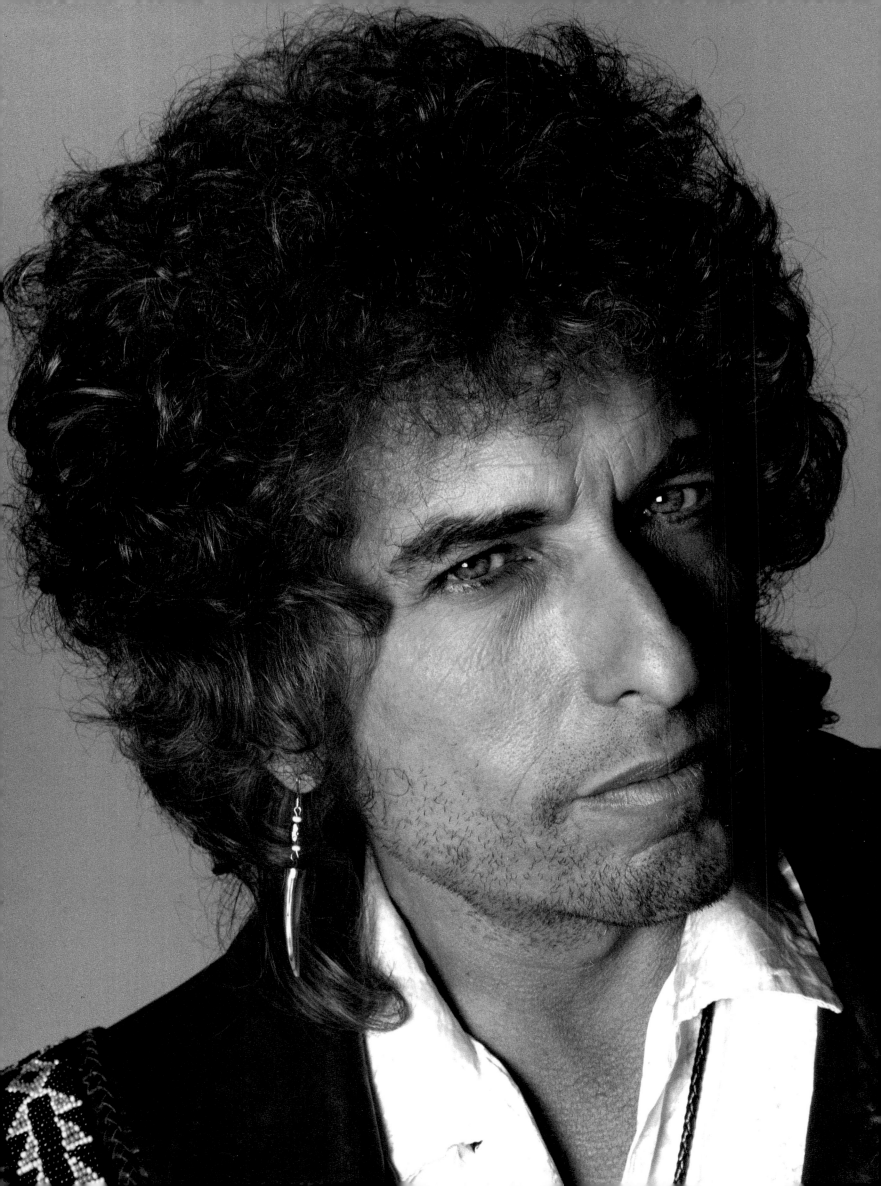

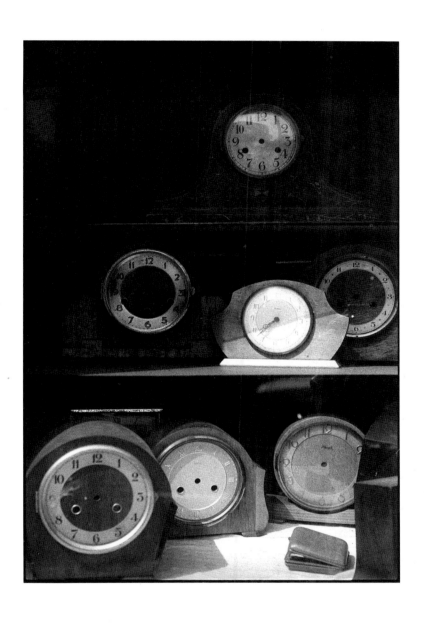

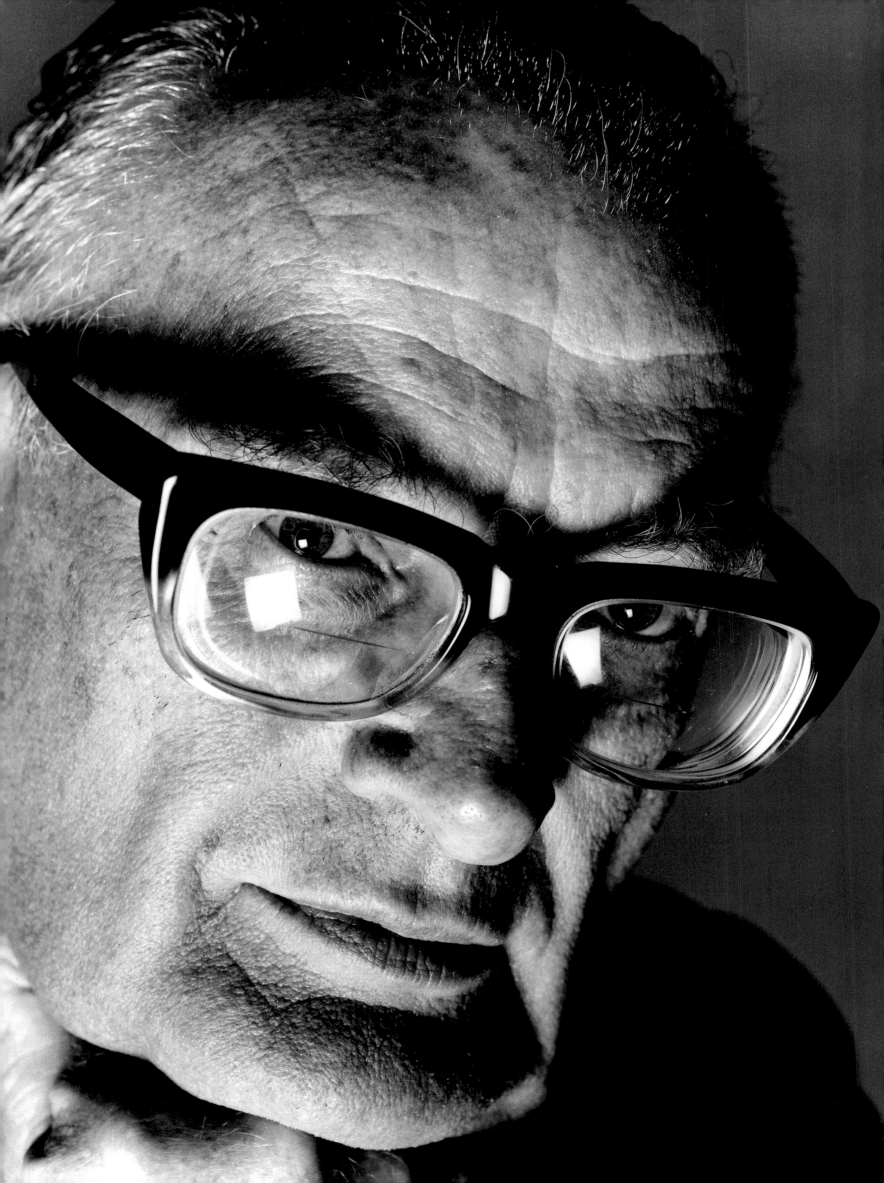

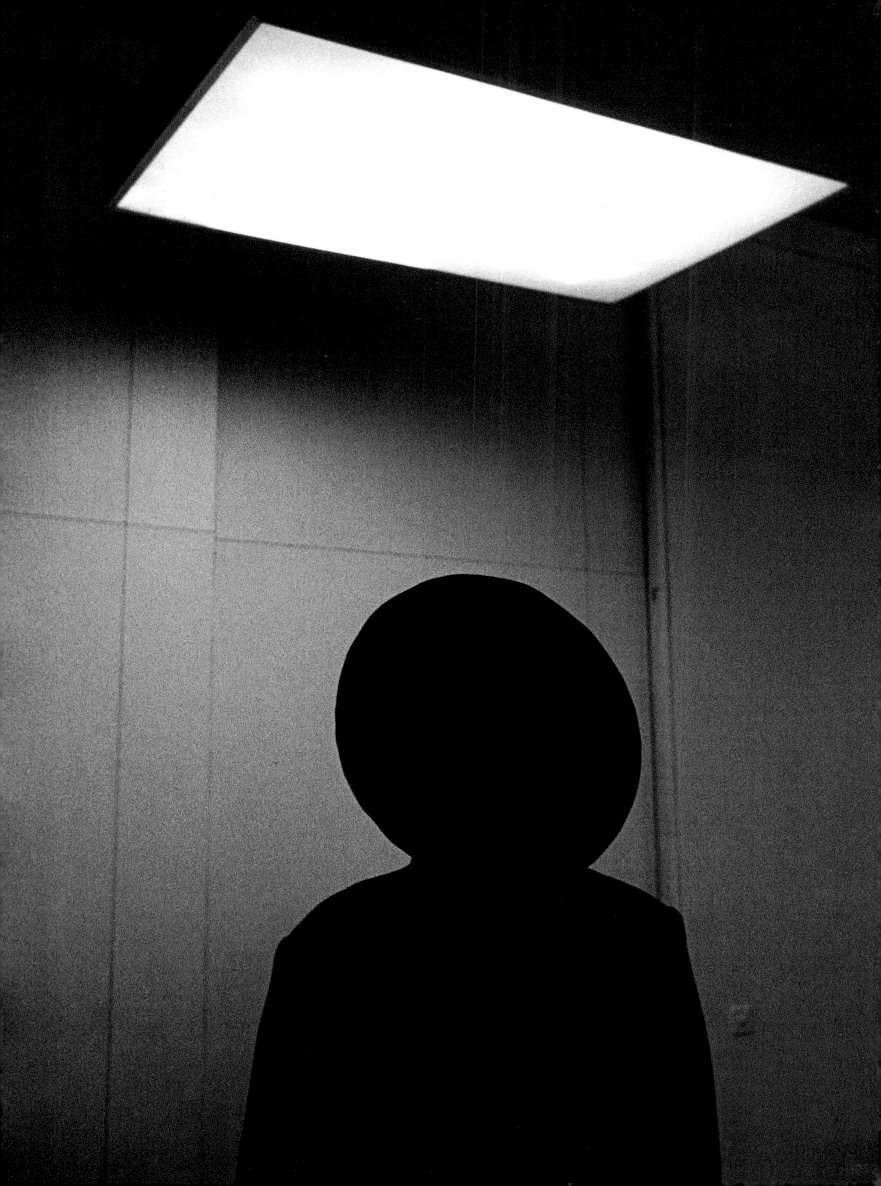

I would like to extend my thanks to
Stephanie Rushton,
and to Johanna Neurath of Thames and Hudson,
for their help in the preparation
of this book.

David Bailey